blmnopqrstuvwxyz

ALL ABOUT

techniques in

CALLIGRAPHY

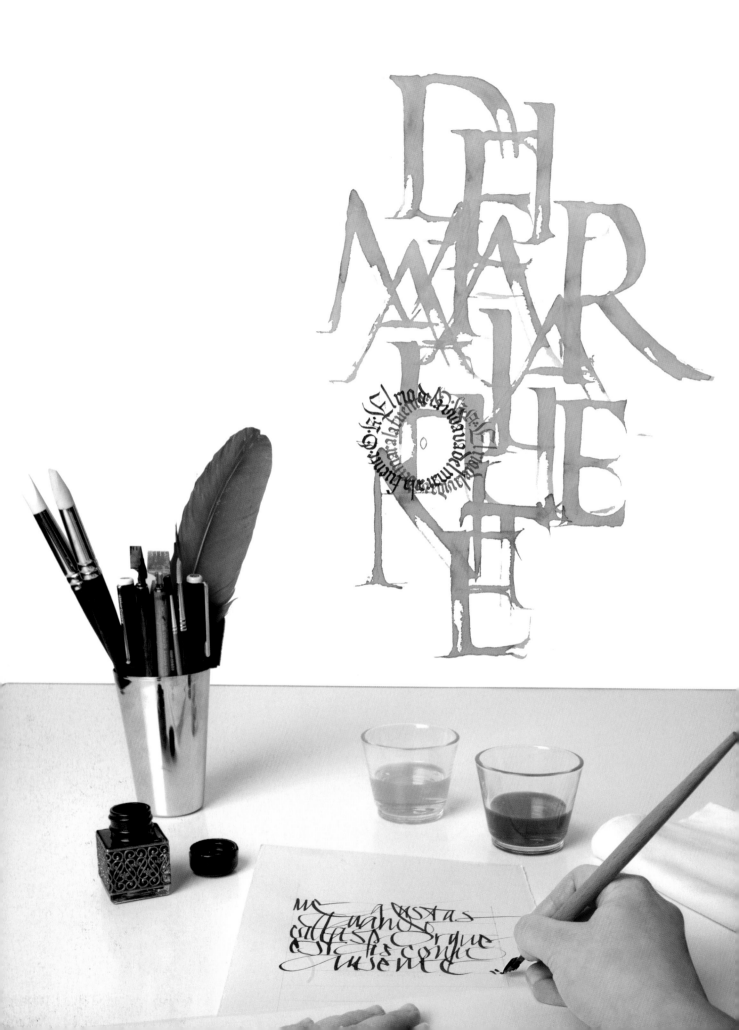

ALL ABOUT
techniques in
CALLIGRAPHY

BARRON'S

© Copyright 2010 of English translation by Barron's Educational Series, Inc., for the United States, its territories and possessions, and Canada.

Original title of the book in Spanish: *Todo sobre la caligrafía*

© Copyright Parramón Ediciones, S.A., 2009 World Rights
Published by Parramón Ediciones, S.A., Barcelona, Spain
Editor: Tomás Ubach
Text: Queralt Antú Serrano
Designed and produced by Parramón Ediciones, S.A.
Exercises: Queralt Antú Serrano, Walter Chen, Oriol Ribas, Massimo Polello
Other collaborators: Antoni Argilés Solá, Jean-Francois Bodart, Julien Breton, Barbara Calzolari, Marco Campedelli, Walter Chen, Silvia Cordero, Monica Dengo, Di Spigna, Claude Dieterich A., Vera Evstafieva, Peter Horridge, Inocuo (Javi Gutiérrez Gil), Chen Li, Christel Llop, Marina Marjina, Gabriel Martinez Meave, Betina Naab, Massimo Polello, Oriol Ribas, María Eugenia Roballos, Anna Ronchi, Ricardo Rousselot, Fabián Sanguinetti, Marina Soria, and Seward J. Thomas
Graphic design of the collection: Toni Inglés
Photography: Estudi Nos & Soto, Katja Seidel, Queralt Antú Serrano

Translated by Michael Brunelle and Beatriz Cortabarria

All inquiries should be addressed to:
Barron's Educational Series, Inc.
250 Wireless Boulevard
Hauppauge, New York 11788
www.barronseduc.com

ISBN-13: 978-0-7641-6388-3
ISBN-10: 0-7641-6388-4

Library of Congress Control Number: 2010022790

Library of Congress Cataloging-in-Publication Data
Todo sobre la caligrafía. English.
 All about calligraphy / [translated by Michael Brunelle and Beatriz Cortabarria].
 p. cm.
 Includes index.
 ISBN-13: 978-0-7641-6388-3
 ISBN-10: 0-7641-6388-4
 1. Calligraphy. I. Title.
 NK3600.T6313 2010
 745.6'1—dc22 2010022790

Printed in Spain
9 8 7 6 5 4 3 2 1

The intent of this book is to introduce the reader, page by page, to the fascinating art of calligraphy. A brief introduction to the history of writing shows that with it, mankind has history, thanks to the human desire to search, communicate, and transmit.

"Language," *said Heidegger*, "is not just an instrument among many possessed by man, it is the first to guarantee the possibility of being in the middle of the publicity of beings. The world only exists where there is language, that is, the always changing circle of decision and work, of action and responsibility, but also of caprice and disorder, of failure and loss. Only where the world rules, is there history. Language is a gift in the most original sense. This means that it is good to guarantee that mankind can be historic. Language is not a handy instrument, but rather an event that encourages the highest aspirations of mankind."

In the following pages we will analyze the different styles of calligraphy, the tools that are used for creating it, and the different styles of the classic letters. Finally, through educational step-by-step exercises, the reader will be able to acquire, with some practice, the ability to create beautiful writing.

In addition, this book is illustrated with excellent works of calligraphy. You will be able to enjoy the great works, an unending source of inspiration and reading.

Marina Soria, Language. *2002, 21½ × 18 inches (60 × 50 cm). Acrylic, gesso, sand on canvas. Bronze and silver sheet. Sumi and walnut ink on Arches paper and Japanese paper. Pens, brushes, and a folded pen, an experimental instrument invented by the artist. The work is structured in three well-defined parts: a series of horizontal rows above, with ancient signs and symbols that represent the era in which writing supports were clay and stone; an intermediate section, which represents writings made on parchment, vellum, and paper; and, finally, the industrial era, when the supports were metal plates. This synthesis of the evolution of writing can be seen vertically crossing the text. At the top is the cover of an antique book on the history of Rome, the original, which belonged to the artist's father.*

The Origins of Writing: Proto-writing

Proto-writings were systems of graphic symbols used to transmit ideas. They are not exactly writing since they lack characteristic letters and a system, but they are interesting as a way to know how writing began and to see the graphics once used to transmit thoughts. There are innumerable forms that can be considered proto-writings, but here we will look at the three most relevant ones.

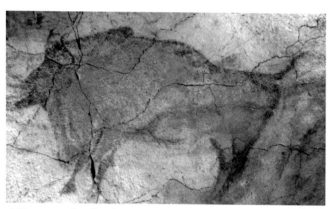

A bison painted in the Altamira Cave (Cantabria, Spain). The outlines were drawn with manganese black and the inside colored with reds and ochres mixed with agglutinants like animal fat.

CAVE PAINTINGS

During the last ice age there were already numerous paintings, in fact forms stenciled on the walls of caves. These were the first human attempts to communicate a message. Generally the messages have not been deciphered, but they seem to say *"me hunting a bison."* Excellent examples of such paintings can be seen in the cave discovered in 1868 at Altamira, Spain, where paintings have been preserved for 20,000 years since Upper Paleolithic times. There is disagreement on whether they can be considered writing, which is why the symbols are given the name "proto-writing."

THE CLAY BULLAE

Ancient Mesopotamia of about five thousand years ago is considered to be one of the sites where human civilization began. Within the historical context of the discovery of the wheel, the pottery wheel, and other new technology in an incipient agricultural and herding society, two states coexisted on each side of the Tigris River: Sumer between the Tigris and the Euphrates, and Elam to the west of the Tigris, whose capital was Susa. These populations used a system with hollow clay balls (*calculi*), which we call "bulla." These balls were recipients for markers of shapes that differed according to an agreed commercial value. They symbolized goods using spheres, cones, and cylinders to account for goods, lands, and livestock. When needed, the bulla was broken open and the list of accounted goods could be seen. This system of transactions became more complex, and symbols called logograms (from

In this illustration we see a bulla and its contents, and flattened bullae that become a sort of tablet for making iconographic marks called logograms. These marks on the surface of the tablets recorded commercial trading records.

the Greek *logos* = knowledge and *graphos* = writing) were carved into the surface of the clay. The system was based on symbols and icons, with a schematic (not phonetic) representation of real objects accounted for in quantity as well as quality. The Sumerians represented the head of an ox with a triangular shape with horns, and the number of triangles indicated the number of cattle.

THE FIRST CLAY TABLETS

Over time a more practical solution was developed—flattening the ball of clay and drawing the content of the contract on both sides of it: "what, how much, and when." That was the beginning of clay tablets. Since they were numerical tablets, they could not be considered writing per se, only sums and pictographic symbols. The Mesopotamians resorted to clay because it was abundant and wood and stone were scarce. Besides, clay is a malleable material, easy to work with, to mark and erase in case of error, and after firing it is permanent.

Later, these logographic representations were simplified and became more abstract, developing into what we now know as cuneiform writing.

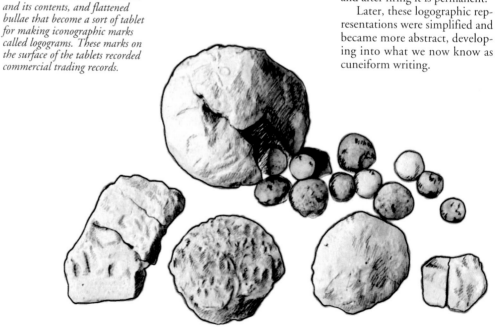

MESOPOTAMIA. SUMERIAN WRITING

About 40,000 people inhabited the city of Uruk, located on the banks of the Euphrates River. It became the most important city in Sumer, which controlled a large part of Mesopotamia and was the first great power in history. It is believed that four millennia ago, writing appeared in Uruk. This development coincided with the rise of cities. The first Sumerian writings—accounting records, contracts, and inventory registers—date to 3300 B.C. Writing was born from the need to preserve a record of commercial activity.

CUNEIFORM WRITING

The first clay tablets were pictographic, but towards 2500 B.C. these pictograms were stylized and abstracted until they developed into the writing and symbols we call cuneiform. The first cuneiform writings were made on clay tablets where pictograms were printed in vertical columns with a very sharp reed. One end was cut into an angled point, so that it would make a triangular mark when pressed into the soft clay—a wedge shape. Cuneiform is derived from the Latin word for wedge, *cuneas*, and means writing in the shape of a wedge. Reeds were also an abundant material in the marshy land of Mesopotamia. The clay tablets were later fired or recycled while they were still soft. The largest tablets had eleven columns and could measure 144 sq. in. (929 sq. cm.). One side of the tablet was flat, while the other was convex to keep from erasing the written side when turning the tablet over to write on the other side. Later, in addition to clay, they began using other materials as writing surfaces, like stone, clay pots, and panels coated with wax.

Cuneiform writing was later adopted by the Babylonians, the Elamites, the Hittites, the Assyrians, and the Akkadians; it was employed all across the territory to write the Sumerian language.

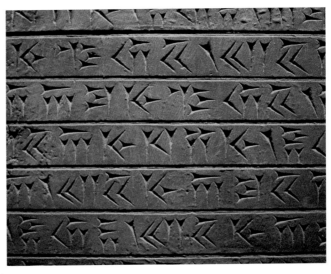

Inscription with cuneiform writing, shown enlarged. British Museum, London, England. Photo by Jan van der Crabben.

Inscriptions of Ganjnameh, Persepolis, Iran. The Spanish ambassador in Persia, García Silva Figueroa, discovered it in the ruins of Persepolis in 1618, near Shiraz; it was a type of writing unknown until then in the Western world. These inscriptions were geometric, triangular in shape, and all the same. For a long time it was believed that they were just decorations or ornamentation. The inscriptions of Ganjnameh were carved in granite and divided into two sections. The one on the right was ordered by Darius I, the one on the left by Xerxes, both during the 4th century B.C. These inscriptions were the key to deciphering cuneiform writing. Photo by Mary Loosemore.

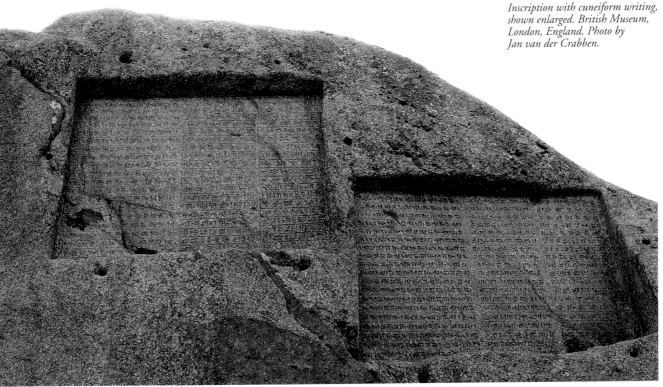

THE EGYPTIAN CIVILIZATION

Geographically, ancient Egypt was limited to the basin of the Nile River and was divided into three key areas: the valley of the Nile, the delta, and El Fayum, along with the additional areas of Nubia, Palestine, and Syria, and even extending to the farthest islands of Crete and Cyprus. The Egyptian civilization developed and thrived for more than 3,000 years. It began with the unification of various cities in the valley of the Nile around 3150 B.C., and ended in 31 A.D., when the Roman Empire conquered and absorbed Egypt.

Its writing, hieroglyphics, was of two types, *hieratic* and *demotic*.

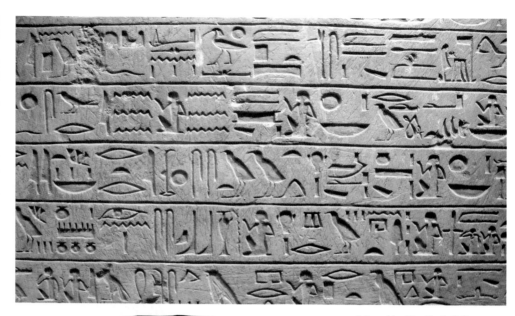

Minnakht (detail). Relief on limestone from 1323 B.C. 4.9 × 2.9 × 180.5 feet (1.48 × 0.89 × 55 m). Louvre Museum, Paris, France.

EGYPTIAN HIEROGLYPHICS

There is no consensus regarding the origin of Egyptian hieroglyphics. While there is a known evolution of cuneiform writing, Egyptian hieroglyphics seem to have suddenly appeared around the year 3150 B.C. It could be that there was Sumerian influence, but it is not known for sure since there are profound differences between the Egyptian hieroglyphs and the cuneiform pictograms. While cuneiform writing evolved toward abstract angular shapes, hieroglyphics maintained their figurative beauty and their representative complexity throughout their history.

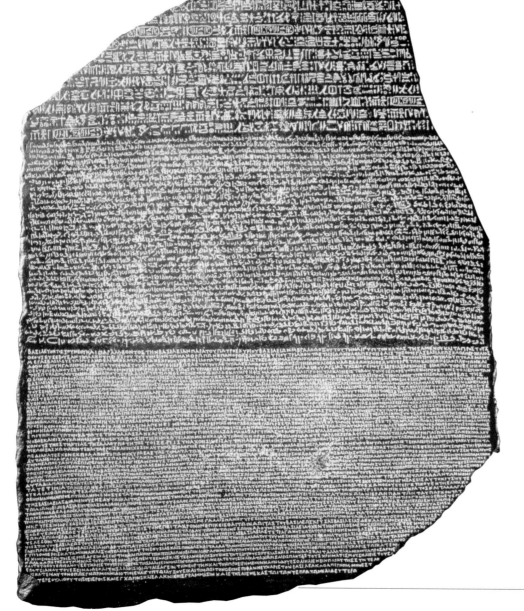

Rosetta Stone. British Museum, London, England. This is a piece of black granite 46½ × 28¼ × 10⅝ inches (118 × 72 × 27 cm). It contains inscriptions in three different scripts: Egyptian hieroglyphics, demotic script, and Greek. Dating to the 2nd century B.C. the Rosetta Stone helped the French Egyptologist Jean-François Champollion decipher the hieroglyphic writing.

HIERATIC AND DEMOTIC SCRIPTS

Hieratic writing was based on hieroglyphics; they were written with a brush, a quill, and ink on clay, wood, leather, and fabrics, but mainly on papyrus. It was very commonly used for making notes of administrative, scientific, literary, and religious proceedings. In the beginning it was written vertically, but very soon texts written horizontally began to appear. A very clear difference from the manuscripts of 1000 B.C. can be seen, where in the religious texts the hieratic type was consecrated scripts, which is why the Greeks called them *hieratikós*, which means "iron" or "sacred."

The name of the demotic script comes from the Greek work *demotikós* (of popular use, from *demos* = people). It comes from the Greeks and appeared in Egypt after 650 B.C., where it was used for day-to-day documents as the writing of the common people. It was the script used on the Rosetta Stone, which dates from the 2nd century B.C. In 1799 Captain Pierre-François Bouchard presented this heavy black granite stone that he found while leveling some ground near the Nile to the Cairo Institute. In Cairo it was studied by scientists traveling with Napoleon Bonaparte's expedition, but it was Jean-François Champollion who, in 1822, successfully deciphered the hieroglyphics, using the technique of comparing cartouches (the names of the pharaohs, which are always framed). This was possible because the Rosetta Stone had the same text, a decree of King Ptolemy V from 196 B.C., in hieroglyphics (the "writing of the gods"), in demotic script, and in Greek (which were popular scripts).

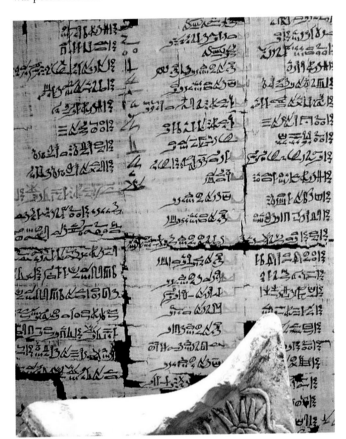

Fragment of the Book of Dreams, *of Deir el-Medina (Egypt), from the period of the 19th Dynasty, c. 1275 B.C. British Museum, London, England. It is known by this name because it narrates different dreams and their interpretations. When the interpretation was unfavorable, the text was written with red ink. This writing in demotic script on papyrus, and the direction in which the pictograms are facing, indicate the direction of the text.*

EGYPTIAN SCRIBES

The difficulty of representing hieroglyphics and the high rate of illiteracy (it is believed that only one percent of the population knew how to read and write) was the reason that writing was only accessible to a very elite group who knew how to read and write. Their status was envied by many, since writing guaranteed the immortality of whatever was written. The high government positions and those of scribes were very desirable and difficult to achieve. The studies for being a scribe and assimilating the numerous hieroglyphics took as many as 12 years. The apprenticeship took the form of repetition: dictations, copies, and more copies of great texts from the classic period. A papyrus ended with these words: *"The profession of scribe is princely. The task of writing and the rolls of papyrus bring the scribe riches and well-being." "Man perishes, his body turns to dust (...) but the book will ensure that his memory will be transmitted from mouth to mouth"* (Chester Beatty Papyrus IV).

The Seated Scribe. *Louvre Museum, Paris, France. This well-known statue reminds us of the functionaries that dominated writing. Thanks to their work, today we know many economic, historic, and social facts that have helped historians to know what life was like for this civilization.*

THE DIRECTION OF EGYPTIAN SCRIPT

Egyptian hieroglyphics can be read from right to left or from left to right. The scribe placed his symbols according to the reading, so that if a line of hieroglyphic symbols (people, animals, etc.) look towards the right it means that the reading is done from the right to the left. They had a great love of symmetry, so they often wrote the same inscription to one side and the other so that it could be read in both directions.

Chinese Script

Chinese writing is possibly the language that has most preserved its original meaning, despite undergoing noticeable changes over the centuries. In China, traditional script is typically used for calligraphy; however, we should be speaking of several calligraphies since different styles are employed according to their social uses. For the Chinese, calligraphy is a venerable art, as much or more appreciated than painting. In the Chinese culture a good calligraphic hand brings admiration and prestige to the calligrapher.

EVOLUTION

Of all the living scripts, Chinese is the oldest. The most ancient examples that have been discovered are *jia gu wen* symbols, from the Shang Dynasty, carved on bone and turtle shell in the 14th century B.C., and known as "oracle bones." Of the 4,500 *jia gu wen* symbols discovered so far, only about 1,000 have been identified and their evolution traced to contemporary characters.

Throughout the three millennia of Chinese characters and their different styles of writing, they progressively increased from those 4,500 symbols of the Shang Dynasty, to 10,000 from the Qin Dynasty (221 to 206 B.C.); by the 12th century there were 23,000; in the 18th century nearly 49,000; and today there are about 55,000 symbols, of which only 3,000 are commonly used.

Oracle bones (14th century B.C.) with inscriptions of jia gu wen *symbols, the most ancient Chinese writing, on a turtle shell.*

Painting and calligraphy work of Shitao (1641–1720). Shitao was a great theoretician of Chinese painting, who followed the concept of "a single brush stroke," still very popular today. His most important theoretical work was the Manual of Painting. *Notice that the artist also inserted his calligraphy within the painting, which is typical in Chinese painting.*

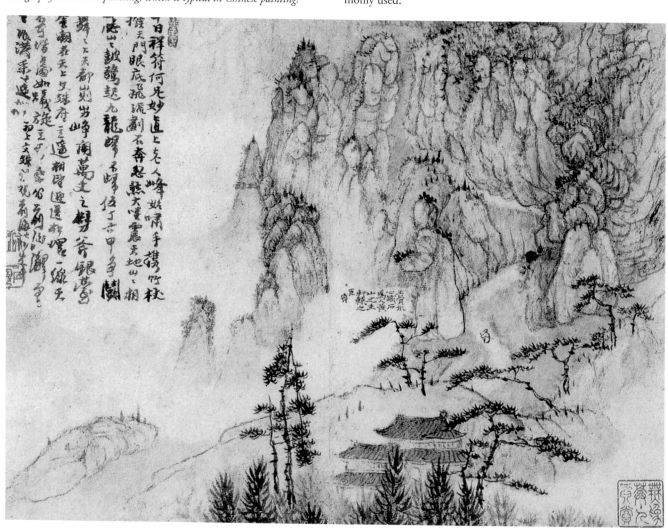

The government of the People's Republic of China generalized instruction and created a simplified version, reducing the characters to 515, in an attempt to reduce the high rate of illiteracy in China (80% in 1949). Thus they were able to increase literacy in adults to 81% by 1995, according to UNESCO. In mainland China, only scholars are familiar with the traditional scripts. This reform has been harshly criticized and rejected by other Chinese communities like Taiwan and those established in other countries, for the enormous loss of identity and tradition in a much venerated part of the Chinese culture that is its writing.

THE FORMS OF CHINESE CHARACTERS

Chinese characters can be classified as:

1. Simple figures that can be images (stylized representations of objects without any indica-

A Chinese calligraphic ideogram done with a brush, the traditional and artistic way of writing. Above we see the red stamp that is equivalent to the artist's signature or the owner's. The stamp is also a form of calligraphy of a more stylized type. In the Chinese culture, calligraphy is highly valued art that brings honor to the person who practices it.

tion of its pronunciation) or symbols.

2. Composed figures and associations of various characters can be logical groupings of several characters whose meanings are combined but that do not give any clues as to how they are read, or phonic compositions—associations of two graphic elements, one indicating the meaning and the other the pronunciation.

MEANING IN CHINESE LETTERS

Chinese writing was at first based on ideograms that suggested very stylized forms of real things. It has evolved over thousands of years to become the different kinds of scripts seen today. In this box are some very simple concepts written in the Chin wen style from the Qin Dynasty (221–206 B.C.) and in today's standard script. We can see how the words are stylized, the figure of the man and the simple definition of the jail with the figure of the man enclosed in the frame, and also the figure of the ox that suggests the animal's horns.

The ancient script is still used for designing the stamps that are used in Chinese culture as a signature or sign of ownership of a document. All of the styles of Chinese writing are very interesting in the practice of calligraphy.

Meaning	Chin wen	Modern Script
Sun	日	日
Mountain	山	山
Ox	牛	牛
Man	人	人
Jail	囚	囚

HOW TO WRITE CHINESE LETTERS

To put it briefly, some of the rules that must be kept in mind to write the strokes of each character are: 1) Since the direction of the writing is vertical, the characters are drawn from top to bottom, first the upper brush strokes and then the rest, the lower horizontal brush strokes at the end. 2) The middle strokes are made first, then the outside ones, from left to right. 3) If there are some lines that surround others, the interior ones are made first and then the outside ones. 4) The horizontal lines crossed by verticals are written first. 5) When two curved lines cross to make an X shape, the right stroke must be made first, then the left. 6) The small and short lines are written at the end of the character.

二　一　二

女　く　夂　女

中　丨　口　中

雨　一　冂　冂　帀　雨　雨　雨

馬　一　冂　厂　厍　馬　馬　馬　馬

An example of the order of writing of some Chinese characters. In the first column we see the complete letter, in the next the different steps in the correct order.

THE ORDER OF THE STROKES

Attention must be paid to the direction of writing Chinese characters. They are written in vertical lines and from right to left.

There are eight fundamental strokes in Chinese writing, and the order of creating them is also one of the fundamentals. The strokes are: 1) dot; 2) horizontal line from left to right; 3) vertical line from top to bottom; 4) hook, curved upwards; 5) nail, from left to right; 6) tail, from above to below, and right to left; 7) short mark, downwards and from right to left; and 8) press downwards from left to right

THE MATERIALS

We need just a few materials for practicing Chinese calligraphy, the so-called "four treasures of the writing table": rice paper, Chinese brushes (*bi*), Chinese ink (*sumi*), and the ink stone (*suzuri*), as well as some basic instructions before starting to write. The layout of the workspace is also very important.

All the materials should be at hand on a very sturdy table, at a comfortable distance and far enough from the paper to keep ink from spilling on it. Since the rice paper is quite thin and the ink often soaks through it, it is a good idea to place a piece of black felt under the paper to keep the table clean and to increase the density of the ink.

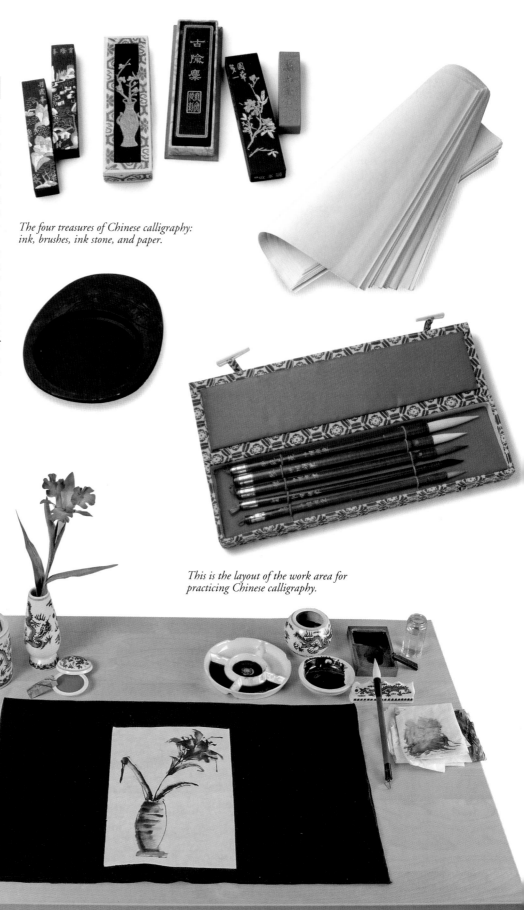

The four treasures of Chinese calligraphy: ink, brushes, ink stone, and paper.

This is the layout of the work area for practicing Chinese calligraphy.

POSTURE

The position of the body is also very important. It is common to practice Chinese calligraphy while squatting, that is, with the gluteus near the floor resting against the heels. The back should be perfectly straight but not tense. The table should be quite low and below the navel. If it is difficult to find a low table or to work squatting, it is also possible to work in a chair, but it is necessary to sit on the edge of the seat, occupying about half of it. The feet should be farther back than the knees, the distance between the heels should be the size of a fist, and the toes more open than the heels to better control the force of the brush strokes.

Chinese calligraphy requires tranquility and meditation, so it must be practiced in a comfortable, calm, and well-lit space. Breathing exercises are practiced as part of the meditation. Some are helped by music; in this case it is preferable to listen to monks chanting because the constant repetition will help encourage controlled breathing.

Chinese calligraphers use these practical mats for laying the writing tools on the table and for transporting them. We must be careful not to roll up the brushes while they are still wet.

The position of the body is very important. In a seated position more typical of the West, the back should be very straight yet relaxed, sitting on the edge of the seat with the feet back from the knees. The distance between the heels should be about a fist, and the toes should be pointing a bit outwards to control the force of the brush stroke.

Arabic Script

Arabic is one of the most widespread scripts and most historic because it is the sacred script of Islam. Since the representation of images of Allah is prohibited by the Koran, calligraphy has great relevance in this religious culture—it is the medium of transmission of Islam and therefore it has extended far from its original region. The Arabic alphabet is defined by its consonants and has its origins in Persian, Aramaic, and Nabataean scripts.

THE IMPORTANCE OF ARABIC CALLIGRAPHY

In the Muslim world, calligraphy plays a role in all areas of daily life because it is the instrument that transmits the Islamic faith. A good example of this can be seen in architecture, actually the most representative structures like the great mosques and palaces like the Alhambra in Granada, Spain. Visitors enjoy the extraordinary ornamentation based on calligraphy that fills stucco walls and tiles with verses and quotes from the Koran, like the Nasrid emblem, "There is no greater victor than God," or poems totally integrated in the walls that even form doors and windows.

Arabic also has a great tradition of beautiful visual poetry, figurative representations of birds, for example, created solely with calligraphy and therefore not in conflict with the Koran. There is also a great tradition of including visual poems in textiles like rugs and tapestries, and in ceramic murals and objects of daily use like cups, vases, and plates.

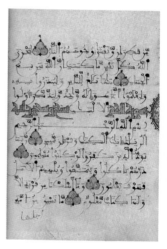

ORIGINS

Arabic calligraphy is a synthesis of several various evolutions of Persian, Aramaic, and Nasrid scripts. Modern calligraphy comes from Nastaleeq calligraphy, which originated in Persia at the end of the 14th century, created by the scribe Mir Ali al-Tabrizi.

Manuscript from a Koran from Al-Ándalus. The thickest lines in the center of the page are of Cufic style. 12th century.

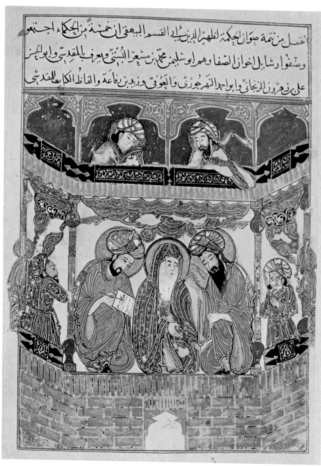

A page from one of the 52 Epistles of the Brethren of Purity, from Basra, Iraq, with Arabic images and calligraphy from the 12th century.

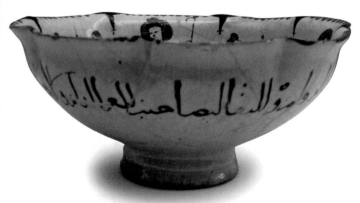

Fragment of an inscription in Arabic on a Persian ceramic piece from the early 14th century. Fundação Calouste Gulbenkian, Lisbon, Portugal.

Bowl of Persian origin with an Arabic calligraphic inscription. Late 12th century. Fundação Calouste Gulbenkian, Lisbon, Portugal.

WRITING TOOLS

The tools traditionally used for Arabic calligraphy are the reed pen and the quill, with a slanted nib cut toward the left. Papyrus and parchment were the most commonly used supports in the early days because of Egyptian influence, but as soon as the Arabs had access to the great Chinese discovery of paper, they produced a great variety of paper manuscripts because it was a less expensive material and easier to manufacture.

Reed pens.

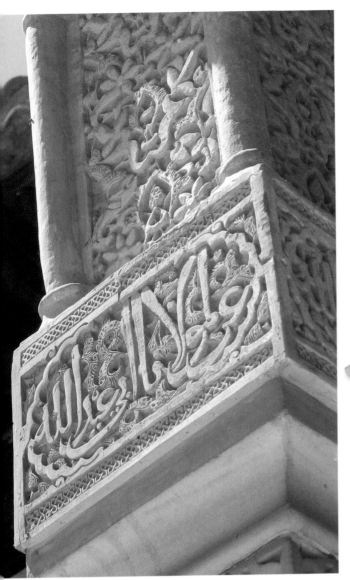

Detail of an arch in the Alhambra, completely covered with ornamental calligraphy. Granada, Spain.

Basmala, or a composition created by Shaykh Aziz al-Rufai. Basmalas usually initiate the suras of the Koran, but they have been developed into very ornamental calligraphy, in this case in the form of a pear.

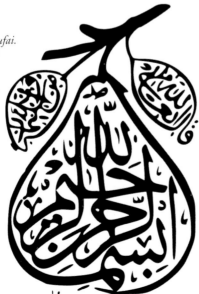

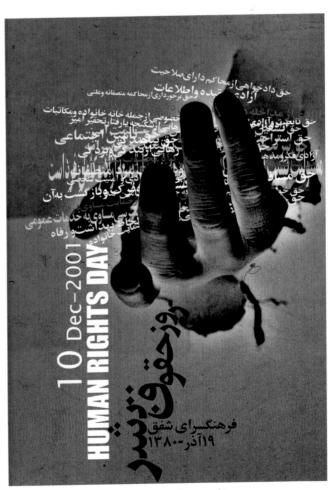

Work by Monireh Zarnegar, where Arabic is used in a contemporary design for a poster.

THE ARABIC ALPHABET

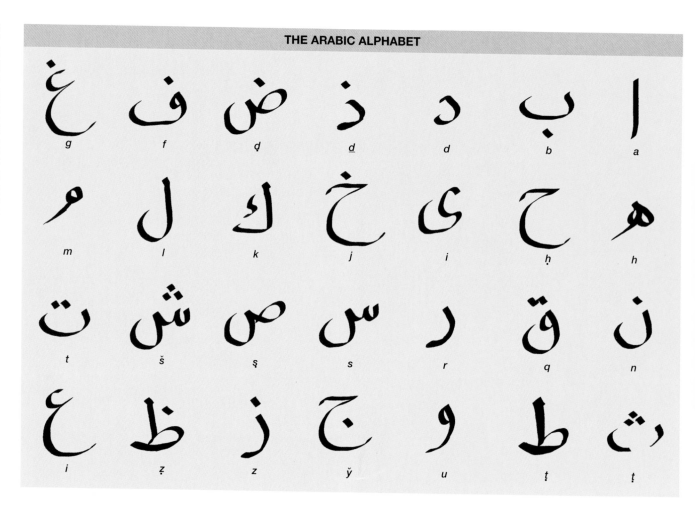

غ *g*	ف ف *f*	ض ذ *ḍ*	ذ ذ *d̲*	د *d*	ب *b*	ا *a*
م *m*	ل ل *l*	ك ك *k*	خ *j*	ى *i*	ح *ḥ*	ه *h*
ت ت *t*	ش ش *š*	ص ص *ṣ*	س س *s*	ر *r*	ق *q*	ن *n*
ع *i*	ظ *ẓ*	ز *z*	ج *y̆*	و *u*	ط *ṭ*	ث *t̲*

ESSENTIAL CHARACTERISTICS OF ARABIC

One very important characteristic of the form of this calligraphy is that it is written from right to left in connected cursive letters. This script does not use uppercase letters; it is always written in lower case. Another characteristic is the consonantal alphabet; it does not use vowels like the Semitic alphabets do. The Arabic alphabet has 28 consonants.

Calligraphy by Nevit Dilmen based on a classic work. It is composed by repeating the letter Qaf eight times and the Alif sixteen times.

THE MAIN STYLES

Over the centuries Arabic has also gone through an evolution of styles that will be briefly discussed here.

CUFIC

This is the most ancient style, whose most representative characteristics are its geometric forms, where the curves become straight with very pronounced angles. Examples of this style are frequently found in architectural applications, framing windows, doors, and in mosaics and tiles.

Calligraphy written in Farsi (Persian) in the contemporary Cufic style by the calligrapher Stewart J. Thomas. The text reads: "In the world, not of the world."

NASKH

This is the most well-known style and also the most basic. It is a cursive style derived from ancient pre-Islamic script. It was used to write manuscripts quickly, which is why it is a very simple style, cursive and easy to write. It is used today in the printing industry, as well as on keyboards.

Arab script in the Naskh style is the most commonly used today in the media. However, beautiful calligraphic exercises can be created with it, like this one by the calligrapher Stewart J. Thomas. The text says: "Eshq," which means "love" or "desire." It is written in circular form to create a mandala.

RUQ`AH

Ruq`ah is derived from Naskh, and is more basic and commonly used. It is the most popular style for daily use in the Maghreb or Arab West. It requires even less space to write than Naskh, the script is more condensed, and its forms tend to overlap and occupy less space.

Calligraphy written in the Ruq`ah style created by Mehmed Izzet Efendi (1841–1904) is known for its simple lines.

This calligraphy was written in Farsi by Stewart J. Thomas in the Diwani style. It is known for its stylized strokes and the harmonious composition of the interplay of the letters. The text reads: "Good thoughts, good discourse, good action."

This is Arabic calligraphy of the Thuluth style, created by Mehmed Izet Efendi (1841–1904). It has baroque characteristics with numerous diacritical symbols and ornamentation.

called *qalam* in Arabic, although the Chinese Muslims used the Chinese brush for their calligraphy. Both instruments are excellent for creating calligraphy in Arabic. Nowadays it is more common to use nib pens made for writing Arabic and markers with brush-shaped tips.

The tips of the reed pens and nib pens used for Arabic calligraphy should have a leftward slant to be able to make the desired cursive letters.

In the traditional practice of this script, the Chinese brush should be held vertically with the point perpendicular to the paper, and more or less 1½ inches (4 cm) from the paper. It is held between the thumb, the middle finger, and the index finger, with the hand forming a curve.

Arabic calligraphy is very fluid and has very organic forms. When selecting paper it is best that it not be rough or very textured, or the lines would not flow very well. Satin finish or glossy paper is preferable for Arabic calligraphy.

THULUTH

This script is also derived from Naskh, but unlike the Ruq`ah style it is a style designed for ornamentation, so it is a more beautiful and harmonious script. The letters are lengthened or shortened according to the space used on the support. One of its characteristics is that the white space between the long ascenders of the letters is filled with diacritical symbols or simply with ornamentation to create a harmonious work.

DIWANI

This style was invented by the calligrapher Husam Runi and is more baroque and ornamental than the Thuluth style. The horizontal lines are lengthened even more and the space between some letters is reduced to create a contrasting interplay of letters between condensed and extended forms. The most natural way to write in this style is to not remove the pen from the paper, inasmuch as possible, to create without a pause a gestural effect in the writing.

HOW TO WRITE ARABIC SCRIPT

When writing Arabic script, the worktable should be prepared in the following manner. The tools are placed to the right of the paper. Remember that Arabic is written from right to left, so it is best to leave the left side of the desk clear. Classic instruments can be used for writing like the reed pen, which is

NASTA`LIQ CALLIGRAPHY

Today's form of this style came from the Nasta`liq that originated in Persia at the end of the 14th century, created by the scribe Mir Ali al-Tabrizi. The Nasta`liq calligraphy is enormously complicated and it is very difficult to obtain a font for computers that works correctly.

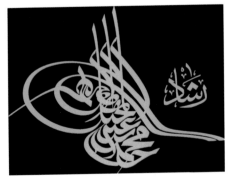

The calligraphic composition of the eight signatures of the eight principal Ottoman sultans is known as Tugra, and it represented the royal aspect of the empire. It was developed at the beginning of the 16th century. This version, created by Micha L. Rieser, reads: "Mahmud Han the son of Abdulhamid is always victorious."

This work by Queralt Antú was done in the Naskh style with gouache and an egg yolk on black Ingres paper. Mixing the egg with gouache produces a relief effect and is bright on the black page.

Hebrew Script

Hebrew is a western Semitic language, and like Arabic it has no vowels. Hebrew has 22 consonants and complementary symbols are used to mark vowels, just like in Arabic. It is also like Arabic in that it is written from right to left.

ORIGINS

The first known inscription in ancient Hebrew dates from the year 925 B.C. Many books of the Bible were written in Hebrew. Beginning in the 4th century B.C., Hebrew began losing ground to Aramaic and nearly disappeared. The language was revived by the Zionist movement in the 19th century and today, along with Arabic, it is the official language of Israel spoken by more than six million people. The revived script is called "square script" or "block script," which is derived from Aramaic and Phoenician script used in the 3rd century B.C., and it was the writing used by the Jews in Babylon. Aramaic script was very important in history, among other things because it was the language of the apostles and Jesus Christ, as well as the language of the evangelists.

In 1945 three Bedouin herders who lived in the Judean desert discovered the oldest known manuscripts of the Old Testament inside some clay jars in the caves of Qumran. The Dead Sea Scrolls, dating from the 1st century, were written in the Aramaic alphabet with ink on parchment.

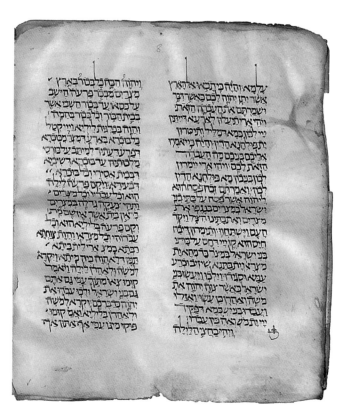

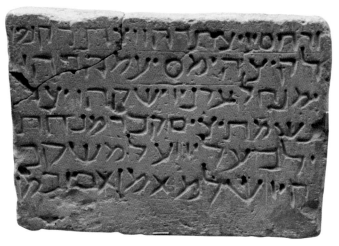

Inscription from the Tránsito Synagogue (14th century) displayed in the Sephardic Museum, Toledo, Spain.

A page from the Old Testament written in Hebrew, discovered in Kurdistan and dating from the beginning of the 11th century.

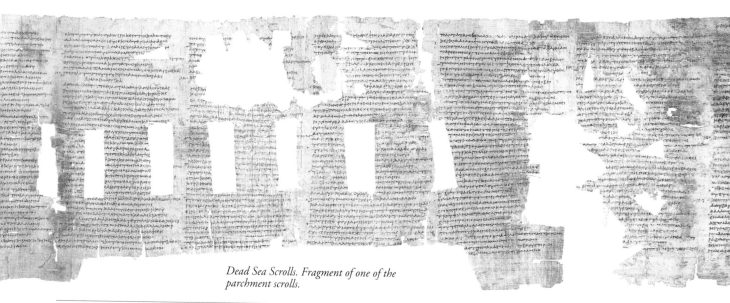

Dead Sea Scrolls. Fragment of one of the parchment scrolls.

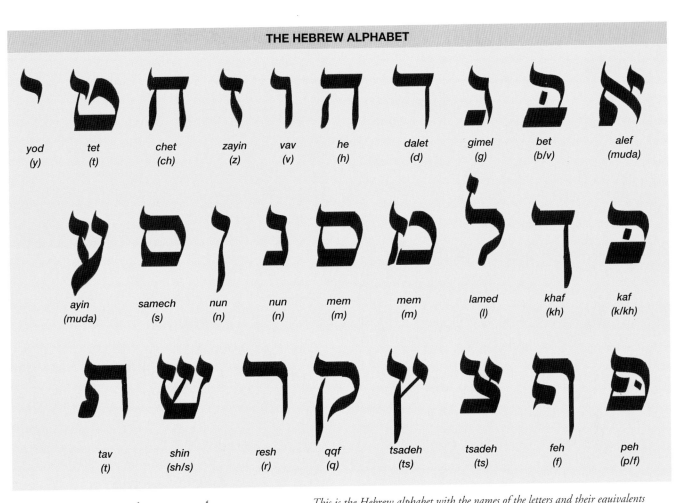

THE HEBREW ALPHABET

yod (y)	tet (t)	chet (ch)	zayin (z)	vav (v)	he (h)	dalet (d)	gimel (g)	bet (b/v)	alef (muda)
ayin (muda)	samech (s)	nun (n)	nun (n)	mem (m)	mem (m)	lamed (l)	khaf (kh)	kaf (k/kh)	
tav (t)	shin (sh/s)	resh (r)	qqf (q)	tsadeh (ts)	tsadeh (ts)	feh (f)	peh (p/f)		

This is the Hebrew alphabet with the names of the letters and their equivalents in the Latin alphabet. It is arranged from right to left, the direction that Hebrew script is written.

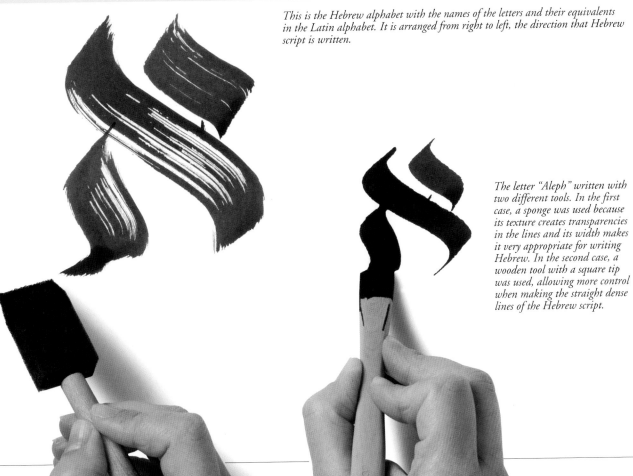

The letter "Aleph" written with two different tools. In the first case, a sponge was used because its texture creates transparencies in the lines and its width makes it very appropriate for writing Hebrew. In the second case, a wooden tool with a square tip was used, allowing more control when making the straight dense lines of the Hebrew script.

The Hindu Scripts: Sanskrit

The Indian subcontinent, with its successive and ancient cultures and its enormous population, is a world apart in which diverse alphabets and their corresponding calligraphy developed over centuries. They are not sufficiently known in the West, and we wish to offer just a quick sketch of their origin and extension. This way any reader who is interested can continue to study the subject on his or her own and further their knowledge.

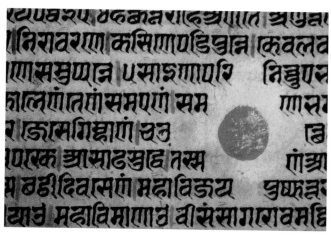

Fragment of a text written in Sanskrit where we can see the regularity of the calligraphy.

ORIGIN

Indian script has its origin in Aramaic writing. The most ancient known scripts are Kharosthi and Brahmi.

The Kharosthi system was at its height between the 5th century B.C. and the 3rd century A.D. It was a syllabic system and was written from right to left.

The Brahmi system was in use from the 5th century B.C. to the 5th century A.D. It was also a syllabic system with added vowel marks, and although originally it was written from right to left, the direction changed starting in the 3rd century B.C. The Brahmi is the most important system in the history of Hindu calligraphy, because the great majority of approximately two hundred Indian writing systems are derived from it, like Bengali, Tamil, Gujarati, and Devanagari, which is the most widespread.

A Tamil inscription dating from the 8th century, in the Kailasanatha Temple in Kanchipuram, India.

A MODEL: SANSKRIT

Sanskrit, derived from even more ancient languages, is considered a classic language today. A multitude of oral and written forms in the immense Indian subcontinent derive from it. It can be proven that nearly all languages in this territory come from Sanskrit, with Devanagari being the most widespread form of writing. Despite the existence of numerous examples sculpted in temples and monuments and vast writings on various supports written with different inks and tools, Sanskrit has had a long oral tradition. In recent centuries, and because of British influence, the written form of Devanagari has become the most common, although Punjabi, Bengali, and Tamil, among others, are widespread. We will focus on the Devanagari alphabet to see a writing system in more detail.

This system is written from right to left. Devanagari Sanskrit has two variations, *samhitapatha*, which is written with ligatures, and *padapatha*, which is written with separated letters. The Sanskrit alphabet has 48 phonemes, some vowels (simple and diphthongs), and other consonants. In the distant past it used accents, not of the phonic type, but of pitch. Neo-Hindu alphabets almost never use accents, which should be kept in mind when looking at the calligraphy.

Sample of calligraphy in Sanskrit in an artistic style made by the calligrapher Stewart J. Thomas.

Sanskrit calligraphy by Stewart J. Thomas written in Devanagari using two inks in earth tones.

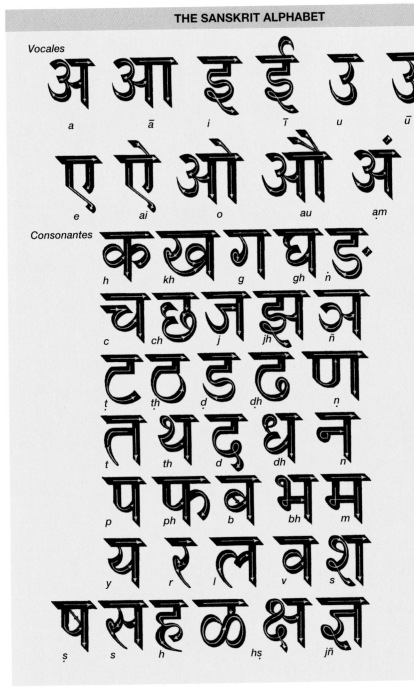

THE SANSKRIT ALPHABET

Vocales

अ आ इ ई उ ऊ
a ā i ī u ū

ए ऐ ओ औ अं अः
e ai o au aṃ aḥ

Consonantes

क ख ग घ ङ
h kh g gh ṅ

च छ ज झ ञ
c ch j jh ñ

ट ठ ड ढ ण
ṭ ṭh ḍ ḍh ṇ

त थ द ध न
t th d dh n

प फ ब भ म
p ph b bh m

य र ल व श
y r l v s

ष स ह ळ क्ष ज्ञ
ṣ s h hṣ jñ

श्री
ऋ
अ आ उ ऊ ए ऐ

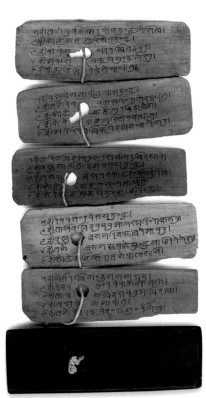

Part of a manuscript on palm leaves in various Indian languages, among them Sanskrit. The palm leaf was a common support in South Asia.

A page of Rigveda written in Sanskrit, a collection of sacred hymns dedicated to the gods that were written in Vedic Sanskrit. This text was written in Sanskrit on paper, with Vedic accents and corrections made in red ink.

The Cyrillic Script

Today's Cyrillic alphabet, which traces its origins to the 7th century, is a writing system used by millions of people in Eastern Europe and in Asiatic Russia, as well as all the lands where the Union of Soviet Socialist Republics (USSR) once held influence. A Cyrillic calligraphy developed, as it was for all other scripts, and all sorts of artistic exercises have been created with it.

ORIGIN

The Cyrillic alphabet began with the invention of a new alphabet by Saints Cyril and Methodius around 862–863 to translate the Bible and other texts to the Slavic languages, commissioned by a missionary from the Byzantine Empire to Bulgaria. It is believed that Saint Clement of Ohrid, petitioned by the Slavic king of Moravia, was the one who desired a script for translating the Bible that was not one of the three alphabets accepted by the Roman Church: Hebrew, Greek, and Latin, the three languages of Christ. The new writing that was invented and put into use was known as Glagolitic, which was inspired by a miniscule Greek script.

Cyrillic was based on Glagolitic, and it was eventually adopted as the official alphabet of the Russian Orthodox Church between the 11th and 12th centuries.

THE CYRILLIC ALPHABET

Аа	Бб	Вв	Гг	Дд	Ее	Ёё
a	b	v	g	d	e	e

Жж	Зз	Ии	Йй	Кк	Лл
zh	z	i	j	k	l

Мм	Нн	Оо	Пп	Рр	Сс
m	n	o	p	r	s

Тт	Уу	Фф	Хх	Цц	Чч
t	u	f	ha	ts	ch

Шш	Щщ	ъы ь	Ээ	Юю	Яя
sh	chch	y	eh	yu	ya

EVOLUTION

The Glagolitic alphabet consisted of 43 letters. Today, after suffering many reforms, including one in 1918 when some letters were eliminated, the Cyrillic alphabet has 30 letters.

The Cyrillic alphabet is used by many languages in European and Asian countries, especially Russian, but also Ukranian, Belarussian, Serbian, Macedonian, Bulgarian, Kazakh, and Mongol, among others. The Russian alphabet is a variation of Cyrillic and has 33 letters.

A letter written in Cyrillic on birch bark, from Novgorod, Russia, circa 1100–1120.

Work by Marina Marjina written in Old Russian, in the Ustav style, where we can see an excellent work of illuminated letters with images of Russian inspiration.

Calligraphy titled The Sun, *from a poem by Maximilian Voloschin in Old Russian, in the Ustov style. The use of gold leaf to illuminate the scene can also be appreciated. Work by Marina Marjina.*

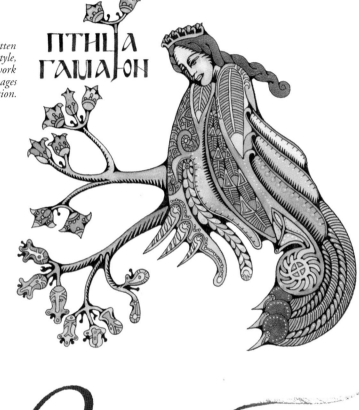

A work titled Iastochka (swallow), *from the series* Bird Names *by the calligrapher Vera Evstafieva. This work was done in pen and ink, and we can see the marks of the bristles at the ends of the brushstrokes, which give them a more oriental look.*

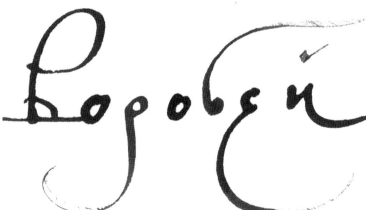

Calligraphy in Russian of the word "vorobey" (sparrow) by Vera Evstafieva. It grew from the project "Calligraphy of the Air," in which several calligraphers met in a park and in that environment wrote the names of birds. Vera used a pen made of bamboo and ink, and was able to create broken strokes where we can see the streaks created by the grain of the wood.

The First Calligraphy Tools

The history of writing is also the history of its tools. Each era has its own support material and writing tool for scratching, carving, or painting upon it. These materials that can be marked, whether of organic (animal and vegetable) origin or inorganic (stones and metals), have influenced the evolution of writing. The history of writing instruments can be divided into tools for working dry and tools used with ink. We can look at the technical evolution from the point and chisel to the quill, to the bronze nib of the Romans, the steel nib of the 19th century, and the fountain pen and other instruments of today.

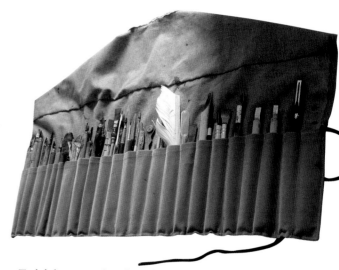

Tools belonging to the calligrapher Massimo Polello. In the holder are automatic pens, brushes, nib pens, a quill, a ruling pen, folding pens created by the artist, reed pens, and other experimental instruments. Massimo Polello keeps his tools in a fabric case that not only dries the tools but also allows them to be rolled up for easy transport.

DRY WRITING

Dry writing is still practiced today, especially on façades and sculpture, but the tools have changed radically and now power tools are mainly used. We will focus on the traditional tools in this chapter and mention the most important ones, even though they are little used for amateur calligraphy since they involve hard materials like stone, soft clay, and wood. These tools are the chisel, the stylus, and even the reed, as we will see later, although nowadays other tools could be used to work with the above-mentioned materials.

GRAVERS

These are engraving tools, with a sharpened metal point and edge used for the first writing, where symbols were engraved on mud and clay tablets.

Chisels are metal cutting tools used for working stone. The edge is quickly dulled by use, and it must be sharpened frequently.

STYLUS

This tool was shaped like an awl, made of ivory or bone, and was used to write by making lines on waxed tablets. The other end of the stylus, which was rounded and smooth, was used to erase what was written in the wax. The stylus made of metal was known as *graphium*.

CHISELS

This is a tool that is used for working stone and cutting it, using strokes applied with the appropriate hammer or mallet. The chisel was most frequently used in ancient cultures like that of Rome, whose stone masons cut the large Roman letters into the stone monuments by hand.

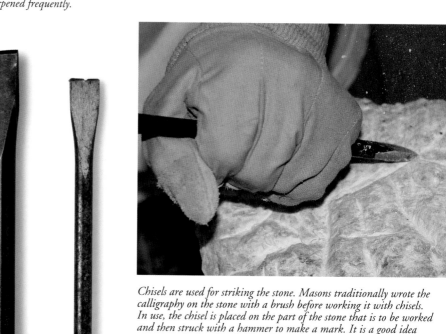

Chisels are used for striking the stone. Masons traditionally wrote the calligraphy on the stone with a brush before working with chisels. In use, the chisel is placed on the part of the stone that is to be worked and then struck with a hammer to make a mark. It is a good idea to protect the hand well. Photo by Andrew Magill.

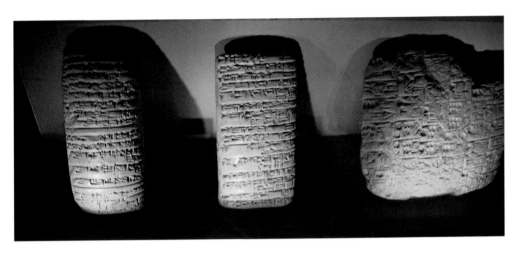

One of the most ancient supports for writing was the clay tablet, which was written on with a hard instrument like a reed or a metal stylus.

INK WRITING

This is the most common calligraphy since it is applied directly on supports like paper and parchment, is easily done on a table, and requires very little space.

Because of this immediacy and ease, mankind began writing many centuries ago with instruments that required a colorant, ink, to draw on an absorbent and more or less lightweight support medium. In the West, and more specifically in the Near East and the Mediterranean area, this material was first papyrus, then parchment, and centuries later paper, which was invented in China. It was easier to write on and later store these materials than the clay tablets, which were larger and less practical.

THE FIRST TOOLS

In the first part of this section, the most ancient instruments are described, the first ones used for calligraphy in the Western world. First is the calame or reed, which had already been used in a different manner to engrave the clay tablets. Later, by the Late Middle Ages, certain bird feathers were used for writing. In both cases, these tools are now usually made by the artist because even if they can be found for sale, they are simple and easy to make.

The brush and its variants is another instrument that has been used for many hundreds of years. It is the most commonly used writing instrument in the Far East and in other cultures as well, but it is not described in this first section because it continues to be used widely. Therefore it will be described in a separate section of its own.

TODAY'S TOOLS

The rest of the instruments used with ink are much more modern and in use today, or at least until a few decades ago, as is the case of the nib pen. For many years, writing by hand—always practiced and appreciated by professional scribes—has become an artistic activity for many people. It is in this context that the use of ancient writing instruments and ink has been revived, and many other tools that were undreamed of have been introduced for artistic work, like sprays and ruling pens. All of these will be described in the following sections.

Arabic calligraphy made with a reed in the Thuluth style by Stewart J. Thomas. The reed pen is the standard writing tool in Arabic calligraphy.

Letterform, a work created by the French calligrapher Claude Dieterich A. with several different instruments. Among them are brushes and flexible metal reed pens for copperplate script.

THE REED PEN

This tool is also called a calame (Latin *calamus*). It is a piece of cane or reed with one end cut to a point or angled and with a slit in the middle so it can be used with ink. This cut allows alternating between thick and thin lines, a characteristic of most calligraphic styles.

The reed pen was used in ancient times to write without ink on clay tablets because it was cheap and easy to acquire. It was a material that grew abundantly in the swampy lands of Mesopotamia, and along the edges of the Nile, the Tigris, and the Euphrates. In the Roman culture it was known by the name *arundo*.

This pen was used for writing Arabic script and was very appreciated. We find references in the Koran (96, 1-5): *"Read, in the name of your Lord, who has created, who created man from a drop of blood! Read! Your Lord is the Generous One, who has taught the use of the Calame, who has taught man that which he did not know."*

Centuries later, the reed pen was very gradually replaced by the quill of a bird. Today the reed pen only has an artistic function in writing, where it is appreciated for the texture of its line, its transparencies, and its washes.

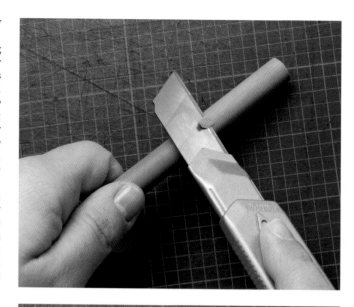

REEDS AND CUNEIFORM SCRIPT

The reed was the tool used for writing cuneiform script, since it was an instrument that was easy to use on soft surfaces like clay. The reed left a triangular mark in the damp clay, the wedge shape was called *cuneus* in Latin, and from that comes the name of this script: cuneiform.

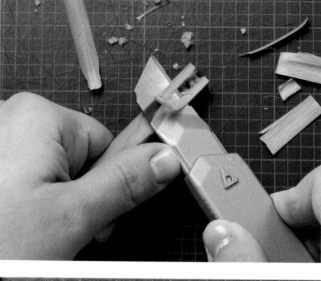

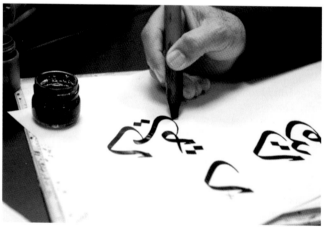

The reed was used for writing Arabic script. This tool is very interesting because it creates transparencies and its work is especially beautiful on rough paper because of the textures that result. Photograph by Miskan.

A reed that is ready for use. These can be found in art supply shops, cut and ready for use.

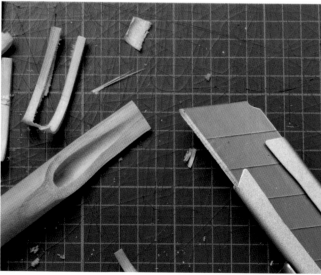

***1, 2, 3.** This sequence shows how the second cut is made at an angle, the process of removing the pith, and how to finish the point of the pen on the cutting mat.*

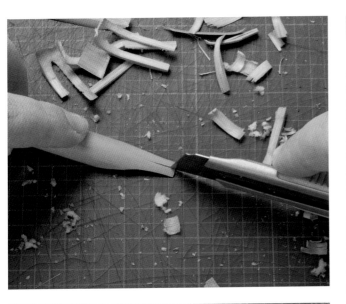

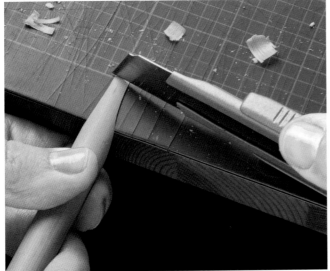

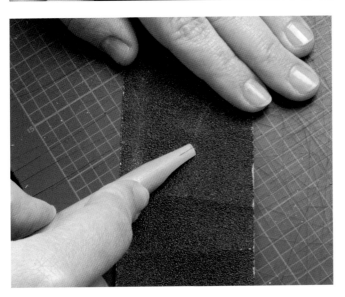

HOW TO MAKE A REED PEN

Common reeds that grow in the Mediterranean area are used to make pens. It is important that the reed is very dry before it is used. It should be allowed to dry from at least six months to a year in a dry place, ideally a sunny one. After this time has passed it should be cleaned and cut according to the following instructions.

MATERIALS

Dry reed
- A craft knife or small saw
- Sandpaper
- A smooth board, a cutting mat, or a hard surface that can be used for cutting
- Sheet aluminum or a piece of a soft drink can
- Scissors for cutting metal

THE PROCESS

After drying and cleaning the reed, it should be cut in straight pieces 6 to 8 inches (15 to 20 cm) long, a comfortable length for the hand and easy to manipulate. Do not cut it near the joint of the reed, which would cause it to be very uncomfortable for writing. A large craft knife or a saw should be used and it should be done on the board or cutting mat, taking care not to injure yourself.

The second cut is made at an angle on the cutting board. The pith must also be removed from the reed, otherwise it will impede the flow of the ink.

THE SLIT

After the first straight cut the lengthwise slit can be carefully opened. The slit should be made by splitting the material and not using an incision. The reed will split cleanly and straight. The slit will allow the ink to flow up by capillary action when it is charged, and it will flow correctly when writing.

The final cut should be slightly inclined and angled. This will create a sharp edge that will be able to write very thin, fine lines.

It is a good idea to sand the point a little to insure that the point is completely clean and totally smooth, so that it will make a clean line on the paper.

CREATING THE RESERVOIR

The reservoir will now be made. It consists of a metal piece that will act to accumulate ink at the end of the pen so it will not need to be charged so often. The reservoir is placed in the hollow inside the pen. A piece of a soft drink can or sheet aluminum of a similar weight is cut with scissors so it will be flexible. It should be a narrow strip about 3/16 inch (0.5 cm) wide, varying according to the size of the reed since it must be placed inside it. The metal strip should be carefully bent to an S-shape and then inserted into the pen.

Finally, keep in mind that after use, the pen should be washed with plenty of water and kept in a dry place.

4. *Making a cut in the reed that can later be split open.*

5. *Making the final, lightly angled cut.*

6. *Sanding the point.*

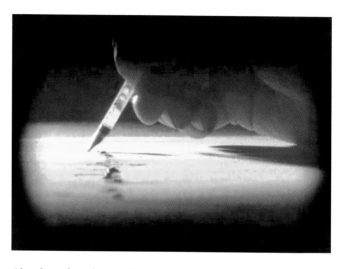

Photoframe from the DVD for the exhibit Leonardo da Vinci: la vera imagine *(2005–2006) where we can see the ink flow from the inside of a goose quill to the paper in a calligraphic work by Massimo Polello. The goose quill is very flexible and allows very fluid writing.*

TYPES OF FEATHERS

During the Middle Ages, feathers of various birds were used for writing, including the pheasant, eagle, peacock, and crow. The quills were classified by what part of the bird's wing they were from, and were referred to as primary, secondary, tertiary, etc.

The quill is a very light and flexible instrument, and it is also very precise. Therefore, one must practice with it a lot before good results are achieved. It is excellent for calligraphy, since it can be used with ink, gouache, and even acrylics.

In recent times there has been a return to the use of the quill for calligraphy, even though using this tool is much more difficult than using a conventional pen.

THE QUILL

It is not known when the quill began to be used, but in the British Museum in London you can see them being used by scribes in Egyptian paintings. But without a doubt its golden era began around 190 B.C. when papyrus, which was then being used as a writing material, was replaced by parchment. As the use of papyrus increased, the price rose greatly, and people looked for more affordable materials to write upon. This necessity was the main reason leading to the use of parchment.

The quill is very flexible and very light, and beautiful loose and flowing lines can be created with it. It was because of its affordability and beautiful results

PREPARING THE QUILL

This instrument is not often found in art supply stores, so if you wish to use one you must first prepare it. Here is an explanation of how to proceed.

CHOOSING

It is best to work with several feathers at the same time and at the end of the process, select the best ones and throw away the defective ones. The feathers should be chosen for their durability, size, and weight of the end of their shaft. The best time for collecting feathers is when the birds are molting.

that it continued to be used for a long time.

If you are interesting in practicing calligraphy with this tool, keep in mind a couple of curious facts: one is that if you are right-handed you must use the feathers from the left wing, since the shaft angles to the right and can thus be correctly used with the right hand, and vice versa. The other premise is that the feathers can basically be obtained in two ways: either going to the fine art supply shop to see if they have quills that have be cut and prepared for writing, or going to a farm where birds are raised and preparing the quill yourself as explained here.

After choosing the largest and strongest feathers, make a cut at an angle across the point with a penknife or craft knife, then put it into hot ashes. This technique is known as maceration.

CLEANING

Next, the barbs of the feather must be removed so you can write comfortably. Hold the feather tightly and remove them in one motion. Scissors or the edge of a knife can be used, if needed, to finish removing what is left and to smooth the feather.

After this, the inside of the feather is cleaned and the pith removed. A wire bent in a U shape or a long stick can be used for this.

Finally the film on the exterior of the shaft is removed by scraping and polishing it with the penknife, a process referred to as clarifying.

A more exhaustive clarification can be done by tying several feathers together with twine or string and soaking the ends in boiling water for about 15 minutes.

During this phase of the process, you must be very careful not to burn the feathers. They are very light and will float, so the tips of the feathers must not touch the sides of the pot or they will burn. Later, when the feathers have softened, they can be scraped, applying a certain amount of pressure to the penknife. After scraping they should be left to air dry completely.

The use of goose quills for calligraphy has made a comeback, and can be seen in this work by Silvia Cordero titled Letter Tree, *done with a goose quill and india ink on textured paper to create a beautiful work of gestural calligraphy.*

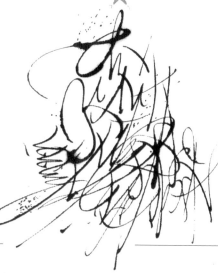

NECESSARY MATERIALS

- Duck, goose, or turkey feathers.
- A cutting tool with a blade and a handle (craft knife) or a small knife with a steel blade that is as straight as possible. In the past the instrument used for cutting quills was called a penknife.
- A smooth wood board, a cutting board, or a cutting mat.
- Sheet copper, brass, or aluminum, or a small piece of a soda can.
- A pot or container for boiling water.
- Hot embers.
- Cotton thread.
- Scissors for cutting metal.

FINISHING

This process is nearly identical to the preparation of the reed pen seen on the previous pages, but the quill is much more delicate, and the cuts should be made with much more precision to avoid causing damage. An angled cut must be made first on the feather, then the sides are cut. These cuts will create the desired width.

Now the slit must be made by cutting an incision in the point while barely applying pressure, and then prying it open with the help of the blade.

Finally, the point can be cut. The feather is held on the cutting board or cutting mat at 90º angle and two cuts are made, one at an angle to the cutting board (the cut that sharpens the point of the quill), and the other perpendicular to the board.

CREATING THE RESERVOIR

Now the reservoir is created, consisting of a metal piece that acts to hold ink at the end of the quill. This allows the calligrapher to write more fluidly and not stop so frequently to recharge the pen. The reservoir is located in the hollow interior of the feather. A thin strip of metal should be cut with snips approximately 3/16 inch (0.5 cm), according to the size of the shaft. The flexible metal is then gently bent into an S shape and introduced into the cavity of the feather. This piece should not move once in place so it can hold ink in the point of the quill. Now the bird quill is ready for use.

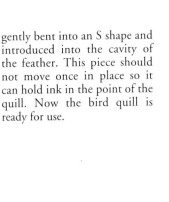
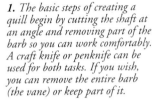

1. The basic steps of creating a quill begin by cutting the shaft at an angle and removing part of the barb so you can work comfortably. A craft knife or penknife can be used for both tasks. If you wish, you can remove the entire barb (the vane) or keep part of it.

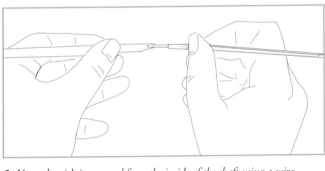

2. Next, the pith is removed from the inside of the shaft using a wire or stick.

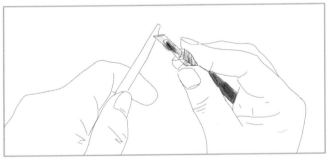

3. Then angled cuts are made on the sides of the feather. That done, a fine incision is made in the point with very light pressure. The cut is carefully pried open.

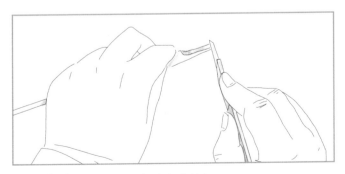

4. Finally, the point is cut to the desired thickness.

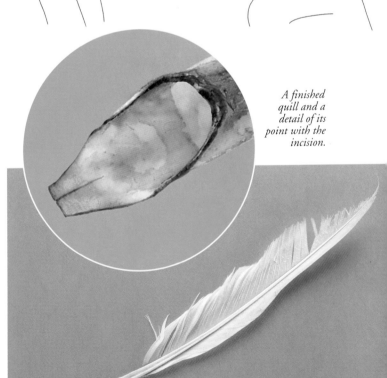

A finished quill and a detail of its point with the incision.

Metal Pens

The metal pen was the result of a search for an instrument that was more durable, controllable, and above all practical, since the use of a reservoir greatly reduced the number of times the pen had to be dipped in ink, making writing more fluid.

The logo for Fontanella written with a nib pen, a creation of the calligrapher Ricardo Rousselot. The metal pen allows the artist to make uniform lines.

THE ORIGIN OF THE METAL PEN

In spite of what you might believe, the metal pen is not a recent development, and traces of them were found in the tomb of the Pharaoh Rameses II. It was a copper pen from the 13th century B.C., proving that the Egyptians were using them. They were used throughout Roman times, and bronze pens shaped like bird feathers have been found.

MODERN NIB PENS

The first documented "modern" nib pen appeared in the 18th century in France, made by the Parisian jeweler Nicholas Bion (1652–1733). In 1700 he invented a nib, an instrument that he attached to the shaft of a bird quill. He was not the inventor of an important technical innovation, but he was admired for the precision of his instruments and the technical excellence with which they were manufactured. He was responsible for the manual *Ingénieur du Roi pour les instruments des mathematiques*, with very well illustrated descriptions, which was republished several times.

But it was during the Industrial Revolution in the 19th century when the metal pen reached its age of splendor, and it was the Englishman John Mitchell who patented the first steel nib pens in 1822. Between the end of the 18th century and the beginning of the 19th, steel nib pens began to be mass produced.

In 1830, Joseph Gillott created an industry in Birmingham, England, where metal nib pens were mass-produced. These points or nibs, as they are commonly known, are attached to some sort of holder or handle to support them for writing and dipping them in an inkwell to charge them with ink. Using this type of nib you can write calligraphy of different styles: Carolingian, Gothic, Humanistic, Chancellery, and Rounded, among many others.

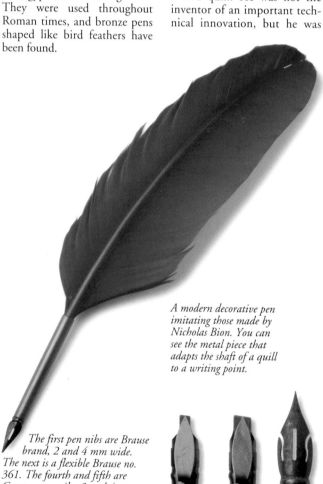

A modern decorative pen imitating those made by Nicholas Bion. You can see the metal piece that adapts the shaft of a quill to a writing point.

The first pen nibs are Brause brand, 2 and 4 mm wide. The next is a flexible Brause no. 361. The fourth and fifth are Campoamor nibs, 3 and 4 mm. The sixth is a 1.2 mm from the French company Blanzy Treraid, and it is also available with a reservoir. The three at the right are "Spanish cut" nibs.

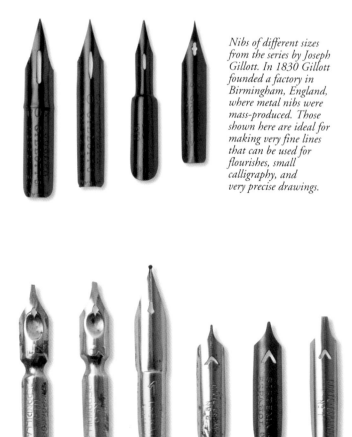

Nibs of different sizes from the series by Joseph Gillott. In 1830 Gillott founded a factory in Birmingham, England, where metal nibs were mass-produced. Those shown here are ideal for making very fine lines that can be used for flourishes, small calligraphy, and very precise drawings.

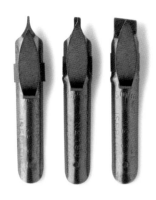

Brause nibs measuring 0.5, 1.5, and 5 mm wide. Brause nibs have an incorporated reservoir for holding ink and allow more freedom when making calligraphy.

Mail Pen no. 138 from the English brand Brandauer & Co.

HOLDERS

These days we can easily find holders of wood, plastic, and even metal. Some are smooth, others textured, monochromatic or multicolored—in other words, there is something for everyone's tastes. There is a metal piece inserted into one end of the handle that holds the nibs.

Detail of a holder with a lever. This lever locks and holds the nib in the handle.

Nib inserted into a wood handle.

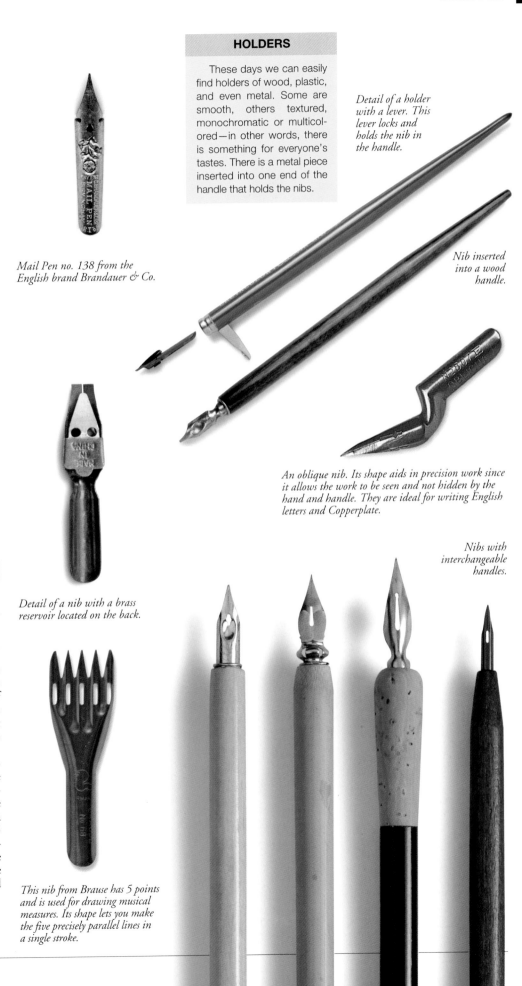

An oblique nib. Its shape aids in precision work since it allows the work to be seen and not hidden by the hand and handle. They are ideal for writing English letters and Copperplate.

Nibs with interchangeable handles.

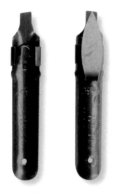

A Brause nib seen from the front and back with detail of the metal reservoir.

KINDS OF NIBS

Nowadays it is possible to buy metal pens in art supply shops and stationers. They have an ink reservoir on top, which permits consistent writing without having to return to the inkwell as frequently. The nibs are classified in millimeters of width, and the number is engraved on them. You must also buy a holder to attach to the nib.

The most commonly available nibs, and the ones that are most recommended for calligraphy, are made by the Brause company. They manufacture a great variety of sizes, from 0.5 to 5 mm, and they have a reservoir for better writing. The reservoir holds ink so that the pen does not have to be dipped in the inkwell as often.

Detail of a nib with a brass reservoir located on the back.

This nib from Brause has 5 points and is used for drawing musical measures. Its shape lets you make the five precisely parallel lines in a single stroke.

THE FOUNTAIN PEN

The first fountain pen was patented in 1827 and was created in Paris by a young Romanian inventor named Petrache Poenaru.

Later Lewis Edson Waterman, who was born in 1837 in Decatur, New York, was one of the key people in the history of the fountain pen, because he invented the capillary feed.

HOW IT WORKS

The capillary feed consists of a part located underneath the nib that encourages a better ink flow through capillary action. The even flow prevented hated blotches and was instrumental in making the fountain pen successful. Unlike previous nib pens, the fountain pen is automatic and there is no need to constantly dip the pen in an inkwell. Fountain pens have an internal reservoir called a cartridge or a converter, and the ink flows out from it by taking advantage of the physics of capillary action. The patent for the predecessor of today's fountain pens was registered in 1884.

FOUNTAIN PENS FOR CALLIGRAPHERS

Nowadays there are fountain pens that are made especially for the practice of calligraphy, but instead of a refillable reservoir they have a disposable cartridge so there is no need to use an inkwell. The best-known sets are the Art Pens made by Rotring. These are very interesting pens that are sold with a range of nibs, including those for calligraphers and left-handed users.

Other interesting fountain pens that are easy to find include those with a Chinese brush tip. These are cartridge pens but the tip is a brush. They are excellent for loose and free work and even for drawing. They are available with different color inks.

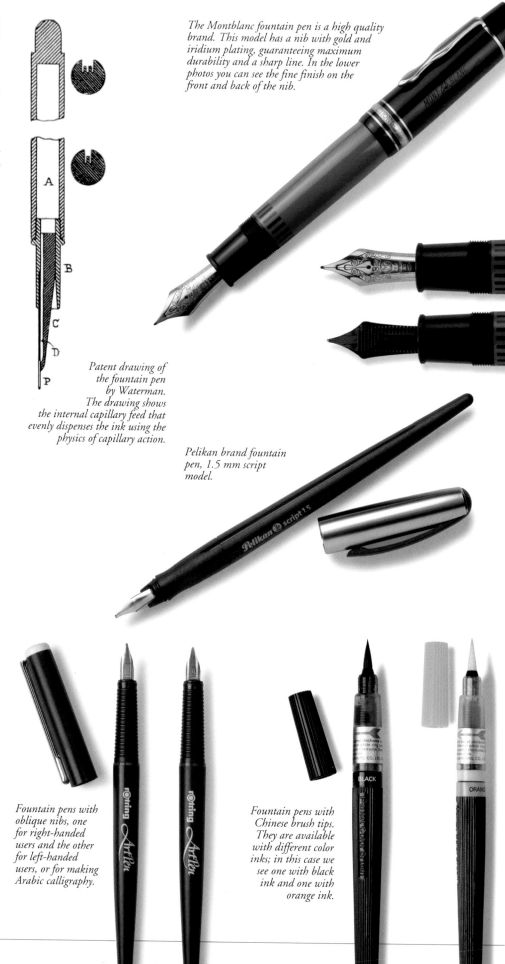

The Montblanc fountain pen is a high quality brand. This model has a nib with gold and iridium plating, guaranteeing maximum durability and a sharp line. In the lower photos you can see the fine finish on the front and back of the nib.

Patent drawing of the fountain pen by Waterman. The drawing shows the internal capillary feed that evenly dispenses the ink using the physics of capillary action.

Pelikan brand fountain pen, 1.5 mm script model.

Fountain pens with oblique nibs, one for right-handed users and the other for left-handed users, or for making Arabic calligraphy.

Fountain pens with Chinese brush tips. They are available with different color inks; in this case we see one with black ink and one with orange ink.

Automatic pens by Brause, tip numbers 2, 3, and 4.

THE COLA PEN

This is a tool that imitates the automatic pen and is made of the metal from a soft drink can. It is a very interesting tool of recent creation that is found quite often in experimental calligraphy for work requiring script with a wide line. These are homemade tools that are found for sale on the Internet, but we can make our own cola pen very easily.

Calligraphy made with a flexible automatic pen, which is available commercially under the name of Folden pen, or it can be made at home like the cola pen shown on the next page.
The work is titled Infinite *and it is by the calligrapher Marco Campedelli in ink on paper. Notice the expressive line, and the errors, which in cases like this one embellish the finished piece.*

AUTOMATIC PEN

Automatic pens are wider than normal ones and have a larger reservoir in a rhomboid shape. There are metal automatic pens with two or more points. These are pens with wide tips that are divided into two or more equal points that are used to write with multiple lines at the same time, creating a curious and interesting effect. They are ideal for writing large size letters.

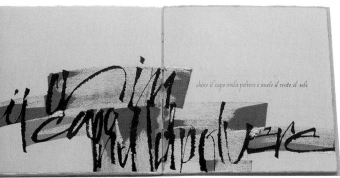

Two pages from the manuscript book Polvere *with poems by Alda Merini and calligraphy work by Anna Ronchi. The work was done in gouache, watercolors, and gold paper. Written with several experimental tools, nib pens, and automatic pens.*

This work by Christel Llop is titled Abstract Calligraphy. *This piece, 19⅝ × 25½ inches (50 × 65 cm), is written with black ink using nib pens and automatic pens with several points on watercolor paper. The work is completed with collage elements. In this work we can appreciate the results of the automatic pens with several points, the wide marks with parallel lines. The marks are very organic forms.*

MATERIALS

- An empty soft drink can
- Scissors
- A craft knife
- Metal snips
- Wood sticks
- Electrician's tape

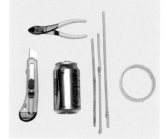

HOW TO MAKE IT

In short, the shape of the cola pen is made by folding and manipulating a small piece of metal from a can. The double surface has a cut edge where the ink flows by capillary action and is transferred to the paper during writing. This wide edge creates very interesting effects when making calligraphy.

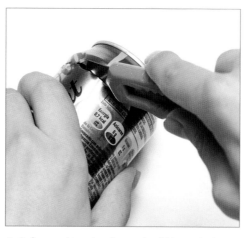

1. Before anything else, the can should be washed, preferably with hot water to remove any traces of soda because the sugar can be sticky. Then the can, held horizontally, is cut with a craft knife. Be careful not to hurt yourself. The ends are removed first, then the cylinder is opened longitudinally, taking care not to bend the metal.

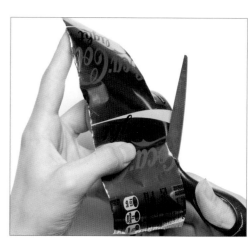

2. After you have created the sheet of flexible metal begin to remove irregularities and burrs with a pair of scissors.

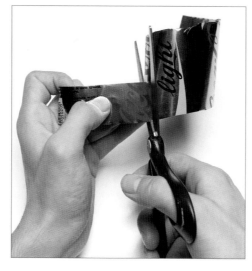

3. Then cut a rectangle 1 inch wide by 3 inches long (2.5 × 7.7 cm) from this sheet.

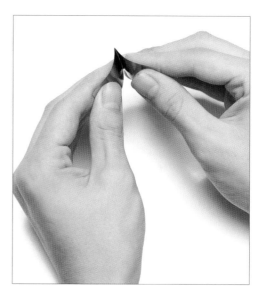

4. Then fold the rectangle in half.

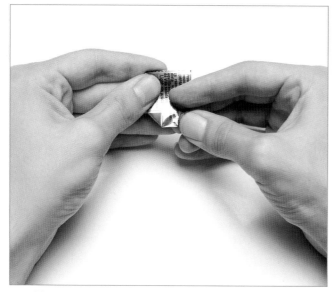

5. Fold the corners of the folded edge into equilateral triangles that do not touch, leaving space between them.

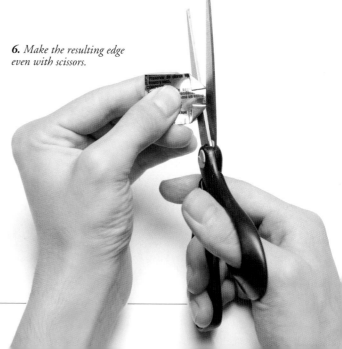

6. Make the resulting edge even with scissors.

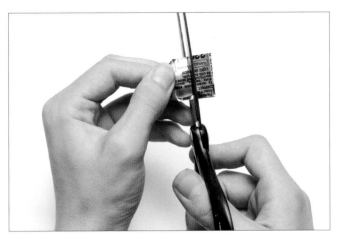

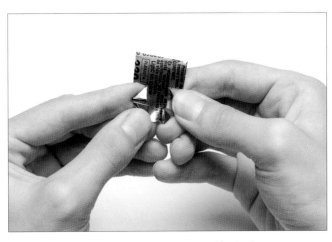

7. *Make small cuts in the middle of the piece, less than one third of the width, taking care not to cut too far.*

8. *Now fold the corners of the previous incisions like the first ones.*

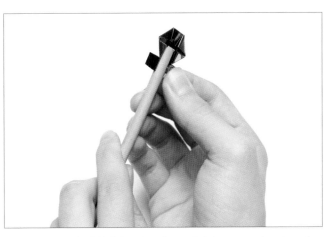

9. *Then make a longitudinal cut with a craft knife at the center of one end of the stick. Be careful not to hurt yourself when making this cut. It does not have to be very deep.*

10. *Next insert the folded sheet into the cut. It is important that the end with the first folds is not inserted.*

Modified pen and lining pen for making calligraphy.

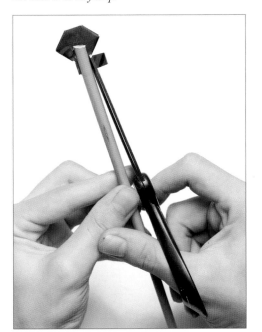

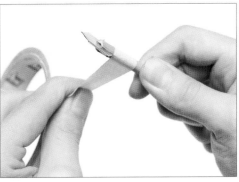

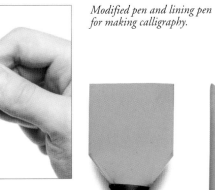

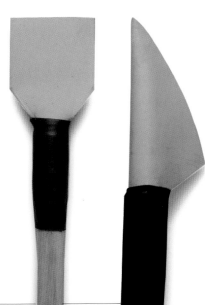

12. *Attach the cola pen to the stick with adhesive tape. It should be applied tightly so that the pen tip will not move.*

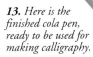

13. *Here is the finished cola pen, ready to be used for making calligraphy.*

11. *Remove the extra sheet metal. If you prefer, you can bend it around the stick instead of cutting it off.*

Brushes

Brushes are the quintessential tools of calligraphy. They are very versatile tools and offer many possibilities because of the great variety available on the market. Among these the oriental brushes from China and Japan stand out.

Gusto Italiano

QUALITY AND USES

The quality of a brush depends on the kind of hair it is made of. Among the many varieties are goat hair, which is flexible and not very durable; sable; hare, durable and very flexible; and horsehair, which is so durable that it is very useful for large format works.

Brushes can also be very interesting to evaluate based on their shape and size. There are brushes with straight, flat points that are very good for lettering; wide and square-tip brushes that are good for making strong expressive lines; round brushes that can be used to make thin lines and contrasting thick lines; and there are also brushes that have fan-shaped hair.

The sizes of the brushes are indicated on the handle of the brush with a number. Unfortunately, there is no standard and each manufacturer uses its own numbering system.

HOW TO KNOW THE QUALITY

The quality of a brush is assessed by the quantity of water or paint that is held in the tip, and by how even and continuous a line can be made by the brush. Conversely, a bad or poorly cared-for brush loses its hair or bristles at each stroke, or the tip does not return to its original shape after use, or the tip splits.

Logo of Gusto Italiano, used for the packaging and labels for an Italian wine sold to the American market. This was created with a brush by the calligrapher Chen Li for Remo Mellano, of Turin, Italy. You can appreciate the looseness of the brush stroke as well as the characteristic contrast between the thick and thin lines.

From left to right, by the shape of the brush: flat, round, filbert, and bright.

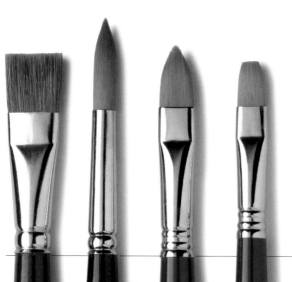

WATERCOLOR BRUSHES

Watercolor brushes are known for having tips with softer hair that are dense and able to hold a large amount of water. We emphasize that the quality of the hair in the tip is very important since it is critical that it quickly return to its original shape when it is lifted from the paper. The best quality hair is Kolinsky sable from Russia, because it is very strong; on the other hand, these brushes are very expensive. But other kinds of brushes are also very useful in the practice of calligraphy, like goat and hare, which are flexible and not very stiff. Other brushes with good quality natural hair are ox hair and the gray mongoose brushes, which are known for their dark brown and beige color. Of course, natural hair brushes are better than synthetic ones, although some of the latter are quite good imitations of natural hair and they are more economical.

ADVANTAGES

Watercolor brushes can be used to make calligraphy with very fine lines, and calligraphy can be superimposed because of the transparency that is typical of watercolors.

USE AND CARE OF THE BRUSH

Before starting to work with a new brush, it should be rinsed well with water to remove the glue put in them by the manufacturers, and it is a good idea to dampen them before use. Of course, they should be cleaned very carefully after use, with soap and water if you have used water-soluble paint, or with solvent in the case of oil-based or waterproof paint or ink. The latter kinds are not very useful for calligraphy because they are difficult to use and take a long time to dry.

The hair of wide brushes is not as fine as those of smaller brushes. It is generally rougher, stiffer, and thicker. When used for calligraphy, the results are more textural and less precise, but there are cases where these are the desired effects.

The brushes must be meticulously cleaned with soap and water and rinsed with a lot of water. Then, to eliminate excess water and return the original shape to the tip, light pressure is applied with the fingertips and a small amount of soap is added. This will preserve the shape until its next use.

WIDE BRUSHES

Wide brushes can be very useful for lettering and making large calligraphic letters because they are flat and much wider than a typical artist's brush.

SILICONE TIP BRUSHES

There are brushes that have silicone tips, and there is a choice of hardness; the gray ones are harder than the white ones. There are also different shapes and sizes. They can be conical or have a triangular prism shape. The different tips will create different strokes. They are interesting to calligraphers because they are completely smooth and flexible. They are useful for controlling the stroke and for creating textures, especially in thick paint like gouache.

These brushes have silicone tips. The points are smooth and they can be used to create interesting textures. They are ideal for experimenting with calligraphy, especially when using dense paint like gouache.

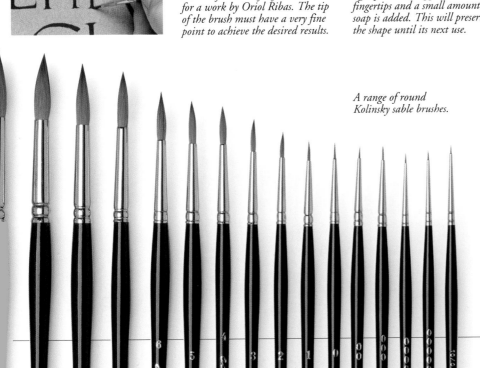

Detail of the use of a fine brush for a work by Oriol Ribas. The tip of the brush must have a very fine point to achieve the desired results.

A range of round Kolinsky sable brushes.

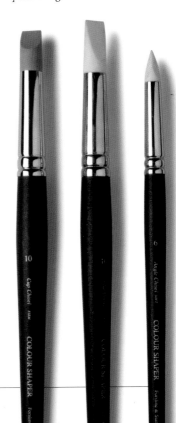

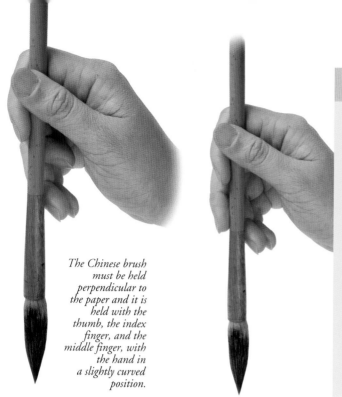

The Chinese brush must be held perpendicular to the paper and it is held with the thumb, the index finger, and the middle finger, with the hand in a slightly curved position.

CARING FOR THE BRUSH

You must be very meticulous in caring for your brush and remove all traces of ink with water, always rinsing it in the direction of the handle and removing the excess with your fingers. Then it should be kept in a vertical position, hanging it by the loop attached to the end until it is completely dry. Chinese brushes are very delicate and can be ruined if they are not cared for and they are not left with their hair perfectly straight, and never in a container with the hair downward.

The delicate hair of Chinese brushes should be rinsed after washing and the tip carefully dried to prevent it from rotting.

CHINESE BRUSHES

"In Chinese calligraphy, the brush is like a magic wand." Chang Kuang-bin.

It is estimated that the Chinese brush came into use between 250 and 210 B.C., during the reign of the emperor Shi Huang Di of the Qin Dynasty. The brush goes hand in hand with Chinese culture and is one of the "four treasures" of the Chinese artist. Being a calligrapher, painter, or poet is to belong to the top ranks of traditional Chinese social status. The brush can be very precise and also spontaneous. According to Chinese culture, the brush "captures" the energy of the calligrapher and reflects it in the line. If the calligrapher has a lot of positive energy, the ink of the stroke will be very shiny, but if he or she is not concentrating or has little energy, the line will be dull and weak. Therefore, meditation and breathing exercises are required prior to starting a work of Chinese calligraphy.

A good oriental brush will have a very sharp point, resulting from careful and laborious manufacture. When buying such a brush you must pay close attention to the quality of the hair. The better the hair, the better it will retain water and ink. Authentic Chinese ink of good quality should always be used with these brushes.

PREPARING THE BRUSH

Before using a new brush it should be prepared, since the hair of the tip has a starch or glue that holds it together and will not allow it to be used. It should first be dampened by rotating the brush under running water flowing from the handle towards the tip, which will dissolve the glue, while the fingers should gently squeeze the hair to remove all of it. If the tip forms a straight line when it is being squeezed, it means the brush is of good quality. Each time it is used, the brush should be dampened first.

HOW TO HOLD THE CHINESE BRUSH

When using the Chinese brush it should be held firmly and vertically, at a 90° angle to the paper. The fingers should be placed so that the brush is held with the thumb, the index finger, and the middle finger on the outside. It should be held firmly, and the elbow should not be rested on the table if you wish to create strong brush strokes.

Here are two works by the calligrapher Chang Kuang-bin where you can see script written with an oriental brush.

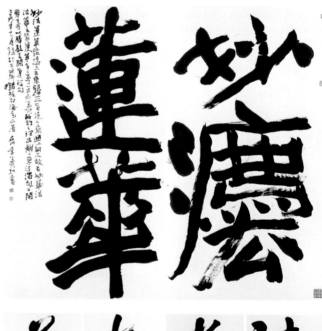

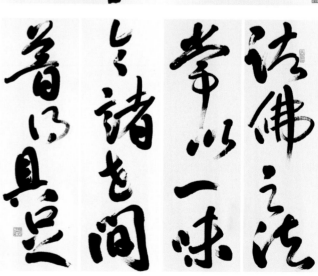

Other Tools for Writing Calligraphy

Contemporary calligraphy invites experimentation, and many instruments and objects that we have in the home are candidates for use in writing. Here are several examples.

THE RULING PEN

This is one of the basic tools of the calligrapher, and it is much appreciated. The ruling pen is the instrument that comes in the case of compasses and drafting tools, and it has rarely been used since the invention of Rotring pens. After its usefulness in the practice of calligraphy was discovered, however, calligraphers cannot stop using it.

Its uncontrolled use throws off ink in beautiful explosions, creating interesting irregularities. It is frequently used today for making logos and posters.

There are several types of ruling pens. The narrow ones, frequently found in drafting sets, have a long reservoir for ink that can be adjusted to very thick and very thin lines. There are also wide ruling pens that allow better control of the line. Among the wide ruling pens are the "butterfly," now very difficult to find in art supply stores, which is very appreciated by calligraphers because of its gestural stroke and better controlled line. It can easily be found on the Internet.

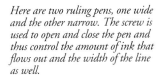

Here are two ruling pens, one wide and the other narrow. The screw is used to open and close the pen and thus control the amount of ink that flows out and the width of the line as well.

These very beautiful works were created with a combination of ruling pens and metal nib pens by the calligrapher Betina Naab in 2005, 19½ × 27½ inches (50 × 70 cm). The work is better appreciated in detail. According to the artist, the idea for this work came from the opposing concepts of space used by potters and sculptors. One works with empty space and the other with full space.

SPONGES WITH HANDLES

These tools consist of a piece of flat sponge attached to a handle so that they can be used. They are very useful for calligraphy since they are available in different widths and can be used on large-scale formats for making wide and uniform letters.

PIECES OF WOOD

Any piece of wood or stick can also be useful to the calligrapher. They make lines of different widths, and like the reed pen they create a mark with transparencies and a peculiar texture.

The sponge is synthetic and absorbs a large amount of ink or paint to allow you autonomy in calligraphy. They come to a straight edge, but you can cut the ends with scissors for a bevel edge.

CORRECTION FLUID APPLICATOR

A correction pencil will make an irregular line with small blotches that can add expressiveness, especially on a black background.

MASCARA BRUSH

Another option for creating effects is the use of a mascara brush, whose bristles will create a stroke with a lot of texture.

SCULPTING AND ENGRAVING TOOLS

Sculpting and engraving tools can also be used for making lines. The wood utensils are ideal for making textured lines.

In nature one can find innumerable objects, sticks, and pieces of branches to experiment with.

A mascara applicator creates interesting results since the various bristles make several lines with each stroke. It can be used alone, dipping it in an inkwell.

This tool was originally created for working with clay, but is also good for experimenting with lines.

A poster by the designer Catherine Zask where the lines were made with a pipette. As you can see, the lines are very peculiar.

Many calligraphers like Antoni Argilés make tools with wood and pieces of flexible cans that create surprising effects.

PIPETTES

Soft plastic pipettes, which are frequently used in cooking or as droppers, create very interesting and sometimes amusing results in calligraphy. The flow of the ink is controlled by squeezing the end of the pipette. The long handle makes a thin line, but one with constant blotches.

All these tools typically create irregular and experimental lines, each one unique and not repeatable. It is important to experiment, and without a doubt there are many more tools to be tried. The reader is encouraged to personally continue the work of experimentation and discovery.

The soft plastic pipette that the calligrapher Massimo Polello gave to the author during a workshop in Italy.

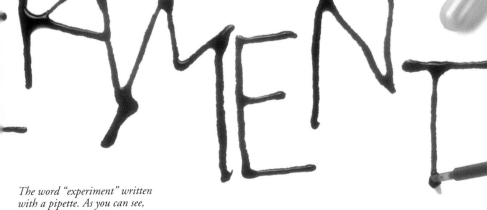

The word "experiment" written with a pipette. As you can see, the result is very unique.

Sprays and Markers

Today there are more tools and techniques that may not be very common in the practice of calligraphy, but that are certainly valid for contemporary use. Although the art of graffiti and tags are considered the most modern calligraphy, in ancient times there were numerous cases of lettering on walls and public spaces. Today these practices are common in our cities.

GRAFFITI CALLIGRAPHY

Graffiti works frequently include text. The most popular script used in graffiti is Gothic, which indicates that graffiti artists have a growing interest in letterforms. They use spray cans and markers to create their graffiti and other types of lettering.

This water-based paint marker has a ½ inch (15 mm) wide tip and is available in several colors. Despite its width it is considered a fine tip for calligraffiti. All the materials shown here are manufactured by Montana Colors, a company specializing in products for this type of calligraphy.

Markers like these with wide tips are ideal for making large format calligraphy. They carry water-soluble paint in several colors and have tips 1¼ to 2 inches (30 and 50 mm) wide.

MARKERS

There are markers with tips in the shape of brushes that are ideal for making gestural calligraphy, and markers with wide chisel tips that are ideal for large-scale calligraphy. If the letter is made with straight lines, like a Gothic letter, it is easier and more natural to make.

SPRAY CANS AND AEROSOLS

There are a great many brands and colors of spray paint on the market. When the valve is depressed, paint is forced out of the can by pressurized gas. The valve or nozzle diffuses the paint as it exits the can. Several different gases are used in spray cans, but in the last few years there has been a move to using gases that will not harm the environment. Some are high pressure and others are low pressure, and they also come in different sizes.

Since the early 1990's there are companies that manufacture sprays specifically for painting graffiti, and they offer several different spray caps and various formats from small cans that fit in the palm of your hand to large cans that will cover a great amount of space. And within the specialties of graffiti and *calligraphiti* different kinds of paint are manufactured for different supports, in transparent and opaque versions, and in a large range of more than 100 colors, including metallic, translucent, and fluorescent paints in varying degrees of transparency.

Often, graffiti artists include letters near their figures, sometimes of their own creation but also old styles, like Gothic letters. They use different spray nozzles for covering large areas, or for fine precision work like highlights and reflections.

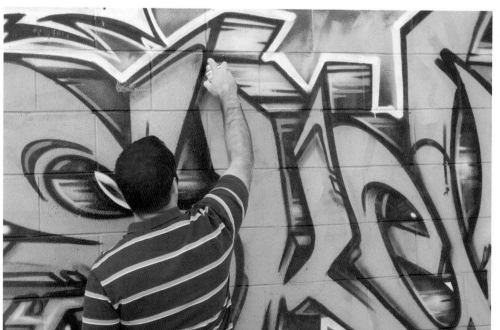

Classic synthetic spray paint. This low-pressure paint can work with screw-on nozzles and is available in several colors.

USE

It is not easy to use sprays and they require a certain amount of practice. But today spray cans have different types of nozzles that make them easier to work with.

The different lines that are needed—fine, medium, wide, and very wide—can be made by exchanging the nozzles and moving closer or farther from the support. This will control both the width and the shape of the paint spray.

The nozzles have different names according to the various manufacturers. Among them are oblique or angled sprays that imitate the line of a calligraphy pen, and they are ideal for writing. Sometimes the angle of the line can be adjusted. Other nozzles have a very small hole and the line can be easily controlled and very good results can be had without pressing too hard. Other nozzles are good for making wide lines or quickly filling an area. Some manufacturers make a needle cap, which has a tube that causes the paint to go farther, making it possible to paint and draw lines higher or from farther away.

PROTECTION

An inconvenience of using sprays is the small particles of paint and gas that spread out and linger in the air, which can be irritating or even toxic. Therefore it is important to wear a mask when spraying so you will not inhale the fumes. The same paint manufacturers sell masks that will keep the finest particles that can be created by a spray can from injuring the health of the user. The silicone masks that adapt to the face are the most practical ones.

The spray caps are an important part of calligraffiti. *Attached to different spray cans these will make lines of different kinds, some for fine lines and even an oblique nozzle that is great for writing since it imitates the stroke of a pen.*

CORRECT USE

Another thing that should be pointed out is that good use must be made of these tools, for the creation of work with artistic value in the proper locations. For a long time this form of artistic expression was looked down upon and considered a form of vandalism. The creative, spontaneous, and even transgressive virtue of the work created with these tools should always respect private property and spaces of others so that people will appreciate more and more the value of what is being painted.

The manufacture of specialized calligraffiti *sprays has diversified into various formats that can be fitted with screw-on nozzles of different kinds to create many different spray patterns.*

This is a mask with replaceable filters that protects against gases and fumes. Made of silicone, it is comfortable and fits the face well.

Inks

The quality of a work of calligraphy is not only seen in the skill of the calligrapher, but in the quality of the tools and the ink that are used. A good ink is brighter, more intense, and makes the work stand out.

Pigments of various brands in containers.

THE BASE MATERIALS: PIGMENTS

The first inks were made from pigments. They were used in the prehistoric era as can be seen in cave paintings. They were made of pigments that were found in the environment, like the manganese black used to dye and paint the walls. Pigments are colorants in the form of fine powder that is obtained from organic substances, or from inorganic ones like some minerals. The colors yellow, red, and sienna, for example, are obtained from iron oxide (Fe_2O_3), green from chrome oxide (Cr_2O_3), and bright red was obtained from the insect *Dactylopius coccus*, commonly called the cochineal.

THE USE OF PIGMENTS

To prepare them for use, pigments were mixed with resins for waterproof ink, or agglutinates for water-soluble ink. The different kinds of paint and patinas are also made this way. During the manufacturing process they take on a liquid consistency and a creamy aspect. In the past, egg yolk was used as a protein agglutinate that also gave it a very bright finish. This also made the paint more fluid and slowed its drying time, making it easier to blend. In addition, it added volume to the lines, and a soft satiny look.

COCHINEAL

Red and vermillion watercolors are made of cochineal (*Dactylopius coccus*), an insect commonly found near cacti, on which they subsist. A bright, high-quality colorant is extracted from the cochineal. Its pigment is used for many things: paint and ink of course, but it is also a food additive. Curiously, it is also used in strawberry yogurt as a colorant.

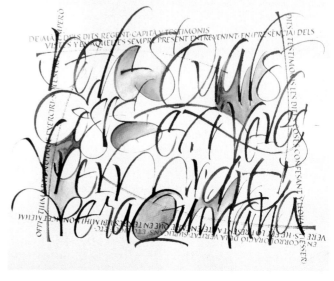

The Notary, work by María Eugenia Roballos. It was done in nogaline and tempera on Arches Aquarelle paper with Mitchell pens and a ruling pen.

THE ORIGINS OF INK

Ink is a liquid made with pigments and colorants. In ancient times natural inks were used like sepia, a mollusk from the cephalopod family that secretes a dark brown to nearly black liquid.

The oldest known inks came from China and were made from lamp black. It is believed that it originated about 2500 B.C. or even before. Lamp black is a pigment made from soot; when mixed with an agglutinate it becomes ink that can be used for writing, and it is the first kind ever used.

The paint can be made more fluid, have a brighter finish, and, most interestingly, be given a line with more volume, by mixing an egg yolk with the pigment. This formula was much used for creating illuminated initials, letters at the beginning of a text that are usually very decorative.

CHINESE INK

Chinese ink is made in stick form, called *sumi*, and it is ground in an ink stone, the *suzuri*, to make the liquid form of ink. It is made from very finely ground vegetable carbon, which is compacted with a water-soluble agglutinate like organic resins. Sticks in the shape of little compressed ingots are formed and left to dry until they reach a solid consistency. They can last for years in this state, even centuries without losing their properties. To ascertain if the Chinese ink stick is of good quality, look at whether it is smooth and regular to the touch, and if it quickly makes intense black ink when mixed with water.

Liquid inks already ground and mixed with water are also available for our convenience.

Nogaline is a natural pigment obtained from the walnut. It is used as a dye but also can be used for writing. It makes brown strokes of varying intensities according to the amount of water added to it.

The process of preparing Chinese ink is long and its intensity depends on two factors: the amount of water used and how long it is ground. Interestingly sumi *ink sticks are marked with the name of the manufacturer or with landscapes that are emblematic of China.*

MODERN INK

Nowadays we can find numerous brands of writing ink that are the heirs of others created during the 20th century, when fast-drying alcohol-based inks were desired. The most important advances were made by the Parker Company with its Quink ink, which today continues to be very good ink. The characteristic of these kinds of writing ink were their intense black color, and they varied by manufacturer and by the fact that, upon drying, the edge of the lines show a small halo of blue, yellow, or ochre. Today you can buy inks made for calligraphy in black, and also other colors like blue, brown, and even metallic ones like gold.

Cover of the disc The Contortionist's Coffin, *a musical project of Alberto González Arellano, done with invisible ink made from lemon juice. The image appears and is fixed when heat is applied to it.*

Abraxas brand ink made with organic pigments from plants.

Winsor & Newton brand calligraphy inks in black, emerald green, and scarlet red.

Quink ink from Parker, and a bottle of gold ink from Winsor & Newton made for use by calligraphers.

"INVISIBLE" INK

Perhaps you would like to write with invisible ink, or more precisely ink that disappears after it has dried. Lemon juice is the source of this magical ink. To read the text after it has vanished, hold the support close to a heat source and watch as it suddenly appears before your eyes.

IRON GALL INK

Iron gall ink was doubtless the most popular ink in the West because it was easier to use than other older inks. They were too dense and heavy, and not good for use with a quill pen. Today there are better inks, and iron gall ink is no longer used, but its importance in the history of calligraphy cannot be denied. No one knows when iron gall ink, made with iron tannate, began to be used. Documents, including a papyrus from the 3rd century, have been found with a recipe for making it.

Modern inkwell decorated in the old-fashioned style.

Paint and Other Materials for Writing Calligraphy

In artistic calligraphy it is very popular to use colors to enrich the finished work. Besides ink, many other color media can be used if properly mixed, like watercolors, gouache, and acrylic paint. Surprisingly, there are other fine arts materials that can also be used for calligraphy.

WATERCOLORS

Watercolor paint must be diluted with water to be used. For this reason its main characteristic is transparency, which varies according to how much water is in the mixture, and sometimes the white of the paper underneath will show through to act as another color. The paint is applied in transparent layers, making the work brighter and giving it a loose and free feeling.

The brightness of the color depends on the amount of water used. If you use less water the color will be more opaque and not as bright than if you use more water, which will make it brighter and more transparent. The colors can be made deeper and richer if you superimpose the brushstrokes. The intensity of the watercolors can be modified by adding or using less water. Watercolor paint is made of organic and inorganic pigments that have gum Arabic or honey for an agglutinate. The quality of the watercolor can be determined from the pigments used in its manufacture, and their quality will determine their light fastness as the better ones do not fade as much.

Watercolors are available in cakes, in tubes, and in a liquid form that is referred to as aniline.

Strokes of watercolor where you can see the transparent texture that is ideal for creating overlaid colors.

Liquid aniline colors. In addition to being used like watercolors, they can also be used for dyeing thanks to their transparency. In the past anilines were frequently used to tint photographs and there are even old films that were colored frame by frame with this product.

Different brands of watercolors available in tubes.

Watercolors can be purchased in cakes, individually, or in box sets containing the most popular colors.

CALLIGRAPHIC APPLICATIONS

Watercolors are ideal for superimposing calligraphy because of its transparency. Interesting textures can be created when texts are painted over each other. For this type of work you will need brushes, reed pens, or sponges with handles.

GOUACHE

It could be said very simply that gouache is like watercolor but opaque. It is water soluble, just like watercolors. But it is different from watercolors in that light colors can be painted over dark colors without the latter showing through. The composition of gouache is the same as watercolors, and it is used in the same way. Gouache is sold in two formats, in jars and in tubes.

When used for calligraphy, gouache is mixed with water until reaching the desired consistency. This should be thicker than ink, but the stroke should not be too fluid. Mixing it with

an egg will help, both for its fluidity and its shininess. When using this kind of paint for calligraphy, you must use a fine brush for charging the nib. If the nib has a reservoir, then it can be filled with the brush.

A jar of white gouache, very useful for correcting errors and for writing on dark surfaces.

Tubes of gouache paint.

Orchid and Orange, *work by Chen Li, based on some Tang poems. Done in acrylics on canvas.*

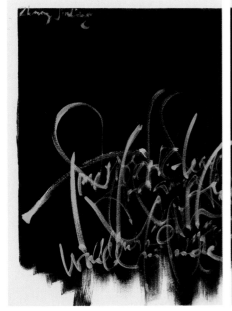
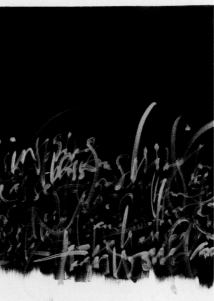
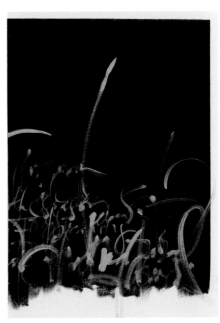

Acrylics are sold in two ways, in containers that can be plastic and with or without spouts, and in tubes.

ACRYLICS

Acrylic paint was invented in the first half of the 20th century and developed in Germany and the United States at the same time.

This paint has a base of pigments bound with a polyvinyl acrylic emulsion. It is a fast-drying paint and it can be diluted with water. Although they are water soluble, acrylics become waterproof upon drying and can then no longer be worked. You must keep in mind that when it dries its tone will change slightly, a bit more than oil paint. Acrylics are used more often than oils because they dry quickly, are elastic, and are easy to use for calligraphy.

USING ACRYLICS

For use in calligraphy, acrylics are mixed with water to a density that will make a fluid line. Like gouache, acrylics can be mixed with egg yolk to make the paint more fluid and to increase its brilliance, and this will also add volume to the strokes. A fine brush must be used to charge the nib pen when using acrylics in this way. If the nib has a reservoir, it should be filled using the brush.

When the work is finished, the nib must be thoroughly cleaned with water because the traces of paint will later be difficult to remove if they have dried.

Gum Arabic is a vegetable resin that looks like amber and is obtained from various species of acacia, especially the Acacia Senegal.

Gum Arabic always has impurities that should be very carefully removed before using. A nylon stocking or piece of silk can be used for this.

GUM ARABIC

Gum Arabic can be mixed with watercolor or gouache pigments. This mixture helps fix the pigment to the paper, dries quickly, and makes a bright and transparent finish.

Gum Arabic is a vegetable resin and the best known and most used glucose agglutinate. The raw material comes from the Sudan and the name reminds us that it was first commercialized by the Arabs.

VARNISHES

In addition to the conventional use of varnish, which is used for protecting paintings, it can also be used for writing. Interesting effects can be created, like making glossy writing on a matte surface.

Varnish creates a transparent and waterproof mark. There are matte and glossy varnishes on the market, and the latter are more transparent than the matte varnishes.

LATEX

Latex can create effects similar to those of varnish when it is mixed with watercolor or gouache pigments. Latex is a milky-looking vinyl medium that, like varnish, can be glossy or matte. It dries quickly, and, in addition to the brightness, its line will have a very attractive feeling of volume.

GOLD LEAF

There were already documents decorated with gold leaf in ancient Greece. This use passed from Greece to Egypt, where there were specialists in this type of work who were called "the gold scribes."

This became a widespread practice during the Middle Ages, but its great expense limited its use to important manuscripts.

Gold leaf is available in extremely thin sheets of gold, individually or in a book form. Pure, authentic gold leaf is more expensive than sheets of metal leaf. There are also transfer sheets of gold leaf, real and metal silver leaf, and sheets of copper leaf.

Gold leaf can be used to make authentic illuminations. This refers to decorating an initial with gold or other metals. They can be applied flat or in relief. They were traditionally applied in relief, where they achieve the most attractive effects, because they create more reflections of light. To make the relief, the gold leaf is applied over gesso (a type of primer) or polyvinyl acetate (PVA) (similar to white glue). The leaf is applied to them with an adhesive base. In ancient times, a glucose agglutinate was used (a component of sugar). The gold leaf should be applied before any colors, since pigments can sometimes be adhesive and cause the gold leaf to adhere to the wrong areas and ruin the manuscript. Gold leaf is not an easy material to use, and given its high price, care should be taken not to tear it.

A bottle of varnish with a brownish tone, and another of latex, a dense, milky liquid.

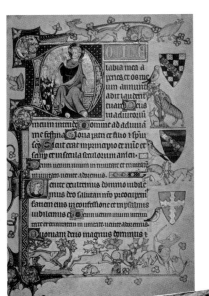

An illuminated Book of Hours preserved in the Fitzwilliam Museum, Cambridge, England, created in the 14th century with gold leaf. You can see, even in this photograph, the reflected light caused by the applied gold leaf.

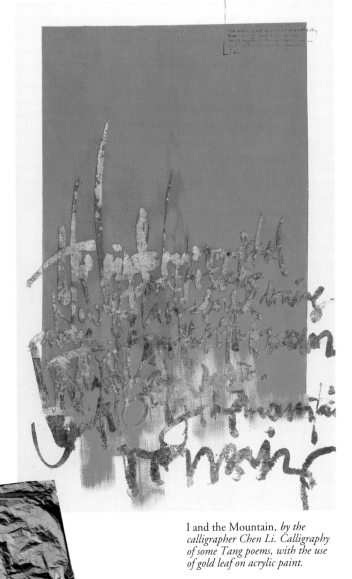

I and the Mountain, by the calligrapher Chen Li. Calligraphy of some Tang poems, with the use of gold leaf on acrylic paint.

A sheet of gold leaf. It comes in extremely thin sheets, available individually or in books.

Paper and Typical Supports

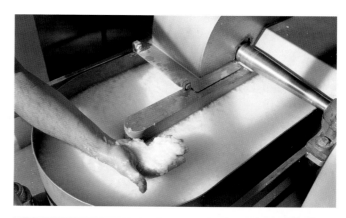

Paper is the most popular support used for calligraphy and there are many kinds that are appropriate for this artistic specialty. But throughout this chapter you will be seeing many other supports, some precursors to paper, and others that are special (and even surprising!).

THE ORIGIN OF PAPER

Paper is undoubtedly one of the greatest inventions that China has contributed to the world. It dates from between 150 and 200 B.C. and its inventor was T'sai-Lin, an official eunuch of the Chinese emperor Ho'Ti. Its use expanded rapidly throughout various regions of China. The pulp used in its manufacture came from the mulberry tree (*Broussonetia papyrifera*) and from bamboo. This paper was very absorbent and ideal for Chinese calligraphy. Today the most widely used papers are Xuab Zhi and Loo Wen Xuan, which have a vertical rainy pattern and a velvety tack that are very good for calligraphy. Oriental papers are commonly called "rice paper," but this is not really true, because although such paper does exist, it is not used for calligraphy because of its fragility and color.

Woodcut print showing the traditional process of making Shiuan paper. It is made from the bark of the mulberry tree and bamboo.

MANUFACTURING PAPER

Throughout history there have been several different processes for making paper. The Western technique that was used until about 1850, was directly inherited from the Oriental method. It was made using various vegetable fibers, especially cellulose and rags. The fibers and rags were shredded and put in tubs with water and lime to begin a process of fermentation and maceration that eventually created a milky-looking pulp. Sheets of paper were made with this pulp by dipping a metal screen into it to make a layer of fibers (the sheet), which was hung to dry on a string.

To differentiate themselves, paper manufacturers began to design their own seals and logos, which were attached to the screen. They left an impression known as a watermark on the paper. The watermark is still used and is a way to identify the paper when we are making our choice.

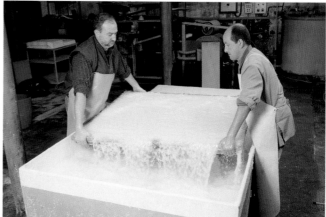

The process of making paper by hand has barely changed from the way it was originally made in China. On the other hand, the industrial process of mass-producing paper has changed quite a bit.

THE WATERMARK

The watermark is a seal integrated into the paper that is created during the manufacturing process. A metal design is attached to the wire screen used to scoop the pulp from the vat, and it creates an impression in the fibers of the sheets that is more transparent than the rest of the paper and that can be seen when illuminated from behind.

The watermark is frequently used on the most prestigious and well-known papers sold by fine art suppliers like Arches, Fabriano, Conquerour, Galgo, and Guarro, and they guarantee recognition of the paper. Since watermarks are difficult to falsify, they are frequently used as a security measure for bank documents and currency.

There is a large variety of papers available for sale, but not all of them are appropriate for use in calligraphy. A paper that is too glossy will cause the pen to slip, and the pen stroke will not be the best. On the other hand, a paper that is too rough will impede the fluidity of the line. Another frequent impediment is the use of paper with too much cellulose, which has too much "fuzz" that obstructs the pen and makes it impossible to do any calligraphy work. Laid paper is the best for calligraphy—paper that will show a screen pattern or very fine lines when held up to the light. Vellum paper, which imitates the texture of calfskin and does not show any lines when held to the light, is also good to use.

We recommend papers like Arches, Ingres by Canson, Rives, Fabriano, Schoeller, Galgo, Johannot, and Lana. All these manufacturers make high quality laid and vellum papers that are highly recommended for calligraphy.

Color opens up a very wide range of artistic possibilities. A great number of colored papers are available today. Light colors can be used with ink and watercolors with little problem, and very good results can be achieved using gouache and acrylics with darker-colored papers.

All these papers and others of similar quality can easily be found in art supply stores. They are sold in individual sheets of different sizes up to 19 5/8 × 27 1/2 inches (50 × 70 cm), or in pads of 20 or 30 sheets in several sizes.

Above and right, different watermarks of paper manufacturers that can be used in calligraphy.

There are many sizes of cardboard available for sale. They can be prepared for use with calligraphy.

CARDBOARD

There are many kinds of cardboard available, from illustration board, to mat board, to shirt board. They can be interesting supports, but they are not good for direct application. Cardboard is very absorbent and the ink will frequently run, so it is not a good support for writing.

Before starting a work of calligraphy, the cardboard should be prepared with a primer or seal coat. Some boards can be purchased already prepared for use, or you can do it yourself applying the primer, usually *gesso*, as a first step. Another possibility that is halfway between cardboard and canvas is the use of canvas boards, which are often used with acrylics and oils.

CANVAS

Canvas and fabrics are not the best supports for calligraphy, since it is impossible to use metal nibs on these surfaces. But if the calligraphy is done with brushes, they can obviously be very appropriate supports because of their texture and quality. They are available in art supply stores, ready to be used. Some have fine textures, like linen, while others, like sackcloth, have very rough textures. These types of support are best for use with acrylic and oil paints. The quality of the canvas is determined by the kind of fabric it is made of: linen, cotton, sackcloth, or a mixture of materials that make it more economical.

The stroke will be more or less fluid according to the quality of the canvas. Before beginning any work of calligraphy, you should test the density of the paint and how it behaves on the texture of the canvas so you can create the most beautiful calligraphy possible. From the top, two linen canvases of different weaves, cotton duck, mixed fabric, and sackcloth.

WOOD

Wood supports have been frequently used throughout the history of writing. The most interesting thing about this support is surely the quality of its texture. Its beautiful figure and organic grain adds great warmth to the work. However, the surface must be primed, usually with gesso, before beginning to work on the wood surface.

PREPARATION: GESSO

Gesso is the most popular material used as a primer for surfaces like cardboard, fabric, and wood. To prepare a surface, the gesso must be diluted with water and then applied with a brush or a roller. It dries quickly, so it is an easy and practical process.

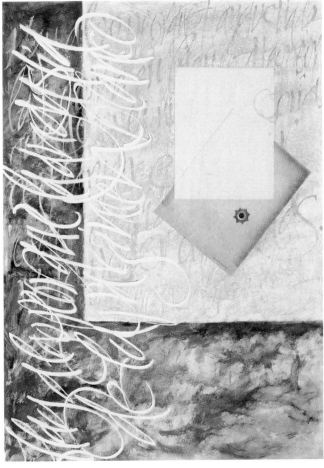

Gesso is a primer in paste form that is diluted with water and applied with a brush or roller to the surface that is to be painted—or in this case covered with calligraphy.

On the Anguish of the Blank Page, *by Fabián Sanguinetti, inspired by a phrase by Polo (Fabián Polosecki). Calligraphy on a wood support done using brush and experimental tools with acrylic, modeling paste, and collage.*

OTHER SUPPORTS

In theory, calligraphy can be applied to all kinds of materials. The secret is in the ability of the ink or paint to adhere to a specific support. With the proper pigment, we can write on glass, metal, painted and enameled surfaces, and even rubber. A practical example of a unique support is this automobile covered in calligraphy by Oriol Ribas. In this field, calligraphy can play an artistic and fun role, and even a commercial one as publicity.

Ancient Supports

Since the beginning of time, writing tools and materials taken from nature have been used. Some of them, probably the oldest ones, were for writing dry—engraving with a hard tool—while others were used to write "wet" with some pigmented liquid. Despite their antiquity, these supports can still be considered for creating work nowadays.

CLAY

In Mesopotamia, clay was used as a material on which to write sums because it was abundant, and because wood and stone were scarce in that area. Furthermore, it is a malleable material, easy to work, to mark, and to erase in case of error, and after it is fired the writing is indelible. Writing on clay consisted of pressing with a reed that made incisions in the shape of wedges. This support was used for centuries by several cultures because of its versatility.

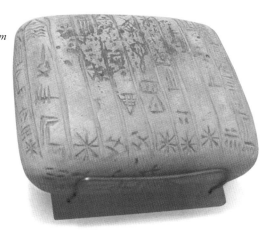

Clay tablet with cuneiform writing.

STONE

Stone was also a widely used material. Dry writing on stone was very common in antiquity, but today it is only done on tombstones. The tools have changed completely—now mechanized tools are mainly used. Traditionally, the pointer and the chisel were used.

Fragment of an inscription dedicated to Augustus, in the Roman Empire, 12 × 8½ inches (30.5 × 21.6 cm). Museum of Fine Arts, Boston, Mass.

PAPYRUS

During the first millennium before Christ, the Aramean nomads entered Mesopotamia and transmitted their language, which was written with a linear, easy-to-understand alphabet that was especially easy to use. The Arameans wrote on a very lightweight support, papyrus, which was made from a plant of the same name (*Cyperus papyrus*). It was made by cutting the stalks lengthwise (following the pith of the long reed) to form strips. Then they were laid flat on top of each other and beaten to cross the fibers. The sheet that was obtained from this was pounded with a mallet, flattened with a weight for several days to extract all the water, and when dry it was a good support. A liquid extracted from the same plant was used to strongly adhere sheets to each other. Rolls were made by attaching several sheets at their ends so that the sides that had horizontal fibers were on top, because otherwise the sheets would crack or break when rolled up.

Papyrus sheet. It is still possible to acquire this traditional material in art supply stores.

ANIMAL SKIN SUPPORT

From time immemorial, humans have made designs on their skin in the form of tattoos. Therefore this living and ancient material has also been a support used for artistic expression. Normally designs with lines and figures have been used, including such impressive extremes as the Maori, the native people of New Zealand.

In the western world, letters have been tattooed as well as figurative motifs, often as dedications along with the drawing. But lately, tattooing calligraphy has become fashionable, whether exotic work like Arabic or Chinese, or with Latin characters. Calligraphy on the skin can be permanent or temporary, depending on the method and the inks used. Before starting to work on the skin, it is a good idea to test the ink on a small area of skin to make sure that it does not produce any kind of allergy or skin lesion. In the photograph is a work by Inocuo.

Parchment was the most popular support used for writing in the Middle Ages. It is a treated animal skin with a smooth white surface that can be written on. When illuminated from behind you can see traces of veins, a sign of its animal origin. It is still made today and used for prestigious writing and books.

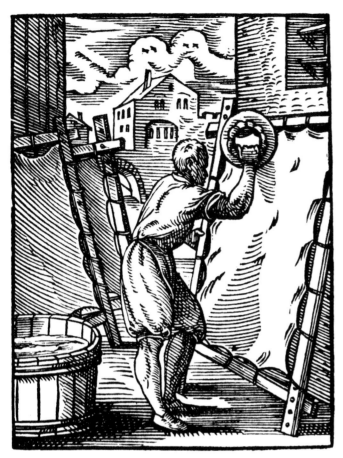

German print from a 1568 treatise on trades, that shows the making of parchment. The artisan is scraping the tightly stretched skin; he will finish the process using pumice stone powder to smooth the surface and prepare it for writing.

PARCHMENT

Parchment is a support made from animal skin that has been processed to make a very good surface for writing. If the skin is from a young animal, the consistency of the skin is finer and it is called vellum.

Parchment is named after the place it was invented, the city of Pergamon in Turkey. It was a widely used material in antiquity, but because of its cost parchment was slowly replaced by papyrus, which was cheaper and easier to obtain. Parchment was relegated to more noble uses such as manuscripts and sacred books.

Originally, parchment was used in rolls. It was during the Roman period when it began to be used in the form of notebooks called *quaterniones*. When the *quaterniones* were sewed together, they were protected by covers. These covers were made of wooden boards (*codex*) and the parchment sheets (*membrana*). The volumes made in this way were called *codex membranei*.

Parchment is still manufactured, but in art supply shops it is easier to find paper that imitates its texture. It obviously does not have the quality nor the finish of real parchment, but it can be interesting for certain kinds of calligraphy work.

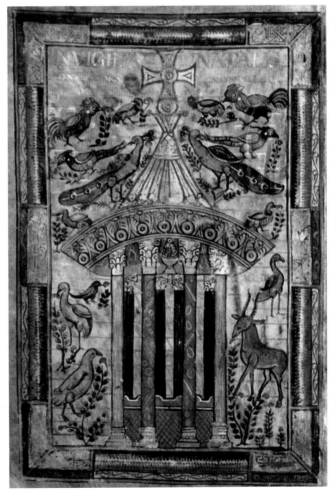

The Godescalc Evangeliary, *a book made by a scribe of the same name on richly ornamented parchment, depicts the fountain of life on this page written in gold ink and decorative illumination on the occasion of the baptism of Pippin, son of Charlemagne.*

Essential Skills for Calligraphy

In this chapter, the reader will be introduced to the essential elements that must be observed when creating artistic scripts. These elements are knowledge of the essential terminology of letters and writing: morphology, pen angle, slant, *ductus*, module, posture, and how to hold the writing tool.

MORPHOLOGY

"Morphology" refers to the way writing looks, and is what allows us to recognize it and date it. Throughout the history of writing some symbols have evolved and changed their form. An example would be the symbol "&," whose name in English is ampersand although it is pronounced *and*. The original symbol was formed by two letters, "e" and "t," but the way of representing them evolved and became the symbol "&." This is what is known as a *ligature* and the morphological characteristics of such a letter can help us identify the date of the writing.

Dating calligraphy is a difficult task, and an empirical procedure is not enough. This is the object of paleography. It must be studied while being aware of characteristics of the letter like the pen angle and the *ductus* that was used.

ANATOMY OF THE LETTER

This refers to defining the principal parts of a letter. The "main" part of the letter, known as the "body," is the part written between the baseline and the waist line. These guidelines (later we will show you how to create them by calculating the module) should later be removed. The parts that go past the guidelines are called ascenders and descenders, the former rising past the waist line and the latter descending below the baseline. There are also horizontal crossbars like those on the letters "t" and "f." The letters with completely closed parts like "a" and "b," are characterized by having an enclosed area, the "counter." Other letters have features called "spurs" or "ears" as in the case of the "r," and in many calligraphic styles the miniscule "g." The term *ligature* refers to the line that connects two consecutive letters.

Other elements are ornaments and flourishes that calligraphy can use to decorate letters. Best known are the serifs that appear at the ends of the vertical strokes, especially the capital letters. Also very common in Gothic scripts are the thin lines that connect parts that are normally not closed in letterforms.

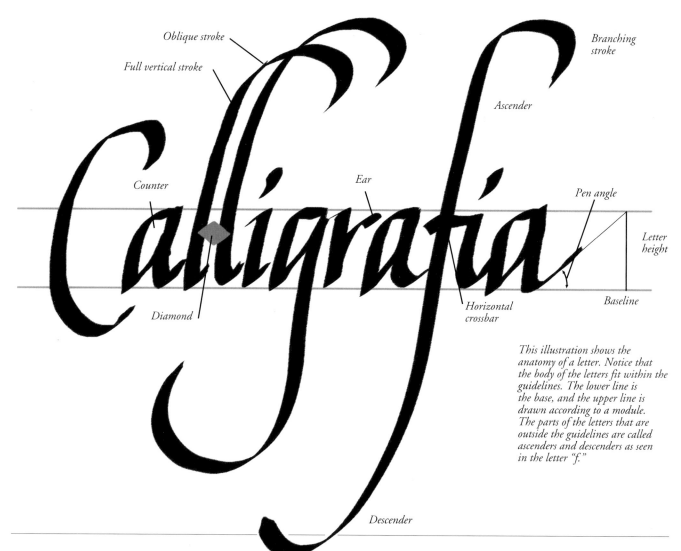

Oblique stroke

Full vertical stroke

Branching stroke

Ascender

Counter

Ear

Pen angle

Letter height

Diamond

Horizontal crossbar

Baseline

Descender

This illustration shows the anatomy of a letter. Notice that the body of the letters fit within the guidelines. The lower line is the base, and the upper line is drawn according to a module. The parts of the letters that are outside the guidelines are called ascenders and descenders as seen in the letter "f."

THE PEN ANGLE

This refers to the angle of the tip or nib of the writing instrument in relation to the horizontal guidelines for the written text, and the angle depends on the degrees of rotation of the central axis of the instrument, which is generally a pen.

There are two different concepts that can be confusing: the difference between the angle of the script (the pen angle) and the inclination of the letter (the slant). They are not the same. The pen angle can vary according to the calligraphy, but it will be stable and constant. It is very important to respect the pen angle, and in this book the modules of the calligraphic styles will note the different angles.

The pen angle was defined by the paleographer Jean Mallon as "the position of the writing instrument in relation to the direction of the line."

According to the paleographer Léon Gilissen, "the able fingers must play with the quill they hold: for the ligatures that form the letters and symbols the pen pivots slightly around itself in a counterclockwise direction when the ligatures are downward, and in a clockwise motion when making ligatures towards the tops of the letters. This slight pivoting of the pen causes a change in the angle of the writing instrument."

The pen angle depends on the angle at which the writing instrument is held. In the case of a nib pen, its position in respect to the guidelines followed by the line of the script depends on the cut or angle of the nib—the shape in which it was manufactured or the way that the scribe cut the point, whether straight and symmetrical, or angled to the right or left.

DIFFERENT ANGLES

When beginning a calligraphy project, you must always keep in mind the pen angle of the letter you are about to write. So if you wish to write in rustic calligraphy the pen angle must be 70º for the vertical strokes and 45º for the horizontals and curves. You will notice a great difference between the 70º strokes, which are thin, and the ones made at 45º, which are thicker. This contrast is very important in this type of writing. For uncial scripts you will use a 20º pen angle. You will use a 45º pen angle for writing most of the calligraphy used in this book, but the reader will find this information in each model.

In this work written with Gothic letters you can see that the ascenders are straight lines with no slant. However, all the lines that finish some letters follow a strict 45º pen angle and a 0º slant.

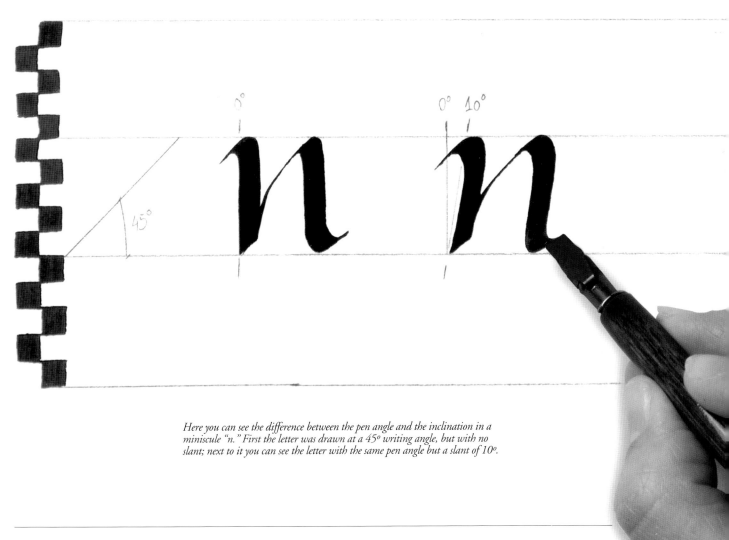

Here you can see the difference between the pen angle and the inclination in a miniscule "n." First the letter was drawn at a 45º writing angle, but with no slant; next to it you can see the letter with the same pen angle but a slant of 10º.

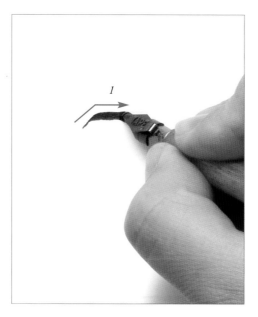

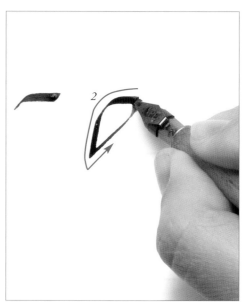

Observe the ductus of a letter "a" in Italic Chancery calligraphy. First a horizontal line is drawn from left to right; after that line, a curved stroke is made to enclose the eye of the "a," and finally we go on to finish the tail of the "a." Therefore, three strokes form the ductus of this letter in this style.

THE *DUCTUS*

The word *ductus* comes from the Latin *digitus*, which means "finger." The famous paleographer Agustín Millares Carlo defined it in the following way: "The *ductus* is the order in which the strokes were made and the direction in which each of them was drawn."

This is to say, the number of strokes needed to form a letter, the direction of each stroke, and the order in which they were drawn. A *ductus* is shown in the models for each style of calligraphy in this book, with arrows indicating how each letter is made. The order and direction are regulated—the *ductus* is the code that must be followed when making calligraphy.

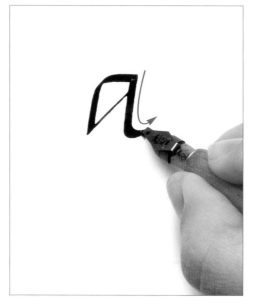

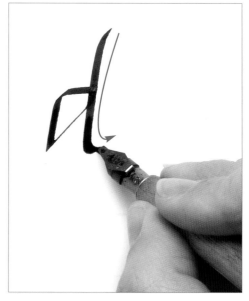

THE ORDER

In general terms, it could be said that the vertical strokes are made from top to bottom, and the horizontal ones are made from left to right. However, in Arabic script the direction will vary, since the script is written from right to left.

Not following the *ductus* of a letter can cause the ruin of a calligraphic form and render it inexact. In the case of Chinese calligraphy, the *ductus* must be followed even more strictly; improvisation is allowed in neither the order nor the direction of the strokes because this is a very inflexible type of calligraphy.

These images illustrate the repetition of the shape or eye of the letter "a" in other letters of Italic Chancery as it happens in forming the letters "g," "d," and "b," although the strokes of the letter "b" are inverted.

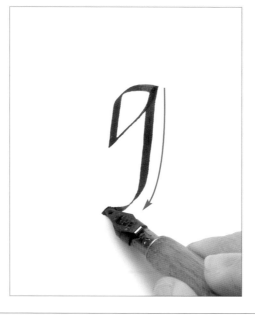

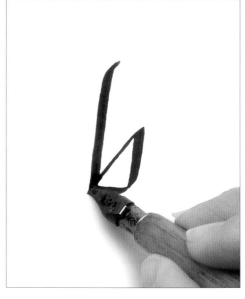

THE MODULE

According to Millares Carlo, the module "designates the absolute dimensions of the letters. By 'modular relation' we understand the proportion between their height and their width."

Calculating and measuring the module of a letter on the sheet of text itself can vary and turn out wrong, since the relationship established between the height and width of ascenders and the descenders will show notable differences, even on the same sheet.

CALCULATING THE MODULE

To calculate the module of a letter you must always go through an exercise before beginning the work of calligraphy. Using a pencil with a sharp point or a 0.5 mm lead, draw a line on a sheet of paper that is ready for writing. The line should be drawn where you wish to begin writing the letters; it will be called the "baseline." Draw some small squares on this baseline with a nib pen, in an alternating stairstep pattern, preferably without lifting the pen from the paper. The width of each square, and the height, will match the width of the nib being used. For example, an Uncial script has a module of five pen widths; on the other hand, a Gothic text has a width of 4½. Obviously, the size of the module will vary according to the size of the nib. After making the squares, draw lines above each of them and parallel to the baseline. This will be the template for writing. For texts, longer than one line, the operation must be repeated.

1. A practical example of how to make the module with five pen widths for italic script with a 2 mm Brause metal nib, with five ascenders and five descenders. We begin by making small squares the width of the nib, arranged in alternating columns one below the other. It is important that the squares are as regular as possible, with the same height and width.

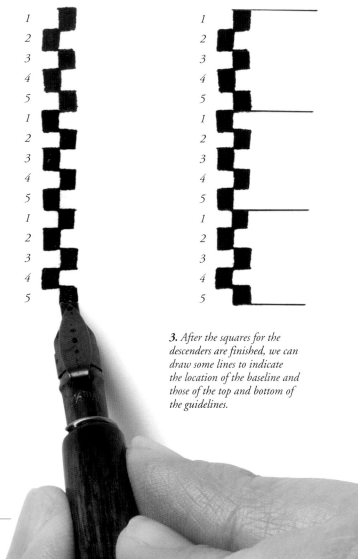

2. The first five squares correspond to the ascenders. The other five are for the body of the letter.

3. After the squares for the descenders are finished, we can draw some lines to indicate the location of the baseline and those of the top and bottom of the guidelines.

TECHNIQUES AND PRACTICE

PREPARING THE WRITING TABLE

Before starting any exercise you should prepare the table and see how your body is situated in respect to it. Ideally you should clear as much space as possible and place the paper at 90°, perpendicular to the edge of the table. The tools for your work should be placed nearby, but spread out so that they do not get in the way of making the lines.

LIGHTING

There must be a good light source for working comfortably, the table must be stable, and the chair must be comfortable. Natural light is always better for activities like this that require visual effort, but avoid direct sunlight because it causes shadows and makes it difficult to see the exercise well. If you must use artificial light, it is very important to have a general lighting that fills the room. The light should not be too bright—non-reflecting lamps are best. You can even have indirect lighting, like aiming a light at the walls or ceiling and combining it with a task light.

The latter should be to the left of the work area if the calligrapher is right-handed, and to the right for a left-hander. It should always be placed to avoid bothersome shadows that interfere with the calligraphy project.

HOW TO SIT

The body should be straight. Leaning over and turning the paper causes tiredness and backache, greatly interferes with the *ductus* and the pen angle of the calligraphy, and is very likely to achieve poor results. The weight of the body should be carried by the spine, the feet should be braced well, and the legs relaxed and never crossed, because this could easily cause the calligraphy to be crooked or slanted.

When writing, the left hand should be placed on the paper, and the right should be loose and comfortable. The wrist should be somewhat raised and free, and the arm should rest on the elbow. It is recommended to place a clean sheet of paper underneath the right hand to keep sweat and oil from ruining the work.

The back should be straight, feet resting on the floor, the legs relaxed and never crossed. Crossed legs or bad posture can easily cause the calligraphy to turn out crooked or slanted.

BREATHING AND CONCENTRATION

It is also important to control your breathing. We recommend inhaling and exhaling slowly and steadily. It is a good idea to be in a state of deep relaxation and concentration. This meditative state is essential to oriental calligraphy, especially in the Chinese art. A relaxed state is very important for practicing calligraphy. It is the only way to create an even, flowing, beautiful line. If you feel restless, tired, or tense, it is best to stop and do some stretching, relaxation exercises, or both. It also helps to listen to relaxing music like classical, while avoiding distracting music.

When writing, a right-handed person should sit with the back straight and legs uncrossed, the left hand on the protective paper and the right hand in a comfortable position. For this, the wrist should be slightly raised and free, and the forearm should be supported at the elbow. A left-handed person should do the same but in a mirror image. Photograph by Katja Seidel.

REQUIRED MATERIALS

In addition to the paper or calligraphy support, you should also have your instruments, ink, and paint that you use for writing on the table. Also, you should have two containers of water, one for diluting ink and the other for washing the pens or brushes. Besides a rag for cleaning, there should be paper at hand for practicing and for making the first pen strokes after charging the pen with ink to avoid excessive ink and blotches on the work.

HOW TO ATTACH A NIB TO THE HANDLE

At the end of the handle you will see a metal piece with a flower shape in it, surrounded by a metal ring. To correctly attach the nib, insert it against the ring, carefully pushing it about halfway in. It should not be loose, or you will not be able to control the pen strokes or the nib may fall out while working. If it is inserted too far, it will affect the flexibility of the nib. A common error that should be avoided is inserting the nib into the flower-shaped slots.

You can see in the photo that the nib is inserted to the outside of the metal piece, and not into the cross in the center of it. This is a common error that impedes good calligraphy work and ruins the tool.

For working comfortably, the tools should be placed near at hand but where they will not be in the way. The paper should be at a 90º angle, perpendicular to the edge of the table. Photo by Katja Seidel.

HOLDING THE PEN

When writing, the pen should be held with the index finger and thumb and supported with the middle finger. The position of the hand should be comfortable but steady and controlled. Not much pressure is required, because it causes the hand to get stiff and tired. It could be said that nib pens are personal and nontransferable, since each hand applies different pressure to the pen and it adapts to that pressure. The points of the nib open more or less; if you do not use much pressure and you loan the pen to someone who applies a lot of pressure, the effects on the nib could be very noticeable.

The pressure on the pen is also determined by and varies according to the type of calligraphy being done. For example, an Uncial or a Carolingian letter is written with a constant angle and with little pressure, but a Gothic letter requires quite a bit of pressure.

When beginning to write a specific type of calligraphy, you must be very aware of the pen angle. When writing Chancellery, the pen must be held at 45º with respect to the baseline of the template. This creates a beautiful contrast between thick and thin lines and is a characteristic of the morphology of each letter.

The pen should be held between the index finger and the thumb and supported by the middle finger. The hand should be comfortable and free. It is best to hold it slightly curved and not to apply too much pressure when writing.

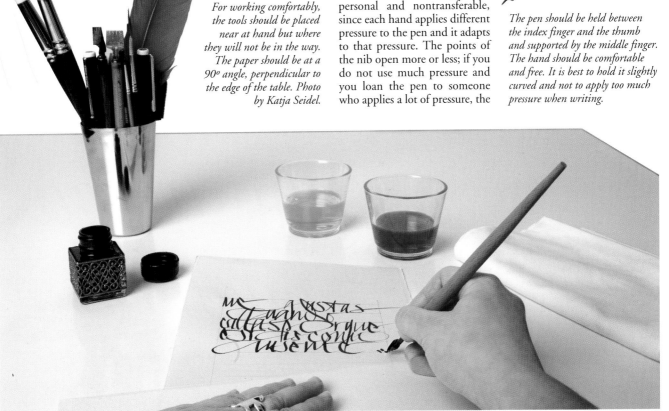

RHYTHM

One of the most important characteristics of calligraphy, especially if it is free calligraphy, is the rhythm with which it is written. Calligraphy requires making strokes in specific equal intervals of time, something very like playing an instrument with the tempo of the music. It is a good idea to begin these exercises with a very slow and measured rhythm and increase the speed little by little as you get some practice. This will help you become more controlled when you write.

LETTER SIZE AND SPACING

The space of the letter, which is the space that the letter itself occupies, is controlled by two things. The first is the type of letter you are going to write. Thus a Carolingian script has more spacing between its letters than you will see in a Gothic one, where the letters are very close and have minimal spacing. Interletter space is the distance between two letters. The second characteristic of letter spacing is part of the morphology of each letter. Thus, the letter "i" is a letter that occupies little space, but you must keep in mind that two narrow letters require more kerning than a wider letter like the "o." The "o," on the other hand, occupies more space but requires less blank space, like what happens with two sequential rounded letters. The balance between the white space and the black determines the spacing between letters.

To clearly see the importance of letter spacing we write the word "raïm" which contains an "i," which occupies a minimal space and can be compared to the letter "m," which conversely occupies a large space. In this case, we see that the "i" is too close to the "a" which creates an unpleasant optical effect. It is clear that the spaces between letters help create and organize a stable and regular order.

In this image you see how the interletter space has been fixed to create a more ordered script with even spaces between the letters. In calligraphy, balance is of utmost importance.

Before doing calligraphy in ink, it is a good idea to practice your rhythm with a pencil. These exercises are important because as soon as the rhythm is under control, you will be ready to begin working with ink.

The exercise of writing the word "minimum" includes nearly parallel repeated lines and shows us the importance of rhythm. Repeating this exercise helps you develop a controlled and regular rhythm, yet with a certain freedom. Calligraphy is like music with a rhythmic organization.

BEFORE WRITING

Before starting to write any letters, it is important to do some exercises to become comfortable with the basic strokes of calligraphy. These are exercises that will help you become familiar with using the nib pen and controlling the line. In the following examples, shown step-by-step, you will see how to make the letters and what positions the pen and the hand must be in to get good results.

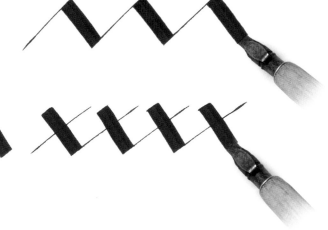

Start by holding the pen at a 45º pen angle and make a border with two lines that form a triangle where the ascending stroke is very thin and the descending one very thick.

Then, changing from the previous strokes, make "X's" with the combination of both lines, one thin and the thick one at 45º.

Another exercise consists of making vertical lines with a 45º pen angle, trying to make them as parallel as possible and all the same height. It is not as easy as it looks, so you should practice until achieving satisfactory results. Then you can go on to make horizontal lines. These are more difficult, but they are found in several letters like the "a" and the "e." Finally, you can combine them to make crosses.

MORE IMPROVEMENT EXERCISES

Vertical and horizontal strokes can be combined to create squares. This exercise is very good for learning to make the elements equidistant with completely parallel lines.

Finally, three more exercises can be done to practice lines that are very common in several styles of writing that you will see later.

Making squares to coordinate the horizontal and vertical distances.

Drawing completely parallel diagonal lines with a 45º pen angle as evenly spaced as possible. This line is common in letters like "x" and "r."

Now you can practice with curved forms, drawing parallel curves like a border. This line is found in letters like "c," "q," and "d."

Finally, it is a good idea to practice the round shapes. You will draw circles with two curves: an arc from right to left, then another from left to right, connecting it to the previous one. You should also make sure that the circles are evenly spaced. This shape is found in the letters "o" and "q."

Composing a Work of Calligraphy

The forms in which writing can be done are very diverse, and depend, of course, on the format of the support, which is usually paper. But there are some classical concepts—the fruit of research in mathematical reasoning—that will help you create a harmonious project.

The Vitruvius Man, *a study by Leonardo da Vinci, where the relationships of the extremities of the human body are established based on the Golden Mean.*

The supports can be as varied as you want: square, rectangular, circular, or any geometric form. The rectangular format, whether vertical or horizontal, is the most usual. A calligraphic composition can be created in many forms with total creative freedom, but if you wish to create a formal work there are ideal spaces that have been established for writing. These standards ensure that the calligraphy text is well placed on the support.

Since ancient times, man has been aware of mathematical proportions based on examples found in nature, like the spiraling curve of the nautilus shell, that determine standards or canons for harmonious constructions. Great artists have applied these proportions to architecture and art to achieve the greatest expression of beauty. The most well known is the Golden Mean, also called the Golden Section and the Golden Ratio.

If we are talking about painting or calligraphy or design, it is a matter of delineating an area of the paper that will encompass the essential part of the work. The rest of the work and the white areas will be based on it as well, and be in balance with it. Great works of art from all time periods and buildings, like the Parthenon in Athens, derive their proportions based on the Golden Mean. There is a geometric approach and a mathematical approach to finding the ratio.

The base of the Golden Mean is a numerical relationship that comes from the Fibonacci sequence. This sequence is constructed by successively adding two numbers starting with 0 and 1, then adding the sum to the previous number. The first results are:

$0 + 1 = 1$, $1 + 1 = 2$, $1 + 2 = 3$, $2 + 3 = 5$, $3 + 5 = 8$, **$5 + 8 = 13$**, $8 + 13 = 21$, $13 + 21 = 34$, $21 + 34 = 55, \ldots$

In this sequence, the proportion 8:13 is the one that defines the Golden Mean. Based on this, for a paper or any given support a format with the Golden Ratio can be calculated mathematically or geometrically.

A geometric method of determining the Golden Mean as explained in the text. When the ratio has been found it can be used (by enlarging or reducing it) to establish proportions.

GEOMETRIC FORM

Start with a square and divide it in two halves to end up with two equal rectangles. Then join far corners on one side of the original square to the center point of the opposite side with diagonal lines, where the two rectangles meet. This creates a triangle. The hypotenuse of this triangle is the radius of an arc whose center point is the lower vertex. Draw the arc from the upper vertex to the extension of the base of the triangle (and the square) to mark a point. A line can be extended from this point from the base to the extension of the upper edge of the original square. The area formed by the half square plus the rectangle created by the extended lines contains the Golden Proportion with a ratio or 8 to 13 on its sides.

You can calculate the Golden Mean by dividing a line of any desired length by 1.618, which will determine another line that is shorter. Using both lines you can construct a rectangle that has the Golden Proportion.

MATHEMATICAL FORM

If you take a line of any given length and divide it by 1.618, you will get another line of shorter length. These two measurements form the long and short sides of a rectangle with the Golden Mean.

THE PROPORTION OF THE PAGE

Using the Golden Mean and other similar mathematical approaches, a paper can be arranged into ideal areas for writing. These principles are also valid for composing texts. The first printers were the ones that designed the pages of their books based on the canons perfected by medieval scribes. In the middle of the 20th century the German typographer, calligrapher, and letterer Jan Tschichold defined in his book *The New Typography* his theories about diagramming a page. Starting from the proportions of the Golden Ratio, he fixed the ideal location of the text block on a page in a position that respected the values of the Fibonacci sequence. This leaves the same distance from the top and outside edge of the page, less distance from the inside and more from the bottom of the page.

COMPOSITONAL FORMS

Before starting, it is a good idea to prepare the text that you are going to write, and according to the height and width of the paper used you must decide on the size that you wish to write, or the appropriate letter modules and the form of the composition.

The most basic and simple way is to align the lines at the left, and with regular spacing fill them in until arriving at the end, without splitting words (this is known as "ragged right"). This means that if the next word does not fit in the space, it is put on the next line. You could also do the opposite, aligning the lines on the right and leaving the left ragged.

It is more difficult to write with centered lines, since you must first determine the center point of the space that will be written in before doing any writing, and then decide the placement of the words. If you end up with a long word at the end of a line, it could ruin the results.

Another possibility, little used in calligraphy but common in the composition of books, is using "justified" edges—aligning both edges. This means leaving more white space between words or even between letters. This should also be practiced beforehand.

Finally, the composition can also be written on a curved line, whether circular, spiral, or wavy. These forms require more skill.

This detail from a work about the four seasons, by Fabian Sanguinetti, shows text that begins horizontally and proceeds to spiral. The positioning of the letters offered a number of artistic possibilities.

An example of text justified on the left and ragged on the right, done by Ricardo Rousselot based on a passage from Martín Fierro*, a work considered a pillar of Argentine literature.*

Calligraphy text with centered lines, or ragged left and right. Work by Ricardo Rousselot in German for the label of a liqueur.

TECHNIQUES AND PRACTICE

Before beginning a work, you must design the guidelines where you will write the letters of your calligraphy. For this you must have a very clear vision of what your desired results will be. If you want the final document to have a classic design, the guidelines can be made based on classic proportions, as explained later. If, on the other hand, a more free and daring design is required, then a special, less regular template can be made. The most important thing about a work of calligraphy is the concept that you wish to communicate, what sensation you wish to express, and what the best composition for it is. The placement of the elements has to preserve a balanced proportion between the "weight" of the calligraphy and the use of the white space, and between the placement and its dimensions so that you can arrive at a formal balance between them.

When designing the guidelines, you must also keep in mind that the black mark of the text and the white space of the document have equal weight. There is no real specific formula that guarantees success, but if you keep in mind what has been said, it is possible to achieve balance. Another way of studying this is to observe the classics.

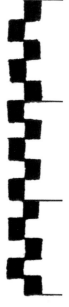

Guidelines are based on the module. For this example we are using one used before that has 15 small squares, that is, 15 widths of a nib pen, in this case a 2 mm nib.

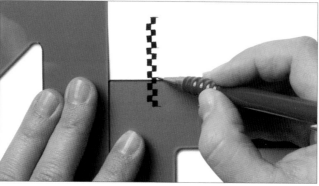

1. First the baseline is drawn. The "body" of the letters will rest on it. Since we have decided to create guidelines with three equal parts for writing Chancellery, the baseline is drawn using triangles as a straight edge at the top of the fifth square.

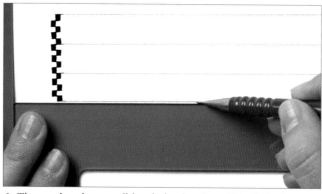

2. Then we draw lines parallel to the baseline that will be the limits when writing the ascenders and descenders.

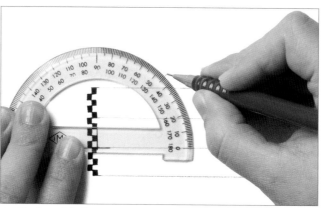

3. The slant of the letters is marked using a protractor, in this case 45º.

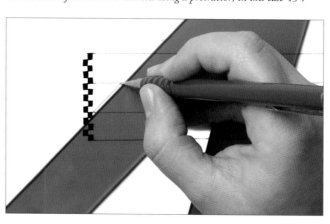

4. The line that marks the slant is drawn using a straight edge.

DRAWING THE GUIDELINES

Once you are clear about the placement of the text on the surface for the calligraphy, you can begin to make the guidelines. The correct proportions of the lines are calculated in relation to the width of the nib. You must use a separate sheet of paper to make the guidelines so that you will not dirty the support for the calligraphy work. First you must calculate the module, as you have seen before. You will draw a number of squares (pen widths) according to the module of the chosen letter style. Therefore, to write in Italic Chancellery you will make five squares that correspond to five widths of the pen nib. The size of the module will depend on the size of the pen. If the nib is 2 mm, the size of the module will be smaller than if the nib is 5 mm. After making these squares a line is drawn above them, parallel to the baseline. This is going to be the guide for the letters. After this is done, you have the correct proportion for the guidelines.

TRANSFERRING THE GUIDELINES

It is usual to make the guidelines on a separate sheet of paper, and if the paper for the calligraphy is not very heavy it can be placed underneath to guide the writing through transparency. Both papers should be joined in some way so they do not shift, perhaps with a piece of adhesive tape. For this technique a light table will help you see the guidelines.

When it is not possible to see the guidelines through the paper, they must be measured and transferred to the support of the calligraphy project. The lines must be very light so that they can be removed after the ink or paint has dried.

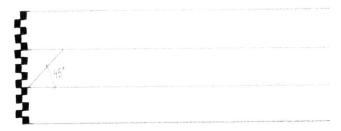

5. *The guidelines are finished. They are normally placed underneath the paper support if it is transparent enough. Otherwise they should be transferred, drawing them very lightly on the surface of the opaque support.*

8. *The baseline and ascender and descender lines are drawn.*

6. *Now new guidelines are started with a 5 mm pen for making a larger letter or for making capital letters.*

7. *The procedure is the same, therefore 15 small squares are made.*

9. *Now to compare both sizes, a letter "n" is drawn with a 2 mm nib pen.*

10. *When the same letter is drawn with a 5 mm pen the lines are in proportion to each other.*

GUIDELINES FOR CLASSIC PROPORTIONS

The classic structure of the guidelines for writing is based on a page size with a 2:3 proportion, which is to say that between the letter and the upper and side margins there is a proportion based on two, and on the lower margin a base of three. The reason for leaving a wider margin at the base of the page is that the eye has a tendency to lower forms and this optical effect can be corrected by leaving more space below.

This proportion, which was used by many scribes, was used in medieval manuscripts, in the Renaissance, and even by Gutenberg in the design of his books. But it was the famous typographer Jan Tschichold who studied and theorized about it for the first time in his book, *The Form of the Book: Essays on the Morality of Good Design* (1955), and it was essential to establishing the basic principles of design for modern books.

To create the classic guidelines, begin with a sheet of paper with the proportion of 2:3, fold it in half, and draw diagonal lines all the way across it. To position the screen that will mark the text block, you must draw some horizontal lines at the same distance where they will cross the previously drawn diagonals, and the point where they cross will indicate where the block of text should begin.

Page with a flowery capital letter next to which is drawn very lightly, the guidelines whose module was calculated on a separate sheet of paper. You can see that more space was left in the bottom margin than at the top and sides, following the rules of classic proportions.

CREATING A MODERN COMPOSITION

Here is an exercise showing the creation of a more modern and free composition by the calligrapher Massimo Polello in a workshop he gave in Turin, Italy. The exercise is simple but very interesting, and it is shown here step by step. To begin, you dampen a sponge with paint of a pleasant color. Look at the blank

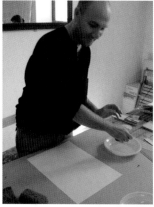

paper and decide where to create a streak with the sponge dampened with gold colored gouache. After visualizing where you wish to place the streak, begin to do it while squeezing the sponge and dragging it as you wish. In this case we have created a rectangular mark. Observe the paper with the mark again, and now locate the areas where the calligraphy will be placed. The text is written freely in any direction you wish, horizontally, vertically, and even diagonally. When the placement of the text is clear in your mind, you can draw the guidelines with a 0.5 mm lead, being aware of the module of the letter and size of the pen. After making the guidelines you can begin to write the calligraphy. The result will be a simple but beautiful exercise. Its objective is to learn to compose simple forms in space. This sponge technique can be used with any similar exercise.

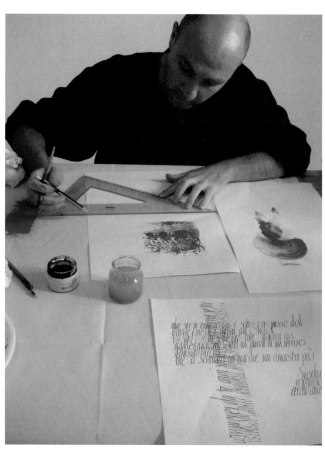

3. *The sponge conditions and helps create a composition at the same time. After looking for a while, a decision is made about placing the text.*

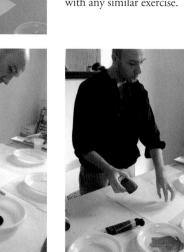

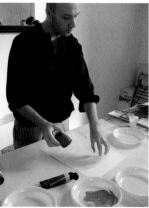

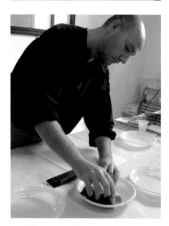

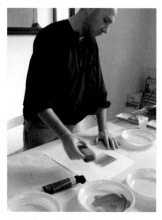

1. *The sponge is dampened in water and the acrylic or gouache paint is prepared on a flat surface like a plastic plate. Then the sponge is dampened in the paint.*

2. *Before making the mark, the paper should be carefully observed and thought put into the composition. After deciding, a mark or a streak is made with the sponge.*

4. *After placement has been decided, the guidelines are drawn very lightly to begin the calligraphy.*

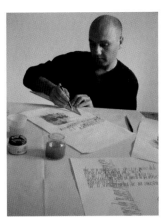

5. The paper is turned and the calligraphy is continued in another direction. This makes the text very dynamic.

6. If desired, you may draw more guidelines in other areas of the paper and write more text in other directions. The resulting work is very interesting.

This piece was made by Queralt Antú Serrano following the instructions of Massimo Polello. In this way a work of modern composition is created with few elements. It is a simple exercise but with very successful results.

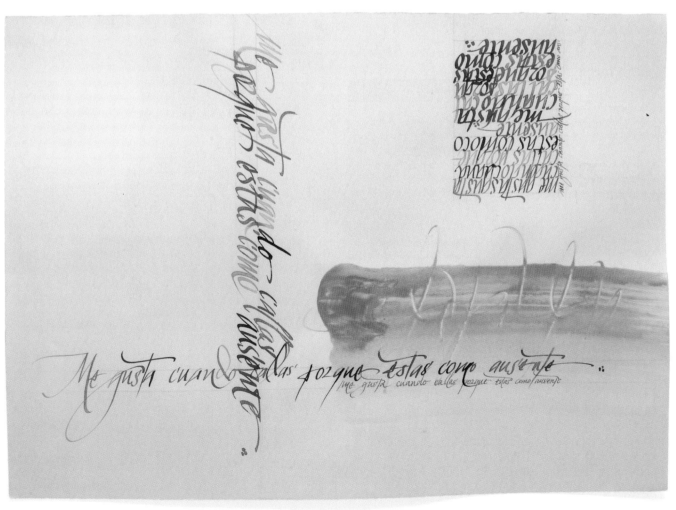

The Origins of the Alphabet

Our alphabet shows a beautiful and continuous evolution of the history of writing. By understanding the morphology of the letters we can begin to understand their origin. That is why in the following pages we will take a look at the different types of scripts so we can gain a basic understanding of their evolution.

PHOENICIAN SCRIPT

The Phoenician script was the precursor of the Hebrew and Greek scripts. The Phoenicians were merchants. As they traveled through many territories along the Mediterranean Sea, they even ventured out to the Atlantic Ocean along the African shore. This is how they spread their writing system, which was written on papyrus rolls that they called *biblion*, a word that means "book" and from which originated the word *Biblia* to refer to many books, and especially to sacred books. Despite all of that, not much is known about these people, because they either left very little written evidence about their culture or it was lost due to the instability of the writing supports they used: clay or papyrus.

Their writing system could almost be considered the first alphabet, although they cannot be called its creators but its precursors. Their original writing dates back to the year 2500 B.C. and it can be called "pseudo-hieroglyphic" because it is made of symbols that could be consonantal letters mixed with hieroglyphics of Egyptian influence, whose meaning is unknown. To delve into the Phoenician alphabet, we must travel back to the 11th century B.C., where we find evidence of an alphabet composed of 22 letters, all of which are consonants.

THE CLASSICAL GREEK ALPHABET

The first important colonizing effort in history is attributed to the Greek *polis* of the 8th century B.C., when they founded many cities along the entire Mediterranean coast. This presence was especially strong in southern Italy—the *Magna Grecia*, or Greater Greece. Among these colonies in the Magna Grecia, the one in Cumae, founded around the year 750 B.C., to the north of the present-day Naples, stands out. Its inhabitants belonged to the dialectal group of the western Greeks, with an alphabet similar to Ionic-Attic Greek, which would later become classical Greek.

An inscription with Phoenician alphabet letters carved in stone.

ORIGINAL PHOENICIAN	PHOENICIAN	ANCIENT GREEK	CLASSICAL GREEK

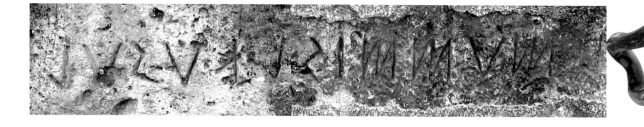

CHARACTERISTICS

The word *alphabet* comes from the Greek "alpha" and "beta," the first two letters of the alphabet. Greek evolved from the Phoenician alphabet and includes vowels, making it the first complete alphabet. It consists of 25 letters, three more than the Phoenician, plus five vowels:

Alpha (Aα) Epsilon-Eta (E ε) Iota (Iι) Omicron (O o) Epsilon (Y μ)

At the beginning, the direction for reading and writing was from right to left, but from the year 450 B.C. on, Greek inscriptions had already changed from left to right. They engraved, carved, and cut out the letters on stone, clay, metal, and wood; and they wrote on parchment paper, cloth, and papyrus using reed pens and ink, chisel, and sharp stones. They carved the most important inscriptions on wood and placed them high on very important public buildings, so they would be highly visible. They were the precursors of signs and also of newspaper headlines.

The exact date of the first alphabet is unknown, but it is estimated to be between the years 1100 and 800 B.C. The Etruscan and Latin alphabets developed into the Greek Ionic alphabet and, as an extension, all the modern European scripts.

The addition of the vowels to the Greek Ionic alphabet definitely changed the way people communicated, but the importance of the Greek culture goes beyond the alphabet: during the same period the first works of epic poetry, the *Iliad* and the *Odyssey* by Homer, were written, as well as the philosophical work by Plato compiling the dialogues of Socrates. Therefore, through Greek writings, we have received the foundation of western thought.

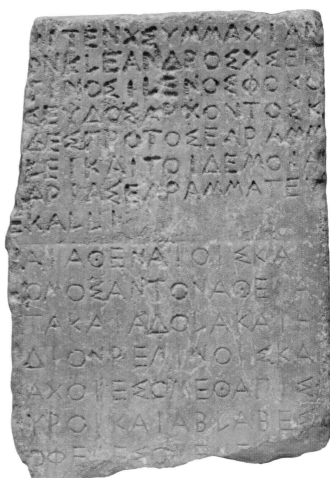

Stone inscribed with a treaty between Athens and the city of Rhegion in classical Greek, before 440 B.C., in the Elgin Collection exhibit, British Museum, London, England. Photo by Jastrow.

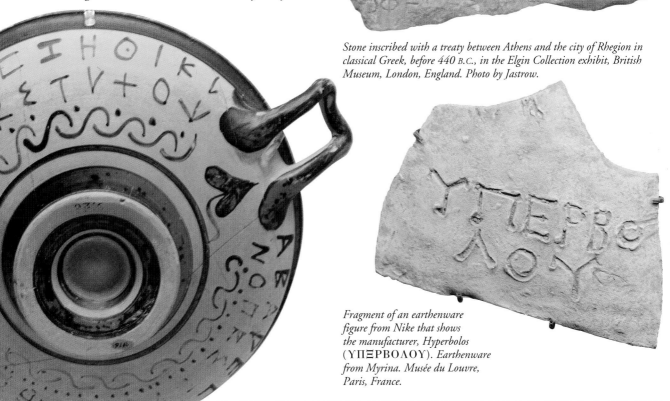

Ceramic bowl with the archaic Greek alphabet. National Archaeological Museum, Athens, Greece. Photo by Marsyas.

Fragment of an earthenware figure from Nike that shows the manufacturer, Hyperbolos (ΥΠΞΡΒΟΛΟΥ). Earthenware from Myrina. Musée du Louvre, Paris, France.

THE ETRUSCAN ALPHABET

The Etruscans lived in the center of the Italic Peninsula bordering Rome around the 7th century B.C.. At the height of their culture, their influence spread almost throughout the entire peninsula, ending in the year 350 B.C., when they were defeated by the Romans. It is probably because of the merchant spirit of the Etruscans that we find numerous artistic representations of Greek mythological figures, as well as great Greek influence reflected in Etruscan writings.

Transcription of the texts from the gold tablets of the Etruscan port city of Pyrgi. These are bilingual texts done in relief; the central and right panels are written in Etruscan, and the left one in Phoenician.

In the so-called "Perugia Stone," Etruscan inscription from the 3rd century B.C, we can clearly make out the letters of this alphabet. It records the agreement between the Velthina and the Afuna families regarding a piece of land that contains the tomb of the Velthina family. Archeological Museum, Perugia, Italy. Photo by Giovanni Dall'Orto.

CHARACTERISTICS

The Etruscans wrote from right to left and their alphabet had 26 symbols. The most surprising characteristic is that very little is still known about this language because it does not resemble any Indo-European language, despite being written with a known alphabet. No Etruscan literary manuscript has survived; we only have about 13,000 inscriptions in this language, a majority of which are nouns and epitaphs. The most extensive inscriptions are contracts and technical and religious texts. The most important ones are three gold tablets from 500 B.C. found in Pyrgi. The inscriptions are written in relief on gold in two languages: the center and right side writings are in Etruscan, and the left side is in Phoenician.

THE ROMAN OR LATIN ALPHABET

The Roman or Latin alphabet derives from the Greek Ionic and Etruscan alphabets and consists of 21 symbols. The influence of the Etruscan alphabet is especially felt in the origin of Latin and its alphabet; research shows that several Latin words were originally Etruscan, for example, *litterae* (writing), or *elementum* (wax, material of the support that they used for writing). During the 3rd century B.C., there was considerable contact between the Greek cities of Magna Grecia (in the south of Italy) resulting in a great number of words of Ionic influence—for example, *tyrannus, philosophus, chorus,* and *theatrum.*

LAPIDARY CAPITALS

Latin, the language of the Latin tribes, transcribed spoken sounds, which had a very novel and pragmatic effect on writing. The script of the 2nd century B.C. is called inscriptional or lapidary capital, a name that derives from its use in headstones or lapidaries (stone engravings).

The inscriptions made with lapidary capital or *quadrata* (square Roman capitals) were extremely homogenous. That is, all the letters were engraved in majuscule and they all had the same height following strict measurements and guidelines, which made them difficult to read. Other orthographic symbols like commas, question marks, and even the separation between words did not exist at the beginning, and were developed very slowly through time. These inscriptions were engraved on wood, chiseled on stone, or written on papyrus or parchment paper. The direction of the writing had a gradual variation; first it was from right to left, then it was alternated with left to right, but finally the latter prevailed. Its construction revolved around geometric shapes like squares, circles, and triangles, which is why they are so regular.

In this detail of the work Senator *by the calligrapher Massimo Polello, he used Monumentalis lapidary writing done with a brush in gouache over acrylic fabric, 13¾ × 25½ inches (35 × 65 cm). The rough texture of the support emphasizes the texture of the lines. The gouache used is not completely opaque, which makes it possible to see through the lines that make each letter and appreciate its* ductus.

LATER EVOLUTION

Roman capitals were the precursors of Western writing the way we know it today, and followed an evolution in form that began approximately in the 6th century B.C. with the Elegant or Square inscription, the Rustic lapidary inscription, then the Uncial, the Semi-Uncial, the Insular, the Carolingian, the Gothic, and the Humanistic. When the printing press was invented about 1436, certain calligraphies were adapted, like the Venetian and Blackletter, to movable type. Some time later these gave way to the creation of an exclusive typography, like the one developed by the French typographer Claude Garamond (c. 1480–1561). But this is outside of the scope of hand-written calligraphy, the subject of this book, even though the design of the printing press types was initially calligraphic in nature as well.

WRITING ON MONUMENTS

We have already mentioned that calligraphy was perfectly executed on lapidaries, which could be funerary or used to identify places. However, the most important ones were those found on monuments, carved with outstanding perfection that can still be enjoyed to this day.

One of the most beautiful examples of Roman script that has been preserved is Trajan's Column, which can be seen in the Roman Forum. This 98-foot (30 m) high column was erected to commemorate Trajan's victories against the Dacians (101–102 A.D.) and was inaugurated in the year 113 A.D. On the pedestal that forms the base there is an inscription carved in stone.

The translation of the text reads: "The Senate and the People of Rome to the Emperor Caesar Nerva Traianus Augustus Germanicus Dacicus, son of the divine Nerva, pontifex maximus, tribune for the seventeenth time, emperor for the sixth time, consul for the sixth time, father of the fatherland, to show the great height of the hills and the place now destroyed for [works] such as this."

COMMON SCRIPTS

The first preserved literary work in Latin is the *Odusia*, a translation in verse of Homer's *Odyssey*, by Livius Andronicus. This work dates back to the year 240 B.C. The most prominent Roman thinkers of the 1st century B.C. were Cicero and Virgil, who elevated the Latin language to its Golden Age. Writing during the Roman Empire was a privilege reserved for priests, lawyers, scholars, state employees, and merchants.

Detail of Trajan's Column located on one side of the Roman Forum. The shaft of the column shows the conquest of Dacia by Trajan. There is a commemorative inscription on its base.

SENATVS · POPVLVSQVE · ROMANVS
IMP · CAESARI · DIVI · NERVAE · F · NERVAE
TRAIANO · AVG · GERM · DACICO · PONTIF
MAXIMO · TRIB · POT · XVII · IMP · VI · COS · VI · P · P ·
AD · DECLARANDVM · QVANTAE · ALTITVDINIS
MONS · ET · LOCVS · TANT<...>IBVS · SIT · EGESTVS

Inscription located on the base of Trajan's Column, where the perfection of the capital lapidary or quadrata *script can be appreciated. Below is the transcription of the text.*

Lapidary, Elegant, and Rustic Capitals

This type of calligraphy was used between the 1st century B.C. and the 1st century A.D. During the first century of our era, Roman writing using capital lapidary went from being written exclusively with majuscules—all of the same height and perfectly aligned—to an elegant capital inscription, which is how it came to be known. Next we will review this evolution.

ELEGANT OR QUADRATA CAPITAL LAPIDARY

This type of script is not as homogeneous in terms of height compared to the classical Roman capital lapidary, because some of its letters are higher than others, like the "L" and the "F," to be able to tell them apart from the "I," while the "Q," on the other hand, becomes smaller, with an extension of the lower part that goes beyond the baseline. Another characteristic is the loss of the horizontal line (crossbar) of the letter "A."

It is believed that the great uniformity of the Roman Lapidary script triggered an evolution, and little by little the scribes began to create variations to improve its legibility. One of these variations was the increase of the size of the first letter of a paragraph, resulting in the creation of the Initial letters. Later, they began to decorate these majuscule letters with rich ornaments, which are still the hallmark of some calligraphers.

TOOLS AND SUPPORTS

The mural of *Terentius Neo and his wife* discovered in the Roman city of Pompeii, dating to 55–79 B.C., shows the tools that were used for writing at the time. She is holding a diptych (*diptycha*) of wax tablets in her left hand and the stylus in her right hand rests on her chin, while he is holding a rolled papyrus in his right hand.

Carved inscription in capital lapidary where the elegant descender of the letter "Q" can be seen clearly.

QUADRATA CAPITALS					
A *a*	B *b*	C *c*	D *d*	E *e*	F *f*
G *g*	H *h*	I *i*	J *j*	K *k*	L *l*
M *m*	N *n*	O *o*	P *p*	Q *q*	R *r*
S *s*	T *t*	V *u*	X *x*	Y *y*	Z *z*

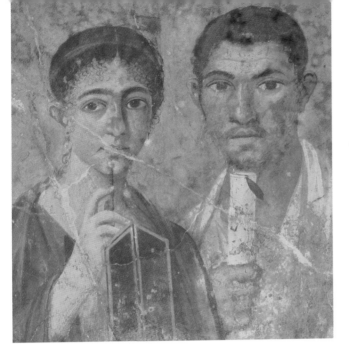

Terentius Neo and his wife. *Mural from the city of Pompeii showing the calligraphic implements commonly used by the Romans: the wax tablets with the stylus and the rolled papyrus. National Archeological Museum, Naples, Italy.*

RUSTIC LAPIDARY CAPITALS

This type of lettering was used between the 1st and 4th centuries A.D. During the first century a new form of capital script called "Rustic" (*Capitalis rustica*) emerged. These letters were less formal—and as a result easier to write—than the Elegant Capitals. This was due in general to the fact that a reed pen or a brush was used, whose tips are much more flexible than a hard chisel. Papyrus and parchment paper were also much easier to work on than stone. Despite that, numerous samples carved in stone have been preserved, which has made it possible to learn more about this less formal type of writing.

CHARACTERISTICS

This type of lettering can be easily recognized because it is narrower and longer. It continues to use majuscule letters exclusively. Only a few letters, like the "B," "F," and "L," surpass the height line, while the tail of the "Q" continues to descend past the baseline. Another element is made possible when writing with a reed pen on papyrus or parchment paper, and that is the difference between the mark and the stroke: the shapes become more rounded, and the straight lines and angles used in the elegant capitals—which were much more formal and precise—disappear little by little.

Reading these letters is not easy, because this type of calligraphy did not use interword spaces. Only in some cases a period was used to mark the end of a word. As with elegant capitals, initials were used—the letter at the beginning of a paragraph was bigger than the rest—to improve legibility.

This style of writing was the most common in the writings of the Roman Empire from the 1st century A.D. until medieval times.

RUSTIC CAPITALS

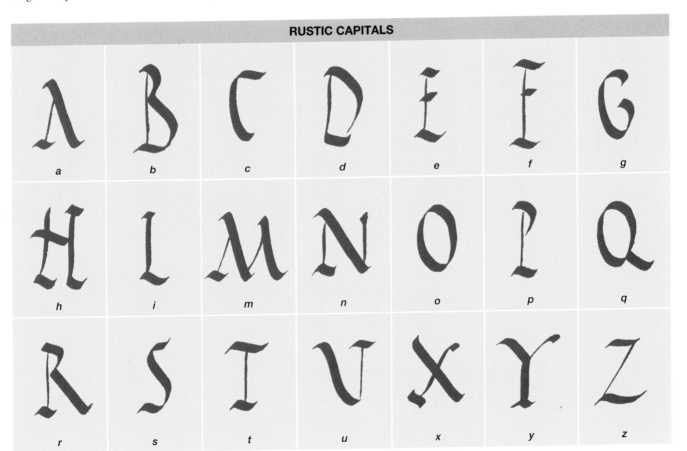

a b c d e f g

h i m n o p q

r s t u x y z

Roman Uncial Script

The Uncial script emerged in the 4th century and was used until the 8th century. It was differentiated by the use of majuscule and minuscule letters and also by the use of a few peculiar letters. The word *uncial*, which derives from the Latin *unciam*, meaning "ounce," is a measurement equivalent to the twelfth portion of a foot, which at that time was already a unit of measurement.

The emergence of this new script is very important because of its formal appearance. It consisted of groups of letters: the typical uncials (*A, D, E, M*), the minuscule letters (like *h, l, q*), whose lines are still rounder and more elegant than the rustic capital, and the majuscule, which are the rest. It is believed that their shape had an African influence.

Corpus Agrimensorum Romanorum, *manuscript from the 5th century, in Uncial script, uses red ink to mark the beginning of a paragraph.*

A quill was used for uncial script on papyrus, because this way the rounded lines were easier to make. The angles of the curvatures ranged from 0 to 30 degrees, which made it possible to tell the thick from the thin lines very well.

The baseline was surpassed by both ascenders and descenders, except for the Q, depending on whether the scribe practiced this in greater or lesser degree.

The first letter of the paragraph became increasingly more ornate, reaching the point of being represented with very creative animal and human figures. Three dots were used to mark the end of a paragraph, two over the baseline and one above, forming a pyramid (which looked like three diamonds when they were written with a quill).

Beginning in the 8th century A.D., the space between words was added (interword space), which improved the reading of the text greatly.

A 3 mm nib pen is used for uncial script. First the guidelines must be established for writing at a pen angle of 20° and a module of 5 nib widths for a 3 mm nib. Then the tools are properly set on the table and one can begin to write.

4TH CENTURY ROMAN UNCIAL SCRIPT

a	b	c	d	e	f
g					

h	*This letter did not exist* i	j	k	l	m
n					

o	p	q	r	s
t	u			

v	w	x	y
z			

THE "A"	THE "B"	THE "C"

Writing the "a" requires two *ductus*: first the diagonal stroke is drawn; then the eye of the letter is drawn by making two arcs in a continuous stroke.

The "b" consists of two *ductus*: the first one is the vertical line, which continues to the right ending in a point. Then the two arcs of the "b" are drawn with one stroke.

This letter is formed by two *ductus*. The "c" is written with a downstroke, followed by an upper arc drawn from left to right.

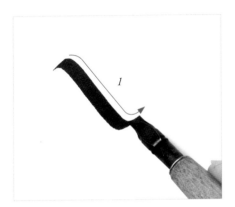
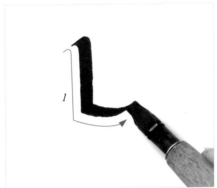
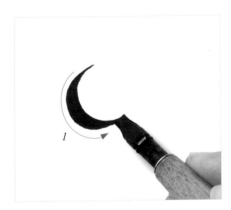

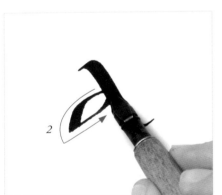
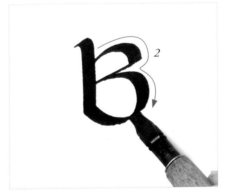
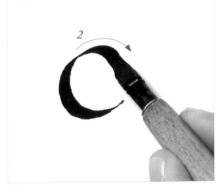

THE LATIN ALPHABET

THE "D"

Made up of two *ductus* like the "c," this letter is drawn with a single downstroke to create the belly of the letter, followed by an ascending line drawn with a rounded gesture.

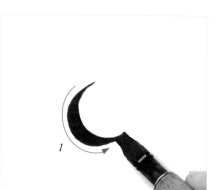

THE "E"

This vowel consists of three *ductus*. Like the "c," the arc of the "e" is drawn with a downstroke and an upper arc drawn from left to right, and then the crossbar is drawn with a slightly decorated end mimicking a rounded line.

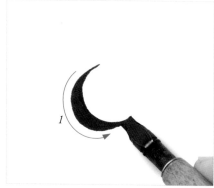

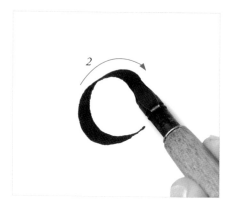

THE "G"

The "g" has three *ductus*. Also like the "c," the arc of the "g" is formed with a downstroke and a top arc drawn from left to right, to which the tail is added with a slightly curved descending line.

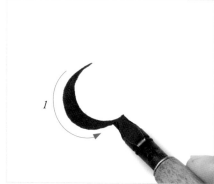

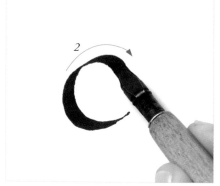

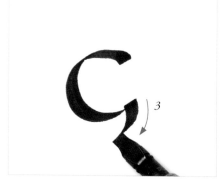

THE "M"

This letter consists of three *ductus*. You begin with a "c," which is drawn with a downstroke to create the first leg; then the second leg is drawn, followed by the third.

THE "N"

This letter is made up of three *ductus*. To begin, draw the vertical line, which will form the first leg of the letter, then a diagonal stroke, and finally the second leg, similar to a capital.

THE "O"

This consists of two *ductus*, and is written like the "c"; first a down stroke is laid out, and then the letter is closed with a second, curved, stroke. The shape is very rounded and even.

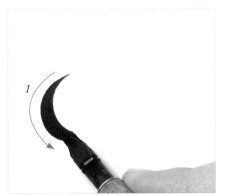

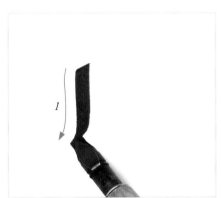

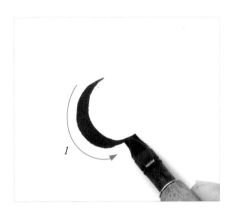

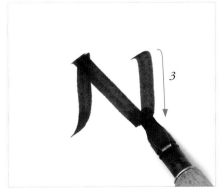

THE "Q"	THE "R"	THE "S"

The "q" has two *ductus*, which, like the "c," are created with a downstroke. The letter is closed with a lightly curved branching stroke.

The "r" is constructed with three *ductus*. First the vertical line is drawn with a downstroke, followed by the eye of the letter (slightly angled), and finally the diagonal line.

This letter consists of three *ductus*. First, the spine (a curved line) is drawn. Then, the lower curve is laid out from left to right and from top to bottom. Finally, the top hook is drawn from left to right.

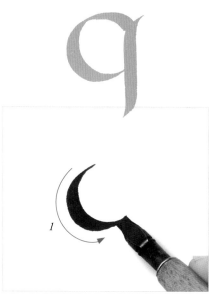

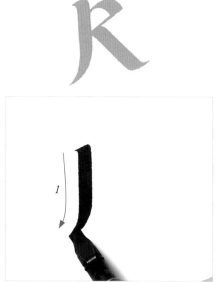

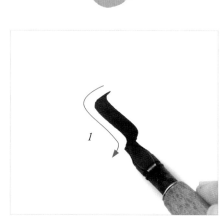

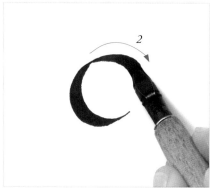

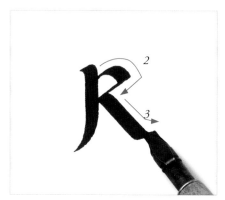

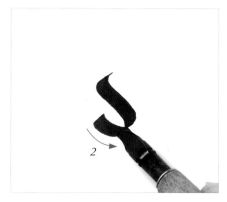

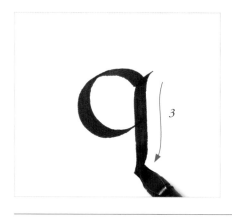

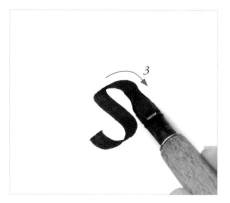

THE "Y"

This letter is composed of three *ductus*. First, the left diagonal is drawn, followed by the curving diagonal (together forming an irregular cross), and finally the vertical line or shaft is drawn. It can be decorated with a diamond shape on the upper part, centered on the cross.

THE "X"

Obviously, this letter consists of two *ductus* and has a very particular and characteristic shape. First, one diagonal is drawn, followed by the other, crossing at the center. The main point here is that the second line must be drawn upwards, from bottom to top.

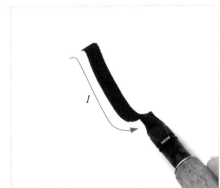

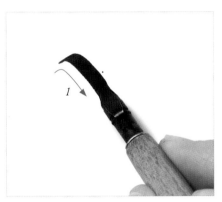

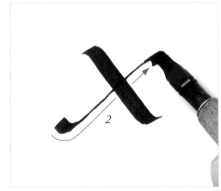

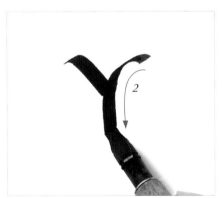

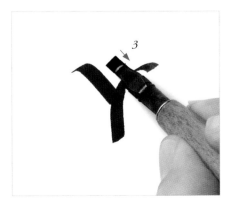

The work Handwritingpower *by Massimo Polello, shows the use of Uncial script in a contemporary piece. Created with pigments, ink, gouache, and collage on canvas. 13¾ × 39⅜ inches (35 × 100 cm).*

The Irish Half Uncial

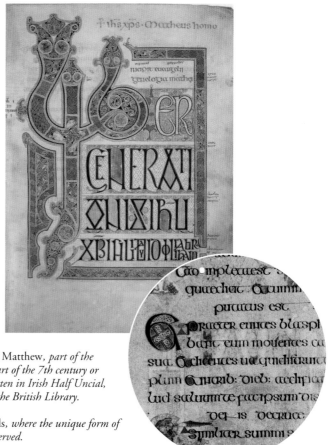

This is a type of vertical writing that was used between the 4th and 10th centuries. It consists of miniscule uncial letters where at least four non-uncial elements can be found. The shapes of the letters "f," "g," and "z" are particularly noteworthy; they are very different from those of earlier and later alphabets. This script comes from Ireland and esthetically is closely related to the Celtic culture.

WRITING MODEL

To write the late half uncial script, a 3 mm nib pen is needed. First, a template or guideline must be drawn for that particular script with pen angles of 20 and 5°, and a nib width of four 3 mm nibs. Proceed by placing the implements on the table and writing. When starting the guideline, it is important to keep in mind that in this type of script the vertical lines are drawn with three strokes; the ends are wider than the central parts.

Beginning page of the Gospel of Saint Matthew, *part of the* Lindisfarne Gospel, *from the latter part of the 7th century or beginning of the 8th. This book is written in Irish Half Uncial, also known as Insular. It is housed in the British Library.*

Detail of a page from the Book of Kells, *where the unique form of the Irish Half Uncial script can be observed.*

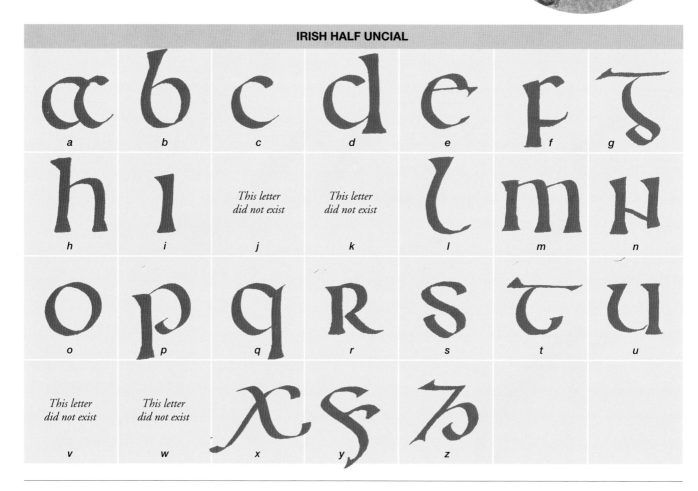

IRISH HALF UNCIAL

a	b	c	d	e	f	g
h	i	*This letter did not exist* j	*This letter did not exist* k	l	m	n
o	p	q	r	s	t	u
This letter did not exist v	*This letter did not exist* w	x	y	z		

THE "A"	THE "B"	THE "D"

It consists of four *ductus*. First, the ring of the "a" is drawn with two rounded strokes followed by a branching stroke (also rounded), and to close the letter, an ear is drawn from left to right.

The letter "b" is made of three *ductus*. First, the vertical stroke is drawn; then, before closing the eye of the letter, a small stroke or decorative serif is added.

The "d" consists of six *ductus*. First the ring of the "d" is drawn, followed by the downstroke or central line. Finally, the small decorative serifs are added at the ends of the shaft.

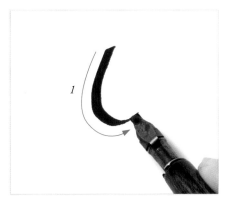

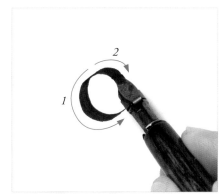

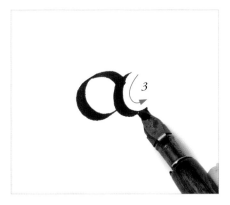

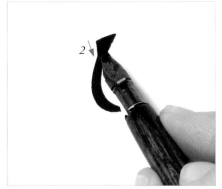

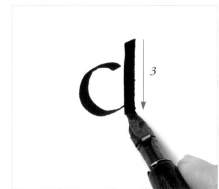

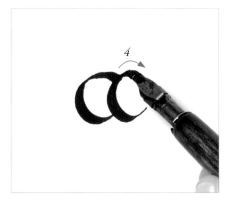

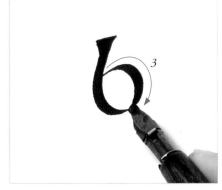

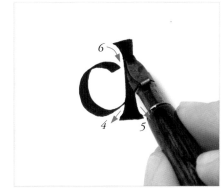

THE "E"

The second vowel is made of three *ductus*. First, the right side of the "e" is drawn with two strokes, then the horizontal or crossbar is added. Finally, a small stroke is added to create a serif as decoration.

THE "N"

It has a very characteristic shape similar to a capital, and it consists of six *ductus*. First, the vertical decorated downstroke is drawn, followed by the crossbar, and to finish, the vertical shaft forms the right leg of the "n," decorated by a serif at its top.

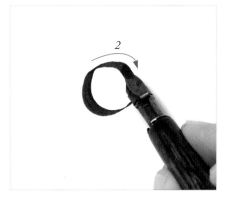

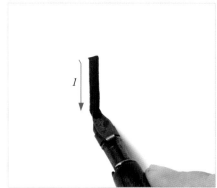

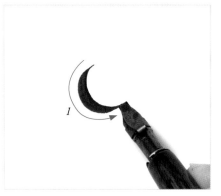

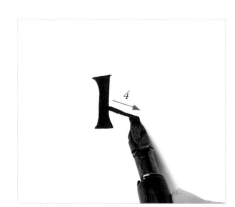

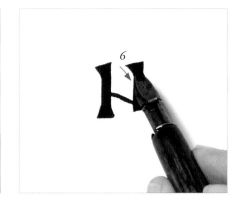

THE "G"

The "g" has a shape consisting of three *ductus*. First, the central shaft is drawn, which is slightly curved; then another curved stroke closes the central shaft; and finally, the crossbar, decorated at the ends, is added.

THE "Z"

This letter has a peculiar shape formed by four *ductus*. First, the upper horizontal bar is made, which is slightly decorated at the tip; this is followed by a diagonal stroke drawn from top to bottom and from right

to left. Then, a curved line is drawn in two strokes, followed by a crossbar. The last one is a curved stroke that is completed with a second one from left to right.

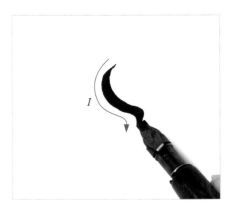

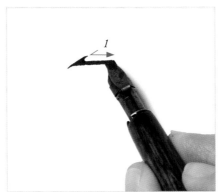

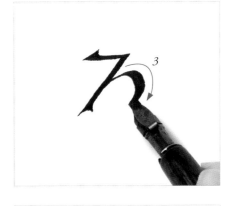

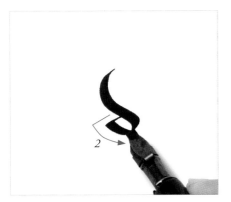

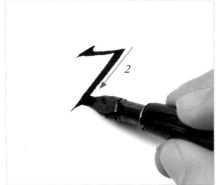

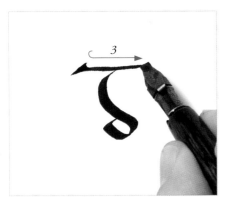

The Carolingian Script

Carolingian is a rounded minuscule script that was mainly used between the 8th and 12th centuries. Its shapes are rounded and regular and are created by writing with a goose quill cut with a right slant, instead of the previous horizontal straight cut.

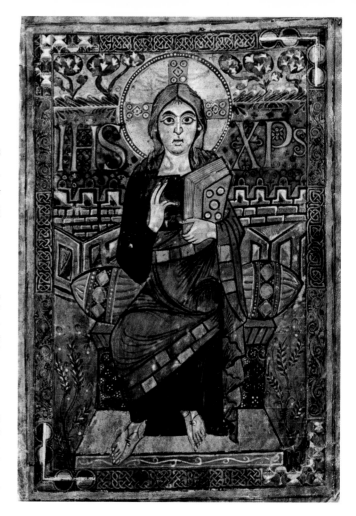

Miniature of Christ from the Godescalc Gospel, executed by Charlemagne's master calligrapher in the years 781–783. National Library, Paris, France.

ORIGINS AND EXPANSION

Derived from the half uncial script, the Carolingian emerged in France in the 7th century, which is why it is sometimes called the *French script*. Towards the year 800, when Charlemagne was crowned emperor, aided by Alcuin of York, abbot of Saint Martin of Tours, a proposal was made to reunify the different writing styles that existed in his empire at the time and to create a new type of script. The result was the *Carolingian minuscule*.

Charlemagne promoted this script very vigorously, and it spread rapidly through the territories that constitute today's France (replacing the *Merovingian* script), Germany, and Italy (replacing the *Longobardus*),

CLASSICAL CAROLINGIAN ALPHABET

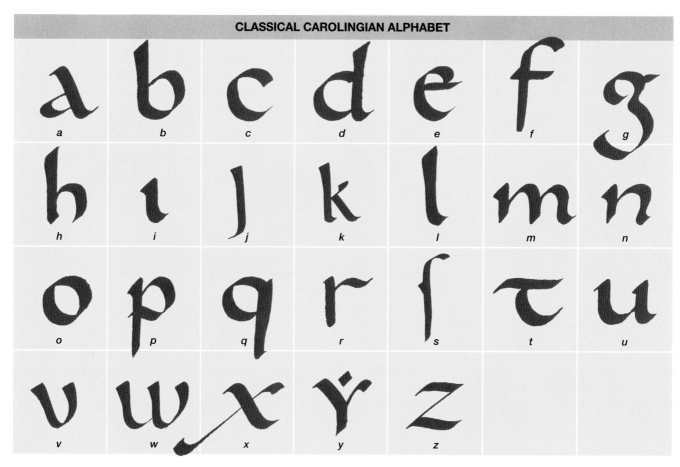

THE EMPEROR'S SIGNATURE

To sign his documents, Charlemagne used a monogram (he was the first one to do this) in the shape of a cross, inspired by the stamps used at the time. Since he did not know how to write, the Emperor drew the diamond shape and the scribe did the rest.

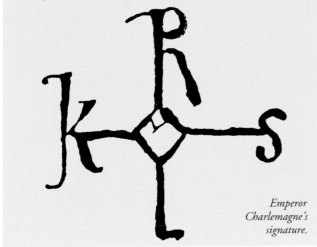

Emperor Charlemagne's signature.

CHARACTERISTICS OF THE CAROLINGIAN

Visually, the Carolingian letters are known for not being angular and for their rounded shapes—especially their profiles, because of the absence of branching lines—and for having almost no connectors. They are also known for the homogeneity in the height of the letters and the progressive use of abbreviations (very common in Gothic script).

One of the most important works of the 8th century was the *Godescalc Gospel*, a 127-page illuminated manuscript on parchment paper, commissioned by Charlemagne to commemorate the baptism and coronation of his son Pepin, between the years 781 and 783. This manuscript contains six miniature figures; the first four are the Evangelists (this iconographic representation composed of four elements is known as a *tetramorph* from the Greek τετρα, tetra meaning *"four,"* and μορφη, morph, *"form"*), the fifth figure was a representa-

tion of Christ on a throne; and the sixth image was a fountain of life that has a sense of volume and depth because of the letters, which were written in gold and silver ink.

LATE CAROLINGIAN SCRIPT OF THE 10TH CENTURY

For the late Carolingian letters a 3 mm nib pen is needed. As usual, it is important to lay out the template or guideline, which in this case is at a 30° pen angle and a width of four 3 mm nibs. After placing the tools on the table properly, one can proceed with the writing.

gaining wide acceptance that made it the most relevant writing style of that period. In the Iberian Peninsula, the Carolingian script first spread through present-day Catalonia (9th century) and later, in the 11th century, to the rest of the peninsula, replacing the *Visigoth* script. From the 12th century on, the Carolingian script became more angular, and, beginning in the 13th century, it was displaced by the *Gothic* script.

LATE CAROLINGIAN ALPHABET

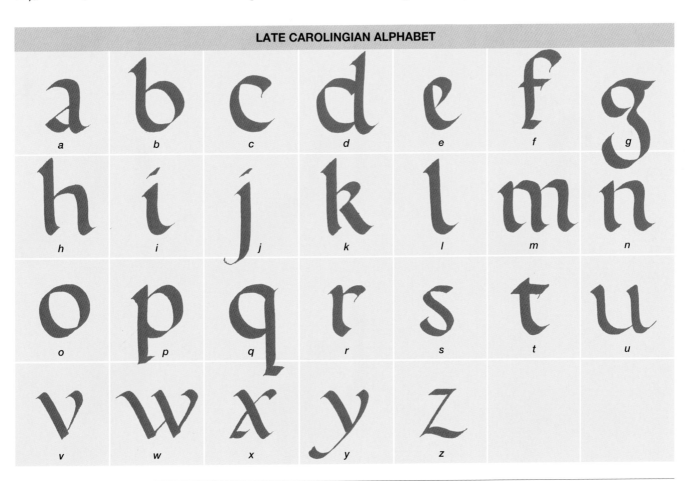

THE "A"

It consists of two *ductus*. It is important to follow the correct order. The vertical lines should not be drawn from bottom to top, or the horizontal ones from right to left.

THE "B"

This is made of three *ductus* created by a downstroke, followed by the closing of the letter, with a rounded line plus a finish. It has a very rounded and regular shape.

THE "N"

It consists of three *ductus*. First, the first leg for the "n" is drawn, then the arch that leads to the other leg, and finally a small serif stroke.

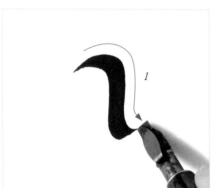

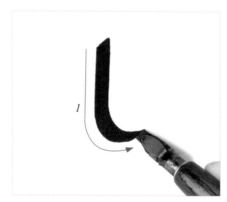

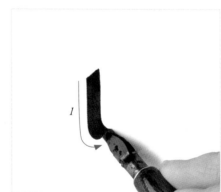

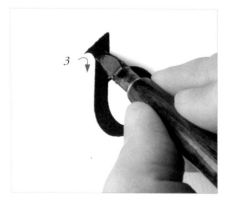

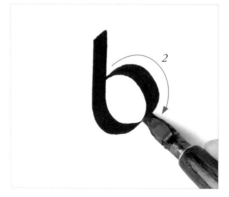

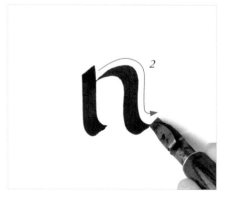

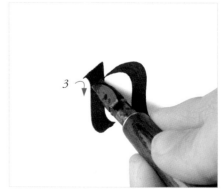

THE "F"

This letter, simple in appearance, has four *ductus*. First, the shaft is written with a decorative serif at the end, followed by the arch, to which a small flourish can be added. To draw it, you can either lift the edge of the nib pen to make a thinner line or use a very thin nib pen. Finally, the horizontal shaft is added. To achieve greater harmony, the latter should not be drawn right in the middle but a little bit higher than the center of the vertical shaft. The crossbar can also be decorated with a small flourish.

THE "G"

The rounded "g" consists of four *ductus* beginning with the eye of the letter, which is drawn in two strokes. Then the curl is closed with another curved line from left to right; and finally, a small serif is added from left to right.

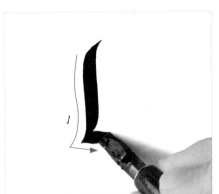

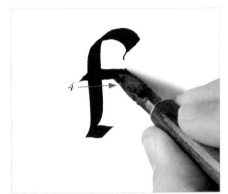

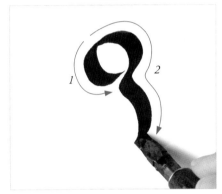

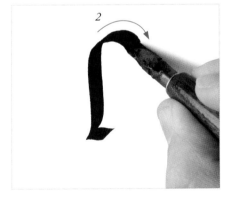

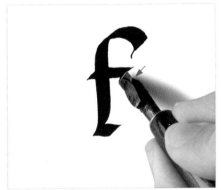

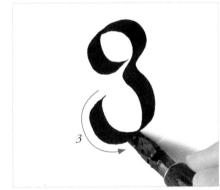

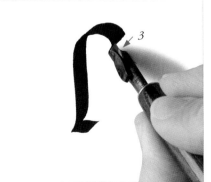

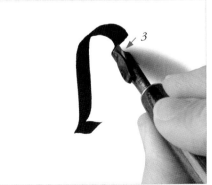

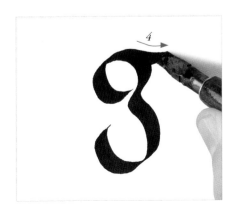

Gothic Script

Beginning in the 12th century, the Carolingian script was displaced by a new style that directly evolved from it: the early Gothic, a script that later evolved into the square Gothic in northern Europe, and the round Gothic in the southern countries. It peaked in the *Quattrocento* with Bastard Gothic, which has very characteristic ornate motifs. This evolution took place from the 12th to the 16th centuries. In the following pages we will see the different variations.

THE EVOLUTION OF SOCIETY

Gothic script emerged in a historic context during many sociocultural changes. Schools and universities were being built in the cities. Society, especially in the cities, was starting to rise against the feudal powers and their rules. Writing, and the culture that extended from it, was not relegated to the monastic scribes but was being transferred instead to the universities, where religious and lay people studied together. Commerce also promoted the formalization of contracts, laws, and treaties, which required more widespread use and knowledge of writing.

THE EVOLUTION OF LETTERS

The letter type that was now needed had to be more condensed to save paper, which was a support that continued to be expensive.

We can see that the ascending and descending strokes were shortened considerably and that the interletter space was reduced. This new script had to be more solemn, more rigid and elegant, and consequently the drawing of its characters became harder and more angular.

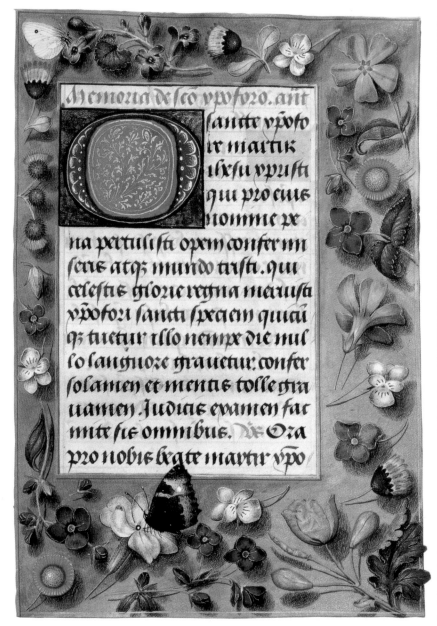

Page of the first printed edition of the Bible (1449) by Johannes Gutenberg. Here we can see that the German inventor used the Gothic Texture script on which to base his movable printing type.

Page of a 1470 Book of Hours, a medieval devotional book, written in Gothic calligraphy.

CLASSIFICATION OF GOTHIC LETTERS

There were many Gothic variations, but one common characteristic to all of them was the regularity and rigidity of the shapes of the letters. In general, they could be classified into the following three styles.

GOTHIC TEXTURE OR LIBRARY

Gothic Texture began to appear in the 13th century and, as its name implies, was used in luxurious books because it was very formal. It has a characteristic vertical stroke and very square and rigid angles. The ascender and descender lines were shortened, and this made these letters more difficult to read. It was hard to tell the "c" and the "y" apart from each other, and the letters "u" and "n" look quite similar. Also, the capital letters were adapted to this formal rigid system. These are the letters that Gutenberg used to create the movable printing type for the first printed edition of the Bible in 1449.

GOTHIC ROUNDED OR ROTUNDA

This type of script has greater resemblance to the Carolingian because it is more condensed and has greater interletter spacing than Gothic Library, which makes this writing easier to read. It was more popular than Gothic Library, which was reserved for luxurious books and was used mainly in Spain and Italy. One of the most important books written in Gothic Rotunda is the *Cantar de Mío Cid* (1307), copied by Per Abat. The original is housed in the National Library of Spain in Madrid.

GOTHIC *FRAKTUR*

As its name indicates, this script has a "broken" quality to it and incorporates a combination of straight lines and rounded shapes, especially in the capitals, which are heavily adorned with flourishes.

This type was used to write the ideas of Luther and Lutheranism in the early 1500s in contrast with the Humanist script used in Catholic countries like Spain and Italy. Therefore it became the national script of Germany until well into the 20th century, when Hitler banned its use by decree in 1941 because he thought that it bore resemblance to Hebrew letters, and therefore it was believed to have been created by a Jew. Despite that, the Gothic script continues to be associated with Germany and is used in certain signs and printed material to this day.

Page from the Cantar de Mío Cid, *showing a capital letter at the beginning of a paragraph. The manuscript is located in the National Library, Madrid, Spain.*

GOTHIC TEXTURE SCRIPT OF THE 14TH CENTURY

A nib pen is needed to write the Gothic Texture script of the 14th century. A guideline is needed before beginning to write, with a 45° pen angle and 5 nib widths for a 3 mm nib. In the following pages we will illustrate how to write the most significant minuscule letters using the required *ductus*.

GOTHIC TEXTURE FROM THE 14TH CENTURY

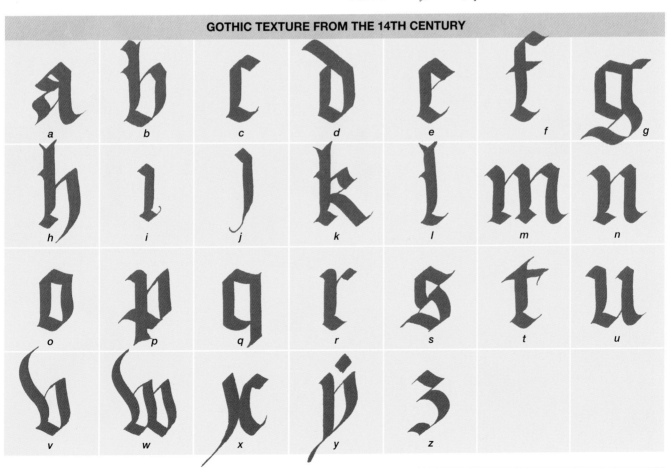

a b c d e f g
h i j k l m n
o p q r s t u
v w x y z

THE "A"

This vowel consists of four *ductus*, and because of its difficulty it is very important to follow the order as shown. The first stroke is a vertical line that begins slanted and ends with a curve. This is followed by a thin diagonal that becomes wider on the right side before connecting with the vertical line. Then the lower ring of the letter is drawn. It is important to make a sinuous rounded stroke. Finally, the ring is closed with a thin branching stroke that connects with the previous line.

THE "F"

The "f" requires three *ductus*. First, the vertical line is drawn with a down stroke and an ending serif. Then the arch of the "f" is drawn, which should not be as rounded as in other styles. Finally, the crossbar is added, which should not be located exactly in the middle but a little higher than the center of the shaft.

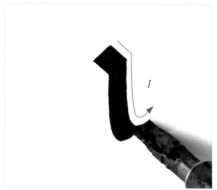

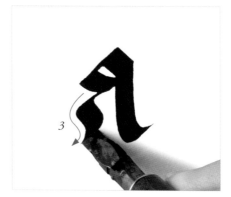

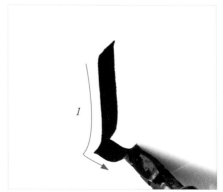

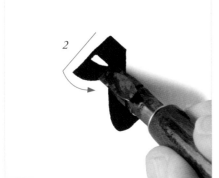

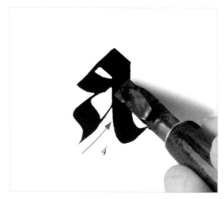

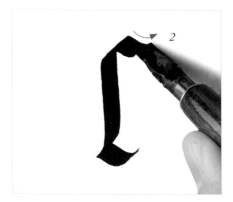

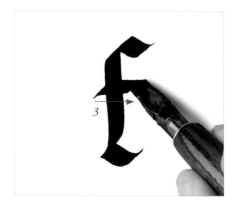

THE "G"

This letter is made of five *ductus*. First, the eye of the "g" is drawn with two strokes: the first one is a vertical shaft, and the second is completed with a left-to-right stroke, which continues downwards, forming the neck and part of the curl of the "g."

Next, the curl is closed with a rounded stroke from left to right, and finally the ear of the letter is added, which is a small line drawn from left to right. A thin line is added as a decorative motif to link the tail with the curl of the eye.

THE "H"

This consists of two *ductus*. First, the vertical downstroke is made with a serif at the end. Then, the second line is added, which forms the arch and the leg of the "h"; the ending is thinner and more curved. A few ending lines can be added as decorative motifs.

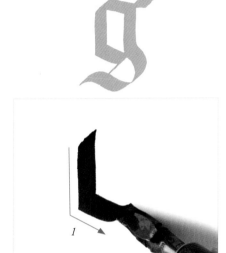

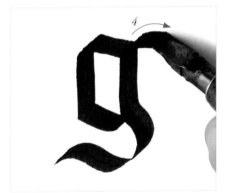

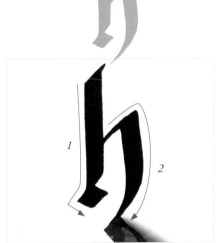

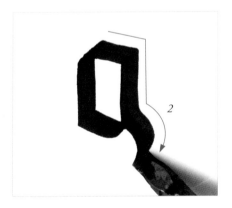

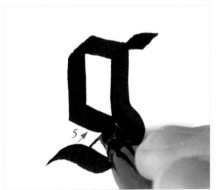

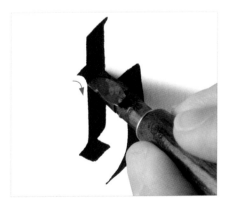

THE "O"

This vowel has two *ductus*. Two strokes are needed to make the eye of the letter: first the one on the left, followed by the one on the right, which closes the shape.

THE "V"

This letter consists of three *ductus* beginning with the main vertical shaft, which in this type of script is very wavy. This is followed by a diagonal branching line. Finally the vertical line is added to close the letter.

THE "Z"

This consonant has four *ductus*. First, the diagonal or branching line is drawn. Then, a fine line that will give the "z" its diagonal orientation is added, followed by a curved stroke that will define the neck. Finally, the other lower diagonal line is added.

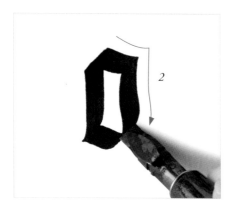

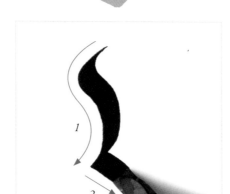

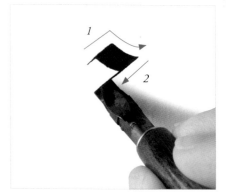

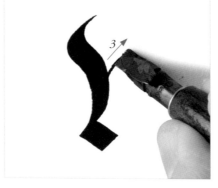

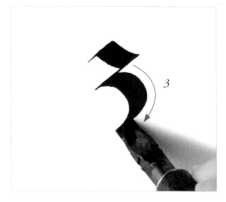

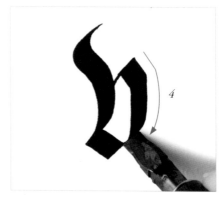

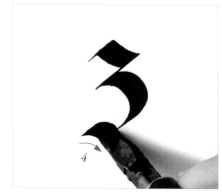

THE GOTHIC TEXTURE MAJUSCULE SCRIPT OF THE 14TH CENTURY

A nib pen is required to write the Gothic Texture majuscule script of the 14th century. First a guide is laid out with a 45° pen angle and a 6½ nib width for a 3 mm nib. Writing the majuscule letters is more involved than the minuscule because, as can be seen below, they are more ornate. Although they are more sophisticated, they are harder to read. Next, we are going to illustrate the most outstanding letters with their required *ductus*, as well as the entire alphabet.

THE "G"

This letter consists of six *ductus*. First, the ring is drawn. Then, the other curved stroke on the upper part is added, followed by the belly of the "G," as well as the two diagonal shafts on the upper side. And, as a decorative motif, a thin line that crosses the letter vertically is added.

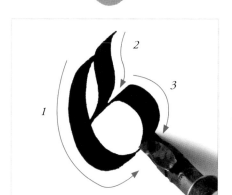

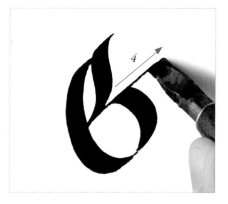

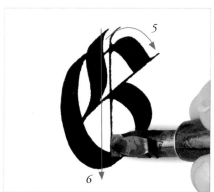

GOTHIC TEXTURE MAJUSCULE LETTERS OF THE 14TH CENTURY

a	b	c	d	e
f	g	h	i	j
k	l	m	n	o
p	q	r	s	t
u	v	w	x	y
z				

THE "K"

The writing of the letter "K" requires eight *ductus*. The first one is a vertical downstroke, followed by one diagonal line drawn from top to bottom, a second one from right to left and top to bottom to create the eye of the letter. Then the stroke for the leg is added. The top hook is next. A smaller vertical parallel line is also added alongside the main shaft as a decorative motif, and then it is finished with a small decorative serif. Finally, a closing line finishes the letter.

THE "Q"

This letter is very different from the previous ones and it also requires seven *ductus* to write it. First, the eye of the letter is laid out by drawing a vertical downstroke

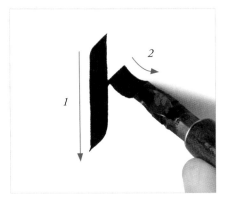
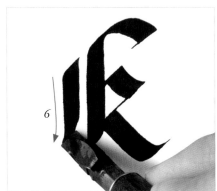
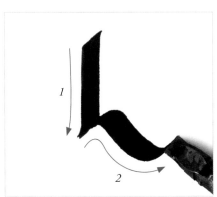

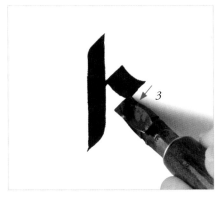
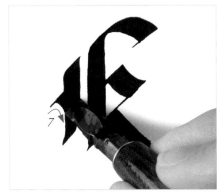
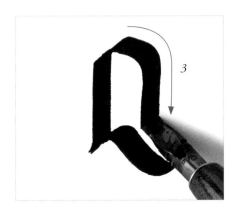

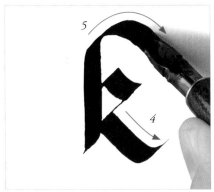
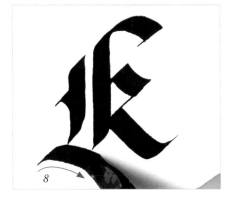
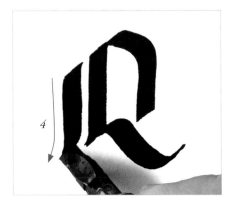

THE "T"

followed by a horizontal curved line, like a stylized reclining "s." The third *ductus* begins at the same point as the first one and closes the eye of the letter on the right side. The upper curve is drawn with a single stroke, which continues as a straight line. Then, a decorative vertical line is added to the left, parallel to the first *ductus*, at which point a decorative finish is added. Finally, with two strokes a parallel motif is added to the tail, which is linked to the second *ductus* with a thin line.

This letter requires eight *ductus* beginning with the vertical main line of the letter, which in this case is a curved stroke. This is followed by a thin diagonal ascending stroke and by a vertical line. We continue with a line that initiates the crossbar, which will continue with a horizontal line that crosses the central shaft. Finally, the end of the crossbar can be decorated with a very thin line.

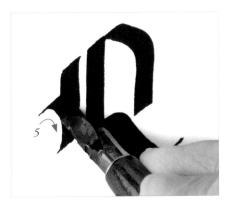

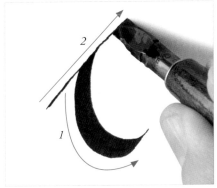

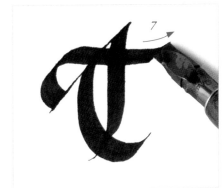

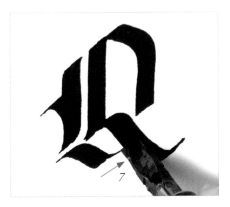

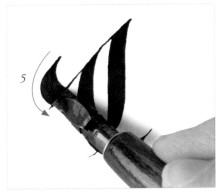

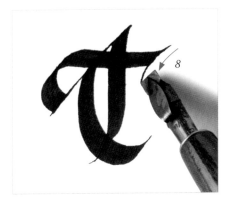

THE "R"

In the case of the "R," eight *ductus* are required as well, beginning with the vertical downstroke or main line of the letter. This is followed by a diagonal line, which is drawn thin first from bottom to top and then thick from top to bottom, and at the end with another thin line from right to left. It is important for the eye of the letter to have a thickness similar to the thick stroke, because the leg of the letter begins where the eye ends. Then, a vertical line is added as a decorative motif parallel to the main line of the letter, which is capped with a small line. Finally, the letter is completed with a finishing line.

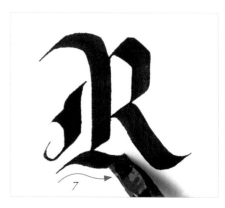

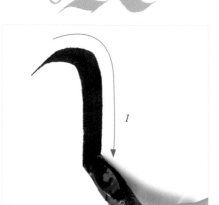

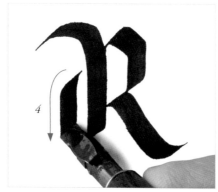

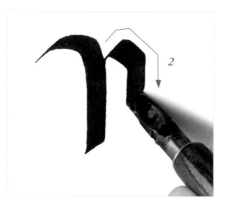

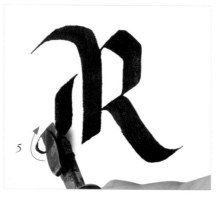

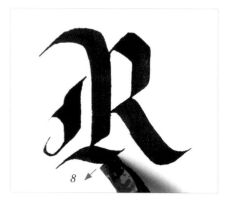

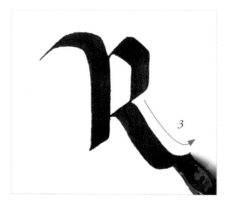

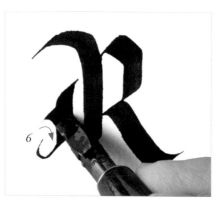

THE LATIN ALPHABET

GOTHIC TEXTURE SCRIPT OF THE 15TH CENTURY

The Gothic Texture of the 15th century requires the use of a nib pen. To begin, a guide is made for a 45° pen angle and 5 nib widths for a 3 mm nib. Illustrated below are four examples of the way the most common strokes are drawn as a model of how to write the remaining letters of this style.

THE "A"

The first vowel requires five *ductus*. The first stroke is a diagonal line that is linked with the vertical line of the "a," followed by a closing line at the end of it. This is followed by the ring, to which a small line is added to make the upper part thicker; it is simply a decorative motif but very important. Finally, the letter is closed with a very thin ascender line that connects with the previous stroke.

GOTHIC TEXTURE OF THE 15TH CENTURY

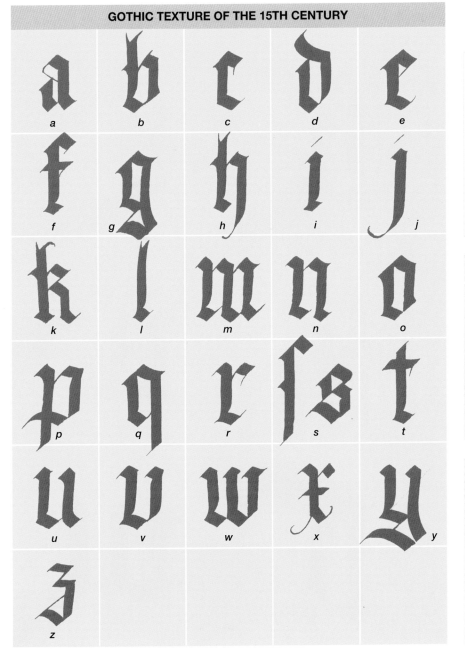

a b c d e
f g h i j
k l m n o
p q r s t
u v w x y
z

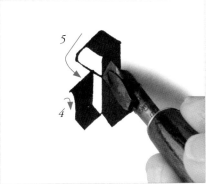

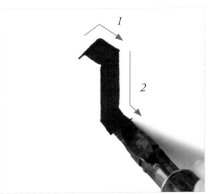

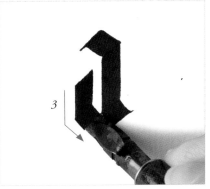

THE "B"

The "B" requires eight *ductus*. First, the ascender is drawn with the upper end thinner than the rest of the line and with a finishing line at the end of it. Then, the ring is made from left to right with a series of strokes, but with angular edges. Finally, the small decorative lines are added.

THE "W"

The "W" consists of five *ductus*. First, the vertical line is drawn with a small finish at the end with a left-to-right stroke, then the same initial line is added to the right of the latter and at a distance that is equivalent to the width of the initial line. Then, the vertical shaft that closes the letter is drawn the same way.

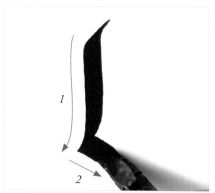

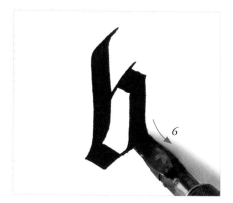

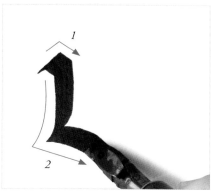

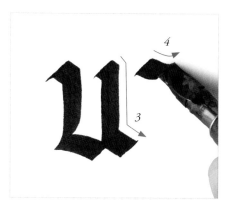

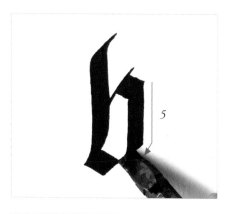

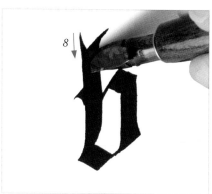

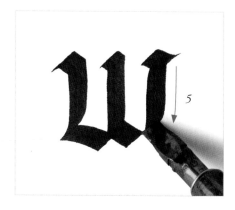

THE "X"

This letter, despite having a simple appearance, consists of nine *ductus*. First, it has a diagonal line that ends in a left-sided point, then this point is completed with a thin finishing line. On the upper part of the vertical line a thin line is drawn facing right, which later forms a wide-line ear. On the lower right, the bottom leg is added, which ends on a thin ascender line. The letter is finished with a horizontal diagonal from left to right. Then an ear is drawn from left to right and a crossbar. Finally, a flourished curve closes the letter.

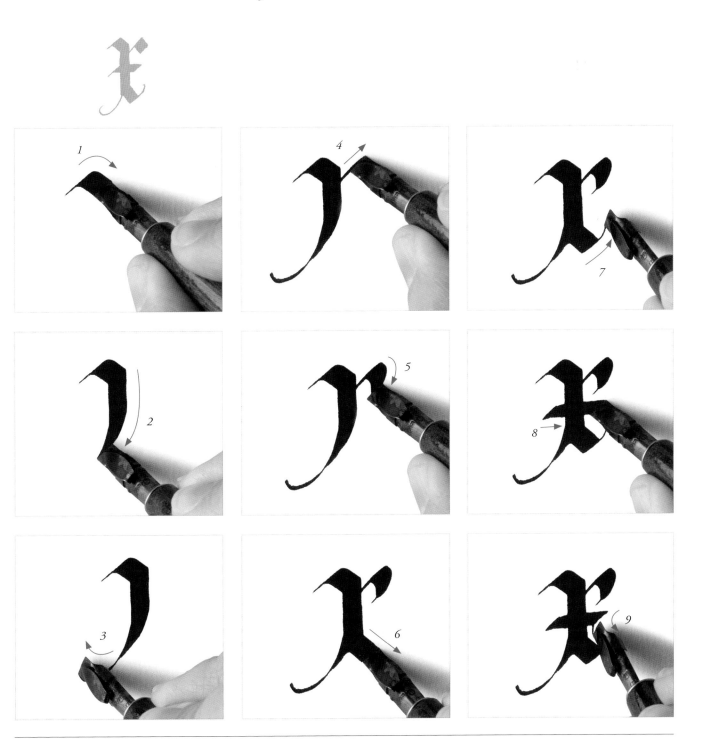

GOTHIC *FRAKTUR* SCRIPT FROM THE 16TH CENTURY

A nib pen is required to write the Gothic *Fraktur* from the 16th century. As usual, first a guide is laid out for a 45° pen angle and 5½ nib widths for a 3 mm nib. The execution of significant minuscule letters from this Gothic script variety will be illustrated, which will serve as a model for drawing the remaining ones.

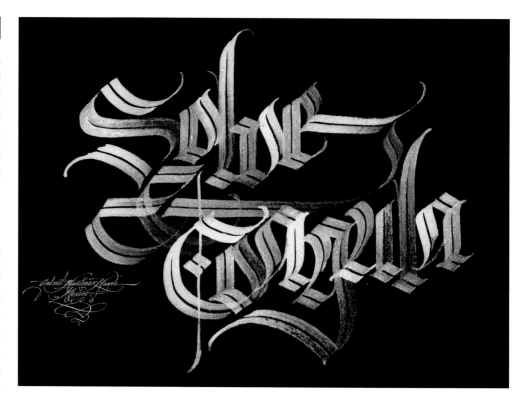

In the book Solve & Coagula, *the calligrapher Gabriel Martínez Meave from Mexico City wrote this alchemist's slogan with Gothic script in white and red ink on black canvas. The ink was applied with a piece of thin cardboard, which created a very interesting texture with transparencies. The signature was executed with a thin and flexible nib.*

GOTHIC *FRAKTUR* FROM THE 16TH CENTURY

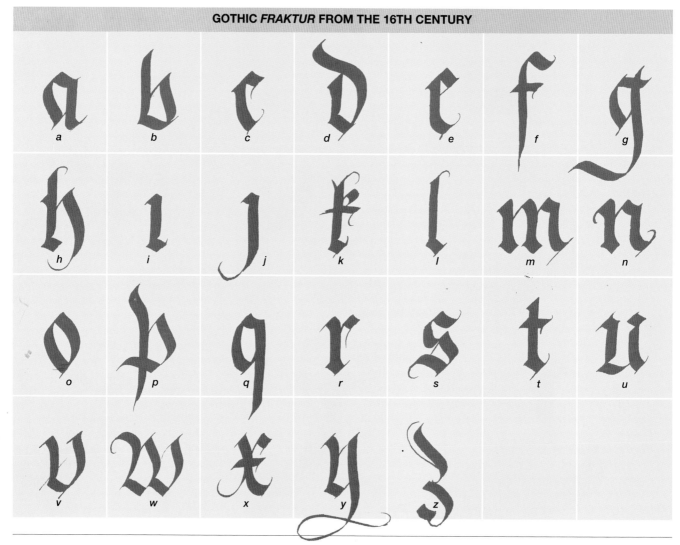

THE "A"

The first vowel consists of five *ductus*. The first stroke is a diagonal line that connects with the vertical line of the "a," to which an ear is added. The writing continues with the formation of the ring, to which a small serif is added on the upper part; this is just decorative, but it is very important. Finally, the letter is closed with a very thin ascending line that links with the previous line.

THE "D"

The "D" requires four *ductus*. First, the ascending vertical line of the letter is drawn, having the upper part thinner than the rest of the line and with a finish at the end of it. Then, the ring is drawn from left to right; finally, small decorative lines are added.

THE "F"

The "F" consists of five *ductus* as well. First, the vertical line is drawn with the end gradually thinner. Then, the lightly rounded arch of the "f" is added, which is a line from left to right with a decorative curl at the end; and finally the crossbar, which should not be drawn right in the center of the vertical line but somewhat higher for greater harmony, should also be decorated.

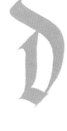

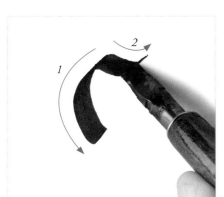

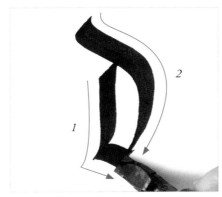

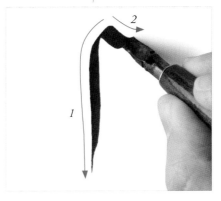

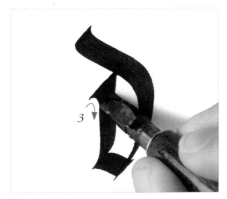

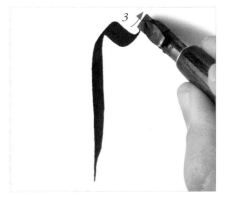

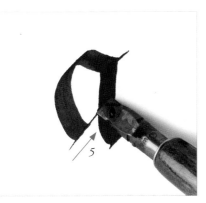

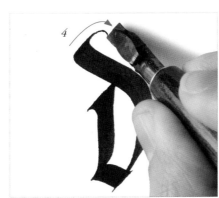

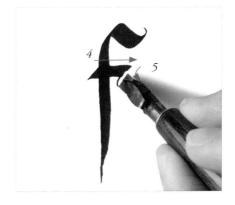

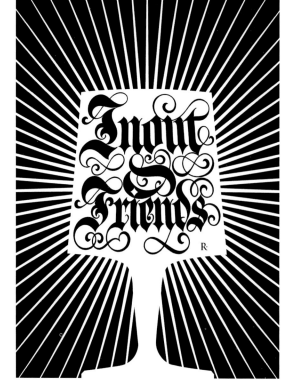

Calligraphy by Ricardo Rousselot entitled Lámpara InOut. *This is a promotional piece for the InOut lamp created by Ramón Úbeda and Otto Canalda for Metalarte. For this piece, the author has chosen a very ornate Gothic script and has used only one color of ink: black. The result looks very modern and has great visual impact.*

THE "H"

The "H" consists of six *ductus*. We begin with the vertical line to which a small finish is added on the lower end. This is followed by the second thin line, which will become the upper part of the arch; and at the end, the leg of the "h." A few little lines can be added to the vertical line as decorative finishes.

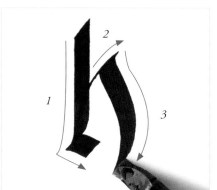

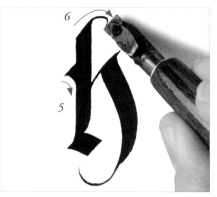

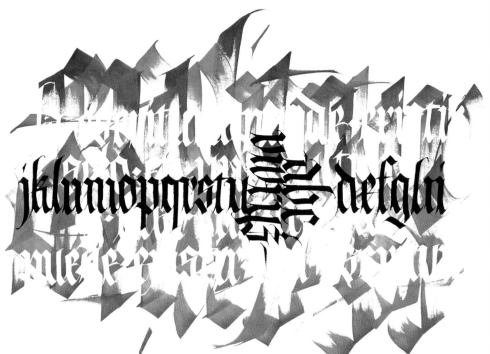

Calligraphy by María Eugenia Roballos entitled Consequences. *It was created with tempera colors and masking fluid on 50 percent cotton Fabriano paper measuring 27½ × 39⅜ inches (70 × 100 cm). The artist used an automatic pen and an experimental instrument. Since the work pays homage to the alphabet, she used Gothic Texture script for the background and for the letters, displaying both their positive and negative forms. The text reads: "Writing can only exist in a culture and culture cannot exist without writing." I. J. Gelb.*

THE "S"

This consonant is made of eight *ductus*. It begins with the wavy spine or shaft, which has two different *ductus*. This is followed by a thick line underneath and a thin correcting line top to bottom. Finally, the upper hook is drawn from left to right. Several thin lines on the outer and inner parts of the letter will serve as decorative finishes.

THE "Y"

The "y" is made of three *ductus*. The first one is the vertical downstroke, and the second one is a diagonal line from left to right. This is followed by a vertical line, which begins thin from bottom to top and then becomes thicker forming the line itself, until forming a descending stroke that is a little bit curved. The letter is closed with a flourish.

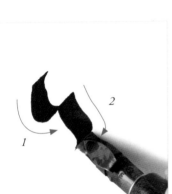

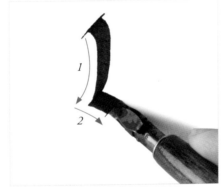

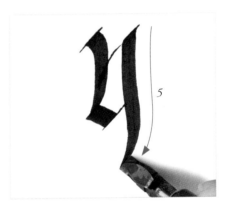

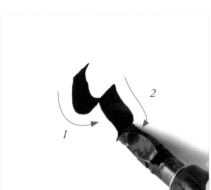

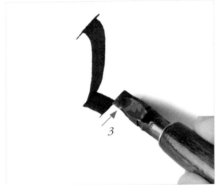

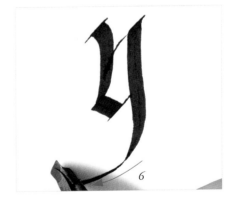

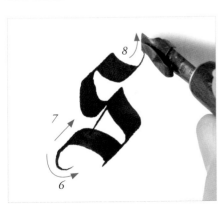

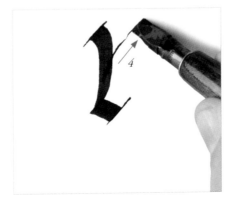

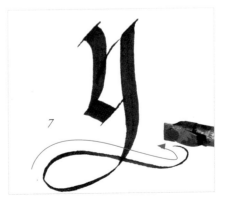

The Renaissance: Humanistic Script

Beginning in the 15th Century, Europe went through a period of changes, not only cultural but in all other areas as well. The Renaissance marked the transition from medieval to modern times. It was a period that coincided with the invention of the printing press by Johannes Gutenberg, the discovery of the heliocentric system by Copernicus, and a new continent in 1492: America. This era of great revolutions—political, economic, as well as religious and cultural—was marked by the humanism that defended the return to a Greco-Latin culture in hopes of restoring human values.

Calligraphy by Claude Dieterich A. entitled The letters, *written in Humanistic script with a fountain pen. Because of the chromatic simplicity of the work, we can clearly see the morphology of the letters, as well as their serifs.*

THE BIRTH OF THE HUMANISTIC SCRIPT

While Gothic script was completely accepted throughout most of Europe, in Italy there was a desire for a more rounded type of script. Humanistic script was created in Italy by Poggio Bracciolini (1380–1459) as an evolution of the Gothic Rotunda and the Carolingian Minuscule, at a time of a resurgence of the values of antiquity and a rejection of Gothic esthetics and those of the Lower Middle Ages in general. During this period several Carolingian codices were discovered and the Humanistic script was the result of admiration for those manuscripts.

The poet Petrarch was the first to manifest the need for replacing the Gothic script with letters inspired by the discovered codices. That is why he began to mimic the Carolingian letters, which are considered the "Gothic pre-Humanistic." But in time, the Humanistic script was attributed to Poggio Bracciolini.

This script, because of its inspiration, was also known as *lettera antica* (*antique lettering*),

Las letras
son símbolos
que transforman
la materia L A M A R T I N E
en espíritu.

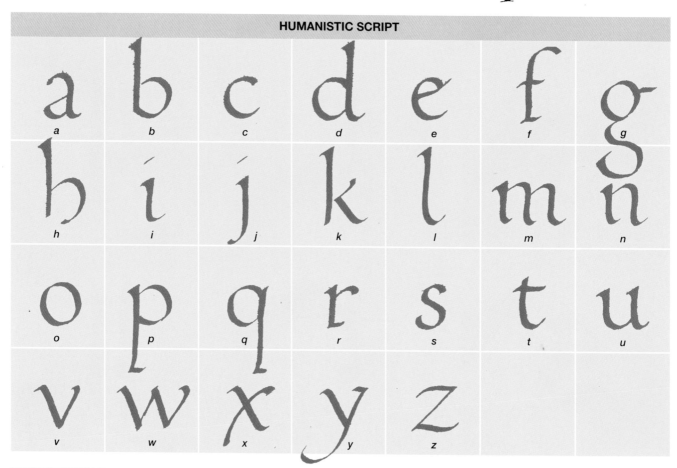

HUMANISTIC SCRIPT

a b c d e f g
h i j k l m n
o p q r s t u
v w x y z

while the Gothic script was called *lettera moderna* (*modern lettering*). It was a very elitist script, and as a result, did not spread to many parts of Europe; an exception was the kingdoms of the Iberian Peninsula (present-day Spain), especially the Kingdom of Aragon, which was in closer contact with Italy where this script was widely used and became more popular than the Gothic script.

THE EVOLUTION

Beginning in 1416, the cursive variation of the Humanistic script, called *lettera antica corsiva*, made its appearance. The interletter space tightened and the branching strokes became more prominent. The cursive Humanistic version does not differ much from the Gothic, but can be considered a slow evolution of the latter. An important characteristic is that the *ductus* becomes slightly angled to the right; the letters are written closer together, forming a compact word. It is a clear script, devoid of unneces-

sary decorative motifs that make reading it difficult, aside from a few ascending or descending gestural strokes, to make the letters more elegant. This cursive type gave way gradually to the Chancellery script, which was even more angled and gestural.

CHARACTERISTICS OF THE HUMANISTIC SCRIPT

First, it is important to point out that there are various versions of Humanistic scripts whose characteristics are different from each other to a greater or lesser degree. Here, we will review the different variations.

THE HUMANISTIC ROUND

It is closely inspired by the Carolingian script of the 10th and 11th centuries. The rounded

forms and the appearance of branching strokes are important hallmarks, but it is very clear and has very few decorative motifs. It is a script of minuscule letters, and the majuscules are based on Roman capital letters. A very characteristic element of this variety of Humanistic script is the crossbar of the letter "e," which is an ascending oblique diagonal line and slightly curved.

THE HUMANISTIC CURSIVE

This is the Humanistic round script, although the *ductus* has a right inclination. During the 16th century, this was the predominant type of script in the Iberian Peninsula. This style evolved into the Humanistic Chancery script, much more ornate and with the ductus even more inclined.

THE HUMANISTIC COMMON

This term refers to the Humanistic Cursive script, quick and informal, that was used to write notes and letters.

Page of a manuscript attributed to Poggio Bracciolini, in which he describes the monuments in the Rome of his time. Poggio wrote and copied numerous works.

Work by Claude Dieterich A. entitled Painting. *It was written with gouache on a dark background using several implements. Several script styles can be seen; written in white in the foreground he used the Chancellery script, and underneath, in yellow, we can see the letters of the alphabet in Humanistic and Gothic lettering.*

Chancellery or Italian Script

The Humanistic round script evolved into a cursive variation that ended up becoming the Chancellery script. Initially, this script was reserved for bureaucratic manuscripts and business transactions of the Vatican Chancellery, from which its name is derived; soon afterwards, they began to use it for other administrative documents that had to be signed by the Holy Father. Later on, during the pontificate of Eugene IV, the humanist Poggio Bracciolini introduced the Apostolic Chancellery script in all the documents, although these letters were still evolving and very similar to the Humanistic script.

At the beginning of the 15th century, in the Renaissance Court of the Medici of Florence, a new script style emerged that was still more cursive than the Chancellery Apostolic. This script, the Chancellery proper, was promoted by the erudite Niccolò Niccoli around 1420. The use of the Chancellery script spread to France through the Chancellery of the Popes of Avignon, during the time of the Church's schism, and this transfer of the Papal Court propelled its use throughout Europe.

Niccolò Niccoli (1364–1437), an Italian humanist of the Renaissance originally from Florence, was an avid collector and copier of old manuscripts. He had access to very important codices from Florence's Laurentian Library, among them texts by Lucretius and twelve comedies by Plautus, by which he became completely fascinated. This fascination for old manuscripts inspired Niccoli to create and spread the Chancellery Cursive script.

After Niccoli's introduction of the Chancellery script in the Papal documents, the new script style became popular and its use spread gradually to the general public, especially among humanists who used it to reinstate the classical works or to write their own, mimicking the classics. But in the private sector, the script was characterized for being somewhat smaller, with more branching strokes and simpler than the public style used in administrative and official documents of the Papal Chancellery.

Bookplate inspired by the work of Hermann Zapf, created by the calligrapher Ricardo Rousselot.

THE CHANCELLERY OR ITALIAN SCRIPT MINUSCULE LETTERS

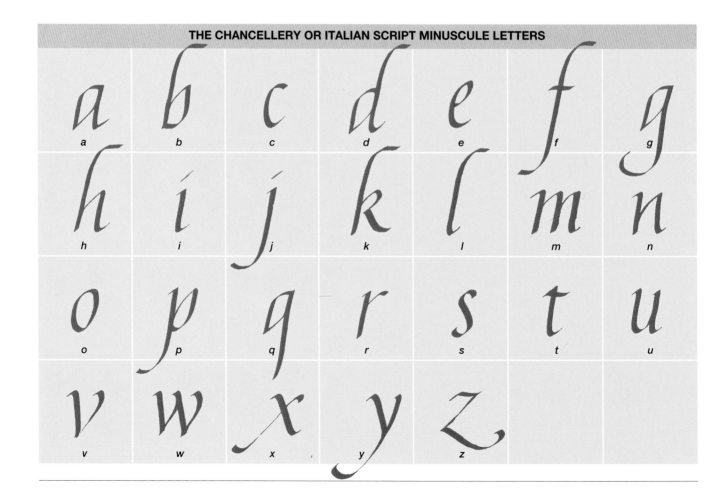

CHARACTERISTICS OF THE CHANCELLERY SCRIPT

Toward the end of the 15th century, we already find written texts with the two Chancellery styles described below.

POPULAR CHANCELLERY

This type of script was used by the humanists of the time in their literary works. It is characterized for the simple and small size of the letters, which can be written quickly. This style of script inspired Aldo Manucio, who had an active print shop in Venice, to design, engrave, and subsequently cast Italic type. Therefore, the popular Chancellery script was used as the basis for the different type styles known as the Italic style.

DIPLOMATIC CHANCELLERY

This script was used for the manuscripts of the Papal Chancellery, and is therefore more formal, with decorative features.

The Diplomatic Chancellery is characterized by its simpler strokes, producing a more elegant and organic writing. Its strokes are harmonious and rounded, with more branching strokes and an ornate quality of the ascender and descender lines in the form of flourishes.

Detail of work by Massimo Polello entitled Quest'arte ingegnosa di dipingere le parole… *Headed by a very beautiful capital letter in red, it introduces a text by Guillame Debebreufe written with Chancellery in white over black Fabriano paper measuring 27½ × 19⅝ inches (70 × 50 cm), drawn with a Brause nib pen.*

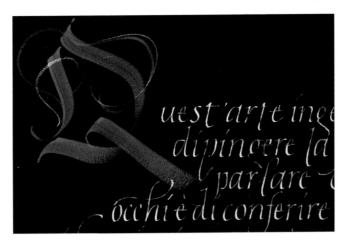

NICCOLI'S CHANCELLERY

The Chancellery script of Niccolò Niccoli can be identified by the use of the characteristic forms of the Carolingian minuscule, as well as Gothic letters of a cursive style used in Italy. At the same time, the majuscules were based on the Roman capital letters.

The pen angle is 45°. The letters are morphologically different because their basic module is the oval shape, with which various letters of the alphabet are constructed, like "a," "b," "d," "g," "o," "p," and "q." Another important feature is the verticality of the majuscules as opposed to the cursive nature of the minuscule letters, and the endings of their ascender and descender strokes, which can be in the form of a teardrop or a finish.

CHANCELLERY OR ITALIAN MAJUSCULE SCRIPT

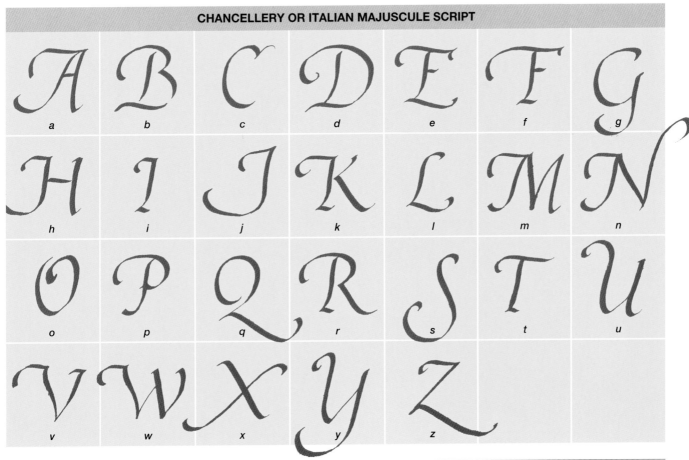

The English Script or Copperplate

The English script, also called Copperplate, is a style inspired by the Chancellery Cursive. The English script became very popular and was used especially in the creation of signs and advertising. Today, it is used mainly for advertising material and for designs that require a sophisticated, delicate, or feminine look. Examples, could be wedding invitations or the label of a perfume.

THE ORIGIN

This script was first found in the book *Les Œuvres* by Lucas Materot, written in 1608. But it was not until the 18th century that calligraphers like William Brooks and John Bland gave it its regular, even form and made it cursive, features that are so characteristic of this type of script.

The English script is written with a very pointed and flexible nib pen. This represents a change from the flat nib pen used by the majority of calligraphers until that time. Copperplate script was widely used during the 18th century, especially from 1720 to 1800, when it reached its peak. It spread throughout Europe and especially through typography foundries. The English script used by the French typographer Pierre Didot in 1798 is an outstanding example.

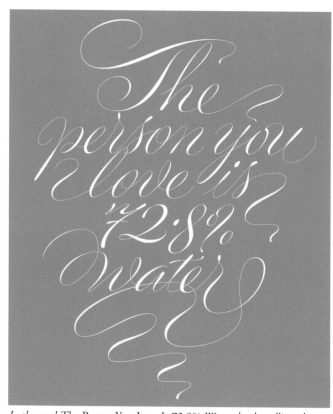

In the work The Person You Love Is 72.8% Water *by the calligrapher Peter Horridge, he used a copperplate nib pen and ink. This is a serigraphic work for giclée or digital printing commissioned by a client.*

THE ENGLISH SCRIPT OR COPPERPLATE

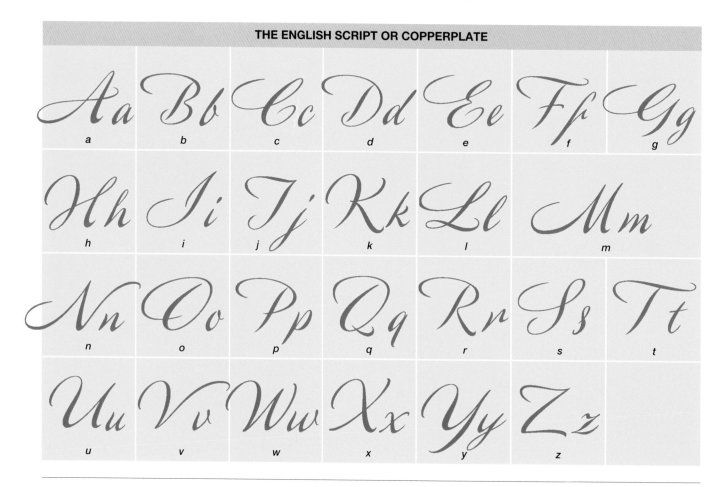

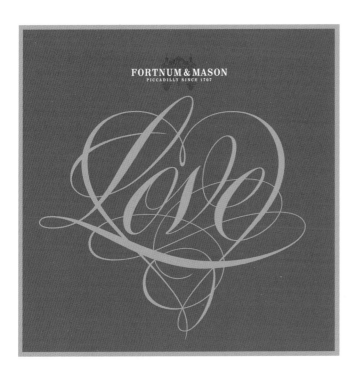

The Copperplate script is a very appropriate type of lettering for feminine themes and subjects relating to love because of its soft forms and branching strokes. Peter Horridge used it to write the word "Love" in this box of chocolates for a prestigious manufacturer.

CHARACTERISTICS OF THE COPPERPLATE SCRIPT

This script is characterized by its precision in the thin and thick strokes of its letters. The strokes must all be the same and cannot be obtained from changing the angle of the nib pen, as is the case with the other types of calligraphy we have seen so far. In Copperplate script, making thin and thick strokes depends on the pressure, applied with the nib pen on the paper: the greater the pressure, the thicker the line, and vice versa. The ideal pen angle is 45°. To make the writing of Copperplate lettering easier, there are special oblique nib pens available shaped like an "S," that are very fine and flexible.

The Copperplate script is taller than it is wide, and the ascender and descender lines are very important and greatly exaggerated, and can also be decorated with flourishes. All of these decorative features make this a very baroque and ornate type of script of elegant and refined appearance. It is not easy to master it, but the work created with this type of lettering carries a lot of prestige.

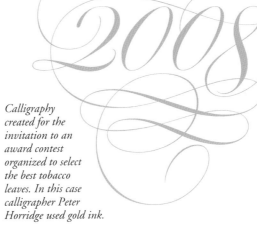

Calligraphy created for the invitation to an award contest organized to select the best tobacco leaves. In this case calligrapher Peter Horridge used gold ink.

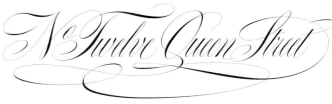

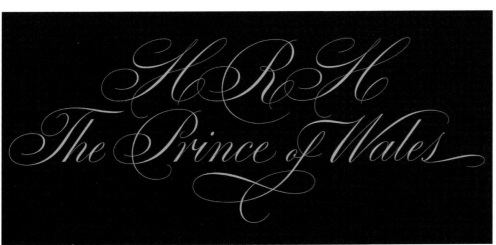

Sign written with English lettering where we can appreciate the features that link the letters after the flourish strokes. These compositions, which are very original, require careful study beforehand to create the strong feeling of harmony.

Calligraphy writing on an invitation from the Prince of Wales. Peter Horridge used a type of English lettering that was especially refined.

Contemporary Calligraphy

Calligraphy is not considered only an art practiced by a scribe who copies texts with the different historical calligraphic styles. Nowadays, calligraphy is a form of expression, an art, a love of beautiful lettering. The text can be an excuse to create a work that resembles art so much that the lettering is executed as a stroke, an abstraction. To become proficient at calligraphy *gestuale* you need to learn the form and the *ductus* of the letter. Only after mastering all the rules of formal calligraphy can one begin to understand the structure of the letter, its positive and negative forms, and be able to turn it into a gestural stroke. Nowadays, calligraphy is also a tool for designers when they need to create a logotype, to make it unique and exclusive for their clients. Therefore, it can be considered a very useful tool and a way to enrich a design. Thus, it seems like a logical evolution that *caligraffiti*, the art of creating graffiti with calligraphy, has become a form of expression.

CALLIGRAPHY *GESTUALE*

Derived from formal calligraphy, *gestuale* is a logical evolution of the art of writing. Artists, through their gestures, leave a trace of their hand movements in their work, giving it a personal style and making the work even more unique. The artist transfers his or her own way of creating the lines, playing with the rhythm and making the letters more expressive. Many times, when we think of gestural movements or strokes we think of spontaneous impressions by abstract painters. This is not the case in calligraphy, which cannot be compared because calligraphers are really not looking for spontaneity but very much the opposite—they want to control the stroke, keeping the form of the letter present in their minds. The more it resembles the formal morphology, the more beautiful the gestural mark will be.

Therefore, we must not forget that to create this type of gestural calligraphy, it is important to master the rules, the writing angles, and especially the morphology of the style of lettering that has been chosen; only by knowing and mastering formal calligraphy can we focus on the gesture. On the other hand, if there is no mastery of the formal lettering, it is easy to revert to our own normal handwriting, abandoning the *ductus*, or the characteristic angles of a Chancellery or Gothic script, for example. As the saying goes, to break a rule one must first know it. But we must also keep in mind the importance of legibility—experimenting with gestural movements of lettering to play with its morphology and its positive and negative forms is no excuse for making the text illegible. The goal of the gesture is to find harmony in the strokes—a rhythm, and especially a personality in the final result—but without forgetting that its goal is to be read, unless the artist decides otherwise.

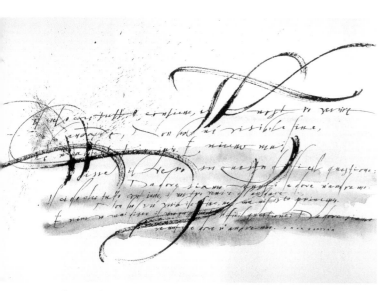

Il Cielo, *by Anna Ronchi, is a work of calligraphy based on a poem by Omar Khayaam, done with nib pens and a metal brush using gouache and watercolor on paper.*

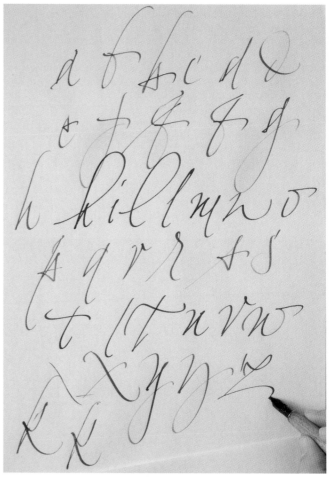

Gestuale *alphabet created with a nib pen and nogaline. The idea is not to abandon the basis of the Chancellery script or its form, while being able at the same time to experiment with variations that make this work something unique and personal.*

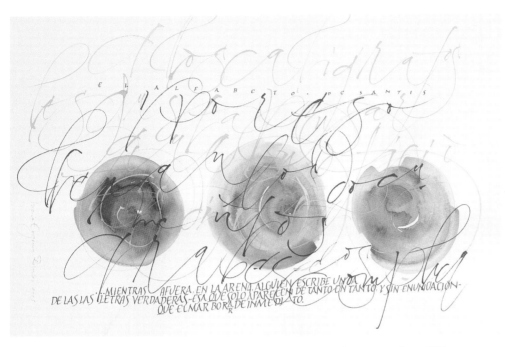

Work Sobre calígrafos *by María Eugenia Roballos, done with watercolors and tempera on Rives BKF paper. She used a ruling pen, a flat brush, and nib pens to write a phrase by the Argentine writer Pablo de Santis, with expressive deliberate rhythm.*

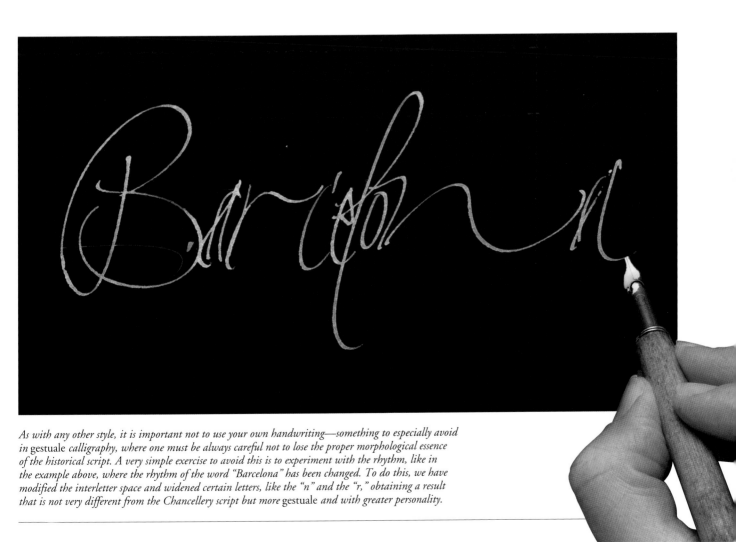

As with any other style, it is important not to use your own handwriting—something to especially avoid in gestuale *calligraphy, where one must be always careful not to lose the proper morphological essence of the historical script. A very simple exercise to avoid this is to experiment with the rhythm, like in the example above, where the rhythm of the word "Barcelona" has been changed. To do this, we have modified the interletter space and widened certain letters, like the "n" and the "r," obtaining a result that is not very different from the Chancellery script but more* gestuale *and with greater personality.*

CALLIGRAPHY AND DESIGN

In this era of computer and digital technology, handmade art is gaining popularity—the uniqueness, the gesture, the artist's personal style, his or her stroke, the writing, the calligraphy.

Name brands look for that particular hallmark that sets them apart in a very competitive market. Calligraphy can give a logotype or advertising slogan that unique personality that is so sought after by clients. Therefore, it is common for big name brands or advertising agencies to hire calligraphers to do this type of work. It is not unusual to find ads with messages written with a beautiful Chancellery, or on the label of a bottle of wine, or on a flyer with a Gothic script with a touch of graffiti style, or on the cover of a jazz CD or a movie poster.

Obviously, legibility is paramount when using calligraphy in that medium. For a message to reach its intended public it must be as direct as possible: the faster a message is understood, the better its design.

The billboard advertising a perfume by Armand Basi represents a slogan that was written in calligraphic letters with a brush by Ricardo Rousselot. This is a clear example of the coexistence of advertising and calligraphy, achieving (as the slogan says) a result that is anything but usual.

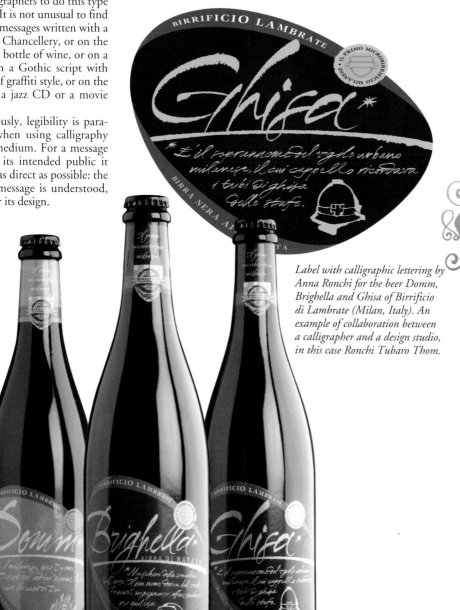

Label with calligraphic lettering by Anna Ronchi for the beer Domm, Brighella and Ghisa of Birrificio di Lambrate (Milan, Italy). An example of collaboration between a calligrapher and a design studio, in this case Ronchi Tubaro Thom.

Hotel Los Patios
Parque Natural Cabo de Gata
Níjar - Almería - España

www.lospatioshotel.es
info@lospatioshotel.es

mov. 34 607 22 11 19
tel. 34 950 52 51 37
fax 34 950 52 57 30

A corporate logo for the Hotel Los Patios (Almería, Spain), created by Queralt Antú Serrano. The artist used Gothic lettering decorated with motifs typical of the patios of southern Spain, as well as images of old movie posters, since many famous spaghetti westerns were filmed in this region.

CALLIGRAFFITI

The term *graffiti* derives from the Latin word *graphiti*: in Italian, *graffiti* is the plural of *graffito*, which means "mark or inscription made by scratching or writing on a wall." This term is used to refer to the inscriptions that have been left on walls from the time of the Roman Empire. Therefore, we cannot say that this is a new art. But it was not until the 1960's that the definition resurfaced and paintings called *graffiti* began to appear on walls and public spaces. Among the most famous graffiti artists are Bansky, Keith Haring, and Basquiat (in fact, the paintings by the latter greatly inspired Andy Warhol, an artist himself). Sometimes considered an act of vandalism, certain graffiti paintings can be true works of art.

The *calligraffiti* is a new trend that mixes graffiti with calligraphy. *Calligraffiti* artists take great interest in learning the art of writing well so they can use it to enrich their work. A good example is the *calligraffiti* by Lucas Barcellona or by Inocuo The Sign (Javi Gutiérrez), where the great mastery of formal calligraphy can be appreciated, and to which the artist transfers his own personality and emotion with amazing results.

In *calligraffiti*, as in *gestuale* writing, the deep understanding of the form and the *ductus* of each letter are paramount. You may end up designing your own script, but first you must learn the art of historical calligraphy.

Basically, *calligraffiti* can be created with markers or spray paint using various kinds of nozzles to achieve different finishes. However, commercial-quality brushes and paint or pencils can be used, and even collage and stencils, or both, as finishes.

THE ORIGINS OF TAGGING

Tagging became popular in the 1970s when it made its appearance on the trains and tunnels of the New York subway system. The first tags were attributed to an artist who signed his work as Taki 183, although his real name was Demetrius. He worked as a mail carrier in New York, which was the reason why he needed to mark his routes. His signatures became famous and several copycats imitated him. Therefore, the origins of tagging can be summarized in a signature and a proclamation, "I exist and I have been here." From this point of view, it is very understandable that Inocuo continues with this tradition to create logos.

Today Is the Shadow of Tomorrow, *calligraffiti created by Inocuo The Sign in 2007. In this work, created in pencil and later painted with watercolors, we can see the combination of calligraphy with proper elements of the language of graffiti artists.*

Calligraphy by Julien Breton entitled Wisdom Teaches Those Who Possess Nothing, *from a quote from Khalil Gibran. The red lines were created with an Automatic Pen and the black text with nib pens and a brush on 25⅝ × 17¾ inch (65 × 45 cm) cardboard. The script, inspired by Latin and Arabic letters, was created by Julien himself.*

Inocuo The Sign (Javi Gutiérrez) created these logos using the tagging technique.

Gallery of Calligraphers

Since writing was invented, its main use has been to communicate messages, record thoughts and numbers, narrate fiction and non-fiction stories, and many other practical uses. However, writing—in keeping with its main function of transmitting a message, has also served for many centuries to create art. The capital letters recreated from the medieval codices are a good example of this. In the last two centuries, in keeping with the evolution of art, calligraphy also continues to transmit ideas, messages, and desires, but with an artistic sense that is remarkable for the variety of forms, supports, media—in other words, the creativity of them all. In the following pages we are going to show samples of all these possibilities.

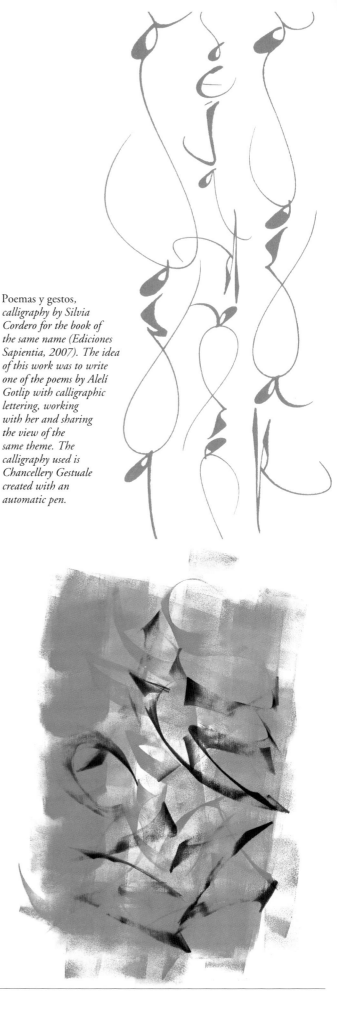

Poemas y gestos, calligraphy by Silvia Cordero for the book of the same name (Ediciones Sapientia, 2007). The idea of this work was to write one of the poems by Alelí Gotlip with calligraphic lettering, working with her and sharing the view of the same theme. The calligraphy used is Chancellery Gestuale created with an automatic pen.

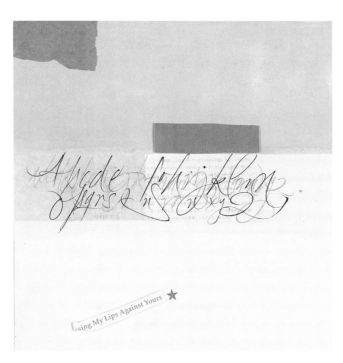

Calligraphy by Silvia Cordero, entitled My Lips Against Yours, *where we can appreciate a beautiful Chancellery Gestuale. The meduim chosen by Silvia is a collage of different colored papers on stretched canvas, which enriches the work and adds texture.*

Calligraphy by María Eugenia Roballos entitled Attimo, *done with tempera and ink for fountain pens on Arches Graphia paper, measuring 27½ × 19⅝ inches (70 × 50 cm). A paint roller and an experimental blunt instrument were used. The layering of textures creates a beautiful glazed effect. The technique of the glaze consists of applying the minimum amount of paint or medium possible, layer by layer, in a way so that the bottom layers are visible through the top ones.*

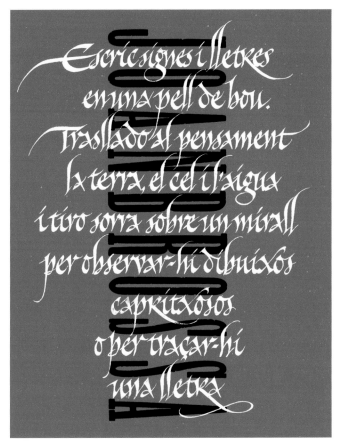

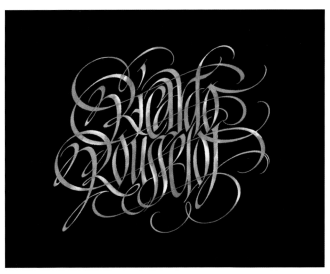

Calligraphic signature by Ricardo Rousselot, on black paper using several tones of orange, yellow, and white. The branching strokes are done with Chancellery calligraphy.

Work by Ricardo Rousselot entitled Joan Brossa. In this work created with a nib pen and typography, the contrasting colors, chosen by the calligrapher from among the most common in the world of the poet and the Catalan artist Joan Brossa, create great overall visual impact.

Calligraphy by Julien Breton entitled Mais alors, si le monde, vraiment, n'a absolument aucun sens. Qui nous empêche d'en inventer un?, a French translation of a quote from Alice in Wonderland by Lewis Carroll. It was created with an automatic pen, nib pens, and a brush on cardboard measuring 25½ × 13¾ inches (65 × 35 cm). The style of the script is Latin with Arabic influence.

This work created by the calligrapher Julien Breton and the photographer Guillaume J. Plisson, entitled Light and Brotherhood, was created on Pointe de Combrit (Brittany, France). The unusual element in this work is the material used: light. This was achieved by a long exposure, which Julien used to create a beautiful and ephemeral work of calligraphy that was captured by Guillaume's camera. The script style is Arabic.

Uno, calligraphy by Fabián Sanguinetti based on the lyrics of the tango piece Uno *by Enrique Santos Discépolo. It was created with watercolors, acrylics, walnut ink, and transfers on 18½ × 21⅛ inch (47 × 69 cm) paper, using a brush and a nib pen. This work stands out for its decorative motifs, for the collage elements, and especially because it is written only with majuscule letters.*

Work by Fabián Sanguinetti entitled The Creation of Kóoch. *This calligraphy is based on a Tehuelche legend about Kóoch, the god that created Patagonia. It was done with watercolors, acrylic paint, and tempera on 19 × 27½ inch (48 × 70 cm) paper using a ruling pen. This work received the third prize in the VI Premis Internacionals Catalunya de Cal·ligrafia Argilés i Solà, Barcelona, Spain, in 2002.*

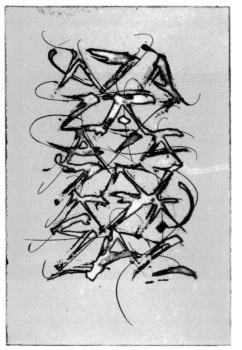

Marco Campedelli Studio created the calligraphy Lamp. *Campedelli shows us that it is possible to use calligraphy on any support and be able to create, for example, an interesting lampshade. The artist used a brush and black ink on a lampshade made of rice paper.*

Calligraphy by Marco Campedelli Studio called AZ, *with the alphabet in Gestuale style. This work, created using the engraving technique, was printed on a manual press.*

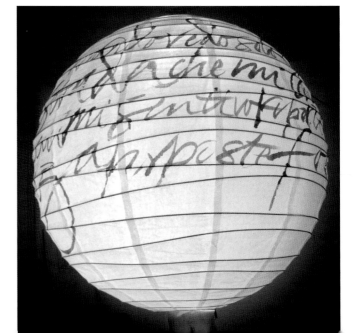

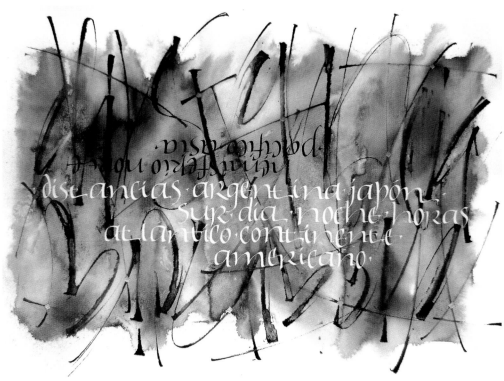

Work by Betina Naab entitled Distances. *It represents the distance between Argentina and Japan. Both countries are separated by turbulent oceans and are located in opposite hemispheres; when night falls in one country, it is daybreak in the other. The artist used a ruling pen, a flat brush, and a nib pen on 12½ × 19⅝ inch (32 × 50 cm) paper.*

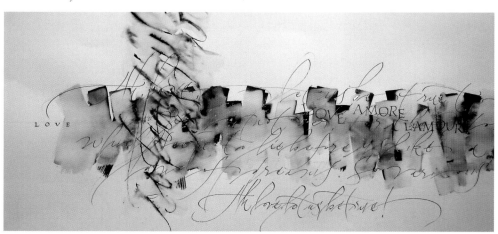

Dover Beach, *calligraphy by Betina Naab. This work was commissioned as a wedding gift, and was done using fragments of an English poem that speaks of love as the only hope in dark war times. The artist used a ruling pen and a nib pen. Gold details have been added using gold leaf. The work measures 13¾ × 27½ inches (35 × 70 cm).*

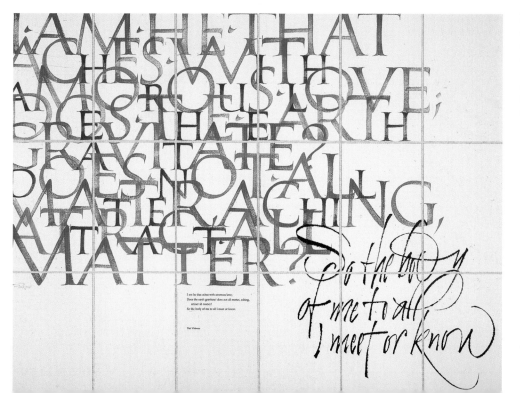

I Am He That Aches with Amorous Love *is a work of calligraphy by Anna Ronchi based on the poem by Walt Whitman. It can be viewed as a book or with the pages unfolded as a poster, the way it is shown here.*

Work by Massimo Polello entitled The Letters Are Symbols and Inner Melody. *This calligraphy, based on a text by W. Kandinsky, superimposes textures and techniques: a dripped and stamped collage, and calligraphy in gouache over a 39⅜ × 39⅜ inch (100 × 100 cm) frame.*

Massimo Polello, …That Your Love Is Not a Prison, *calligraphy based on a text by G. K. Gibson. The energy of this work comes from the combination of dripped bright white enamel paint with the writing in brush and medium density gouache and rustic capitals of Humanistic script, on 39⅜ × 21⅝ inch (100 × 55 cm) black paper.*

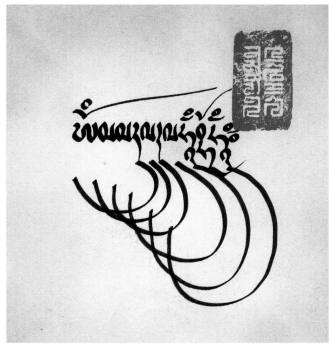

Calligraphy by Jean-François Bodart titled Ekajati's Mantra. *It consists of a Tibetan mantra written with a Tibetan script using a nib pen on 100% cotton paper previously dyed with black tea to create an aging effect.*

Logogram created by Di Spigna for the Antinuclear Proliferation Organization, whose mission is to minimize the threat of nuclear arms in the world.

Book with calligraphy by Monica Dengo written on paper and nude figures, photographed by Marco Ambrosi, with selected text from poems by Tsering Wangmo Dhompa. The calligraphy is perfectly integrated over the twisting bodies, creating a series of very sinuous forms.

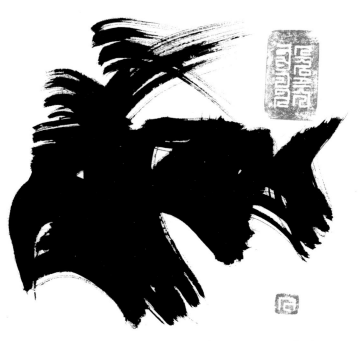

Lokhel, *calligraphy by Jean-François Bodart done on commission for the* Buddhadharma Magazine. *The artist wrote the Tibetan script for "trust" with black India ink and a brush.*

Calligraphy by Marina Soria titled Messages from the Past. *The artist used gesso and sand on canvas, walnut ink, and sumi, and 31½ × 39⅜ inch (80 × 100 cm) Japanese paper. Based on an original text: "Cuanto más se alejan una cultura y su mitología de las formas simples y cuanto más complicado se vuelve su mundo espiritual, más se dificulta su interpretación." Marina Soria has focused on the origins of writing and on the systems of codices and signs. The work is developed on two planes. The one in the background is built with horizontal bands of primitive Sumerian and Phoenician pictograms, Chinese ideograms, hieroglyphics, and Etruscan and Runan phonograms. The origins of our alphabet are the Greek and Latin symbols. Finally, the last three bands represent Aztec, Mistec, and Mayan writing systems.*

Creating a Calligraphic Logotype

In a mass-produced world dominated by the digital, work created by hand is very much appreciated. One of the most valued exercises is designing a logo, an emblem that can become the icon of a company—and the more original the better. When designing a logo, you must have a very clear brief from the client. The logo must represent the company, which means it must reflect well on its dedication. And the client should feel comfortable with the image, since it will surely last a long time. In this practical example, we show the step-by-step creation of a real logo for a television program on a public channel in Catalonia, Spain. It was created in phases, the first manual and creative, then finishing up with the help of a computer. Although it may seem to be a contradiction, this shows the advantages of a mixed approach where the computer amplifies and improves the manual work, and this is in fact the way it is in the real world.

THE BRIEF

The producers of the television program approached Alberto G. Arellano and Queralt A. Serrano of Goal Studio with the task of creating a logo for a program about dreams. The name of the program was *Somiers*, and the name had a double meaning. On one hand the *somier* in Spanish is the frame that supports a mattress, and therefore supports sleeping, which encourages dreaming. On the other hand, the word *somiers* in Catalan means "dreamers." A delightful play on words that without a doubt can help in creating the logo.

TOOLS AND MATERIALS

When creating a logo in calligraphy you can use drawing tools like graphite pencils for making the preliminary sketches, and calligraphy tools like metal nib pens, brushes, and black ink and paper. Finally, you will need a computer and a scanner.

THE PROCESS

Making a logo is entertaining work. Arriving at a good solution requires serious reflection and lots of work making quite a few sketches with different approaches as shown in this exercise.

The work on the sketches begins with putting pencil to paper. Based on these first sketches, it is decided that the logo for a program about dreams should be based on calligraphy, reinforcing the concept of dreaminess. Work began with trying different textures.

2. After several attempts, the experiments continue, now with a nib pen, searching for dreamier forms. This idea was finally rejected because of its similarity to the titles of the credits for the films by Tim Burton.

1. Several sketches were made with a brush-tipped pen. This is a practical tool because it has an ink cartridge and does not need to be dipped in an inkwell all the time, which interrupts the work.

3. Experimentation continues with more textures. Now a wooden tool is used. It was originally meant for working with clay, but it is also recommended for calligraphy work. The strokes contain some very suggestive transparencies. A flourish inspired by the ones used during the 16th to 18th centuries is used to "close" the logotype.

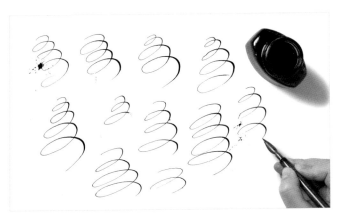

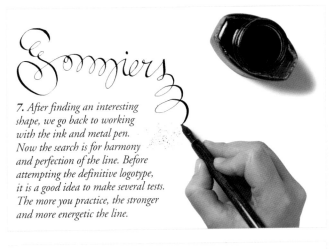

4. *This is the flourish that inspired the main idea of the final logotype concept. The flourish suggests a spring typical of those in a mattress. When you sleep on this flexible furnishing, it will squeak and creak when you change positions during a dream. The spring is definitely a good concept. Many of these organic shapes that look like springs are drawn with a metal pen.*

7. *After finding an interesting shape, we go back to working with the ink and metal pen. Now the search is for harmony and perfection of the line. Before attempting the definitive logotype, it is a good idea to make several tests. The more you practice, the stronger and more energetic the line.*

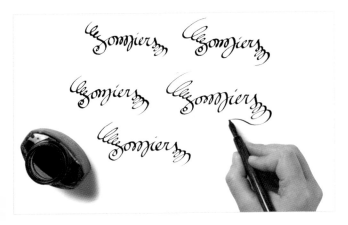

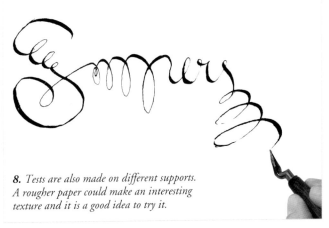

8. *Tests are also made on different supports. A rougher paper could make an interesting texture and it is a good idea to try it.*

5. *The most difficult and important part of creating a new logo is to come up with a concept. The clearer and more direct the concept, the more universal, and therefore more likely to deliver the message to the public. Without a doubt, this is the most important objective of the logo. Another very important factor is its legibility. The spring shape seems at first difficult to integrate in the design without losing this quality.*

6. *We had to return to using a pencil to achieve the required legibility. This gave us an advantage in our work because it is quicker to use and it also helped us be more reflexive. Any space on the paper is interesting, and they were all filled with drawing, turning the support and trying to find the script with the best rhythm without losing legibility.*

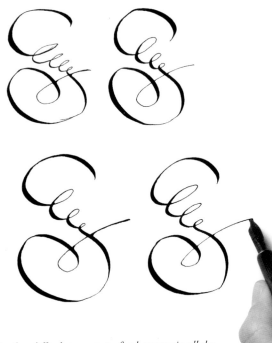

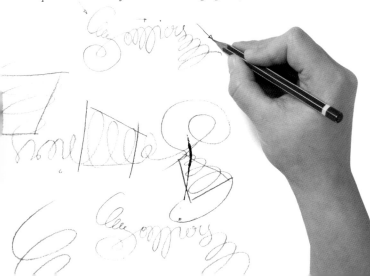

9. *It is often difficult to create perfect harmony in all the parts of the logotype, so it is a good idea to practice all the parts separately. As you will see in the following steps, the different parts of the calligraphy can be scanned and joined on a computer with the right software to make the best possible version.*

PUTTING A LOGO ON A COMPUTER

To continue the exercise, we will explain how to transfer the logo we are designing to a computer. After making several sketches and achieving totally satisfying results, there remain two options for completing this project. Although a unique original design can be created on paper or another support, in professional situations it is more common to prepare the logo for several uses—among them printing—and the calligraphy should be digitized for that.

10. To convert the calligraphy to a vector format so you can make an electronic "original," you should use vector software. To make a vector image of the logo, start with the scanned image and trace around it to create a logo that is delineated with nodes.

THE SCANNING PROCESS

A scanner is used for digitizing the logotype, and it is best to use a high quality scanner. The image should be digitized at a resolution of at least 300 dpi (dots per inch) and saved on the computer. You should keep in mind that if the image is going to be printed, it should be saved in CYMK mode, or else in grayscale or black and white. If, on the other hand, the work will be used in an audiovisual format or used on computers (like on the Internet), it can be saved in RGB mode.

THE BITMAP AND VECTOR FORMATS

Once the image is in the computer, you have the option of leaving it in a bitmap file or a vector file, which will allow you to appreciate the gestural quality, transparencies, and original texture. Everything will depend on the resolution of the scan. There are several programs that can be used for this that will allow you to correct the curves and even the tonalities of the logo. If, on the other hand, you wish to convert the calligraphy to a vector file and in that way create an original—that is, a black-and-white image that looks like it was done in india ink—you can use vector software.

11 and 12. After the logo has been delineated with nodes, the imperfections in the manual tracing can be corrected and the curves changed, using the tools. They are not difficult to control and they can create very beautiful and refined images.

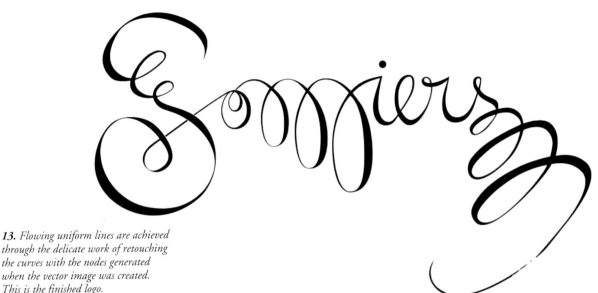

13. *Flowing uniform lines are achieved through the delicate work of retouching the curves with the nodes generated when the vector image was created. This is the finished logo.*

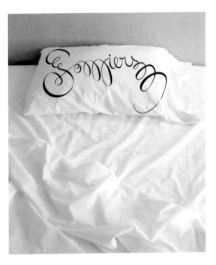

15. *Finally a beautiful logo is achieved—and more importantly, one with a clear concept. In this example, the logo was digitally applied over the image of a pillow.*

14. *Another necessary step you should be aware of when designing a logo is creating the negative, with the white script on a black background. When the inversion is made, an optical effect occurs that must be remedied. The eye tends to thin the white lines on black, causing definition and even legibility to suffer. The line should be slightly widened to achieve an effect similar to that created in the black logo on a white background.*

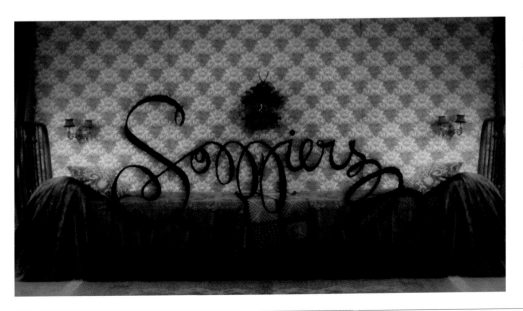

16. *A scene from the television program* Somiers *with the logo created in the steps shown on these pages, by Goal Studio (Alberto G. Arellano and Queralt Antú Serrano).*

Designing a Monogram and a Wedding Invitation

The process of designing a personal monogram is not too far removed from creating a logo. A monogram is a symbol whose design is based on a person's initials, and it serves as a personal graphic that defines what that person does. It should, then, identify the artist in some way. Monograms are useful as letterheads or bookplates (engraved papers attached to the inside of book covers with the owner's name), and also for other things like wedding invitations.

To make a calligraphic monogram, you may need graphite pencils for sketches and tools for making the calligraphy itself, like brushes, nib pens, or other more specialized tools. And, of course, materials like ink and white paper. If the paper is special, it is a good idea to keep a separate piece or even more for practicing.

In the following steps, you will see how to make a monogram in two phases. The first consists of the exercise of making a monogram based on a name, and the second shows how a monogram on a wedding invitation is made.

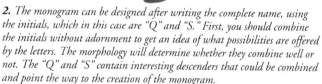

1. *To make a monogram study, the name should be written in a script that represents the personality well. In this case Chancellery script was used. In the quest for interesting results, several sketches were made in pencil to achieve a harmonious composition.*

2. *The monogram can be designed after writing the complete name, using the initials, which in this case are "Q" and "S." First, you should combine the initials without adornment to get an idea of what possibilities are offered by the letters. The morphology will determine whether they combine well or not. The "Q" and "S" contain interesting descenders that could be combined and point the way to the creation of the monogram.*

3. *Combining the descenders of the initials can be an interesting exercise.*

4. *Superimposing the letters can also turn out to be an inspiration. Some legibility might be sacrificed, but since there are just two letters you can risk it. They could be separated by using different colors for each letter.*

5. *Finally, another option can be emphasizing one letter more than the other. In this case the "Q," which is not commonly seen in names, is more representative than the "S" and therefore reinforced.*

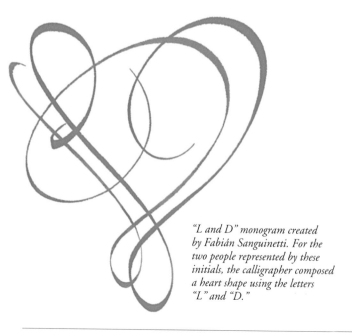

"L and D" monogram created by Fabián Sanguinetti. For the two people represented by these initials, the calligrapher composed a heart shape using the letters "L" and "D."

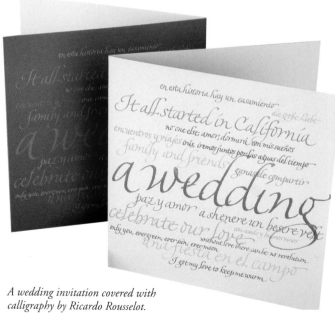

A wedding invitation covered with calligraphy by Ricardo Rousselot.

WEDDING INVITATION

Usually the bride and groom wish to formally announce the ceremony on such a special day in a personal and unique way. For this occasion, a monogram was created from their initials and the invitation was done in calligraphy.

TOOLS AND MATERIALS

The following tools and materials were used to create this wedding invitation: graphite pencils for making sketches; calligraphy tools like brushes, nib pens, etc.; materials like black ink, white paper, and in this case, a scanner and a computer.

1. The design of the wedding invitation begins with the creation of a monogram with the initials of the bride and groom: "B" for Barbara and "H" for Hector, which will go on the cover of the card. To emphasize the concept of the union, the horizontal shapes of the letters are intertwined.

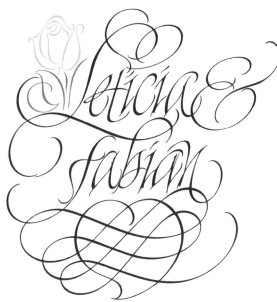

Calligraphy for a wedding invitation created by Ricardo Rousselot.

2. Inside the invitation the two names of the bride and groom should be the center of attention. Therefore several options were tried in pencil until they were united. After arriving at the solution, they were inked using nib pens.

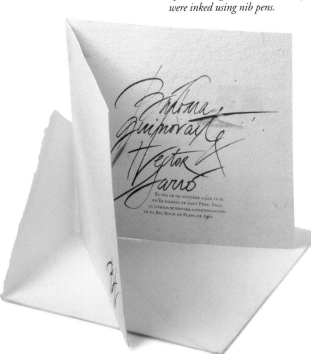

3. After making the monogram and the inside of the invitation, the calligraphy is scanned and saved to a computer. The rest of the invitation is composed using an appropriate software and the scanned calligraphy is integrated in the design. An important part of the design consists of selecting an original and interesting paper for printing the invitation. In this case a handmade paper with flower petals was chosen. The hand-lettered calligraphy was then printed on the artisanal paper invitation.

4. This is the finished wedding invitation with the monogram initials and the names of the celebrants.

Calligraphy of a Poem

In this exercise, the calligrapher Oriol Ribas demonstrates the composition of a poem using a combination of two types of script, some Roman Capitals that he will draw with a brush and the background letters that he will draw with ink and coffee.

TOOLS AND MATERIALS

To create the calligraphy of the poem in the manner proposed by the artist, you will need a mechanical pencil with 0.5 mm lead to draw the guidelines, Canson paper 19½ × 27½ inches (70 × 50 cm), metal nibs and a handle, fine (2 and 4 mm) brushes, black ink, gouache in several colors, coffee, and white paper.

BEFORE STARTING

Before starting any exercise, you should practice on any sheet of white paper the same size or at least proportional to the finished work. It will be used to carefully calculate the spacing between the letters, the rhythm of the work, and this way you will not waste time and valuable paper. You should also look at different types of script to choose the best letters for the look you want.

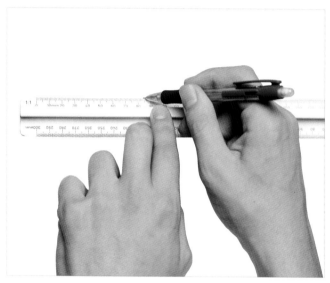

1. After you have worked out the distribution of the text that you will be using in a previous sketch, you can begin the exercise by drawing the guidelines. For this you will have to calculate the module. The template for Roman Capitals, if you are using a 4 mm brush, is 3 cm high for the letter and 3 mm of space between the lines. The guidelines should be lightly drawn with a 0.5 mm mechanical pencil.

3. The spacing is very narrow, just 3 mm between lines, which makes a very interesting visual effect.

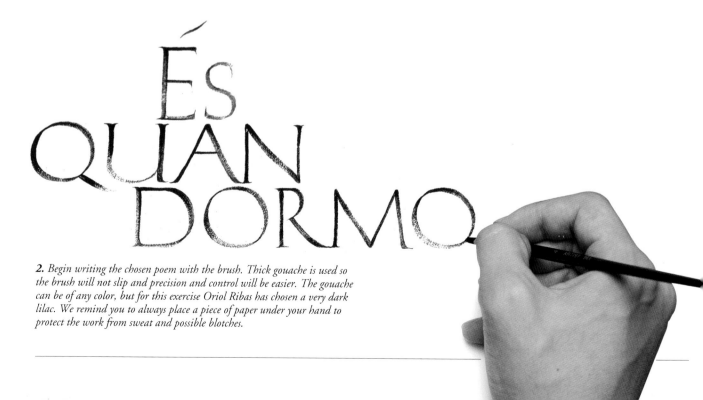

2. Begin writing the chosen poem with the brush. Thick gouache is used so the brush will not slip and precision and control will be easier. The gouache can be of any color, but for this exercise Oriol Ribas has chosen a very dark lilac. We remind you to always place a piece of paper under your hand to protect the work from sweat and possible blotches.

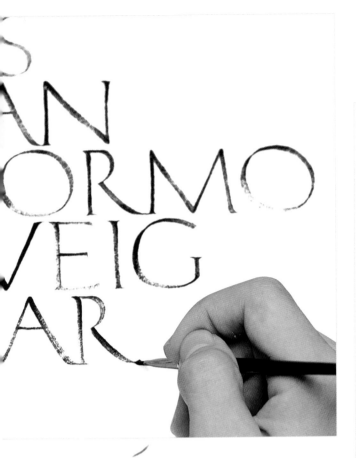

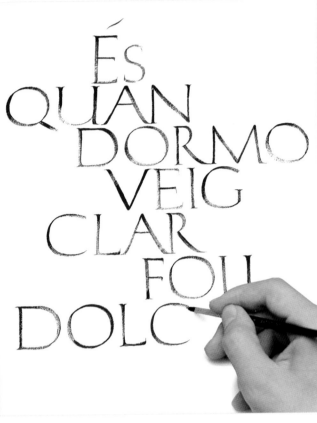

4. *Continue writing the poem, pausing often to reflect before starting each letter. The final work has a certain irregularity in the composition. Poetry allows such irregularities because of its musical nature.*

5. *After finishing the first phase of the work, notice the vertical look where there are spaces that will look very good when filled with the rest of the text of the poem.*

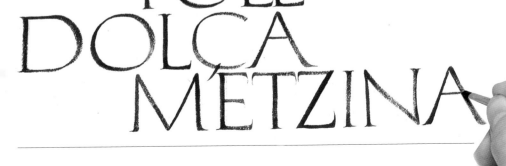

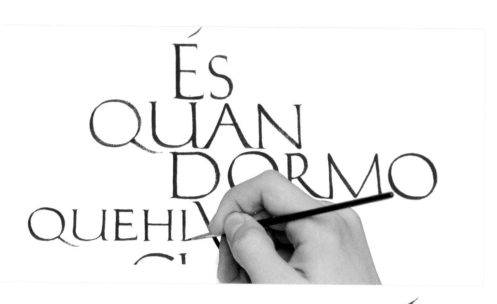

6. *To write "que hi" the artist has decided to use the other smaller brush, the 2 mm, to follow the new template. The new guidelines are drawn using 2 cm as the letter height and they are centered on the previously drawn guidelines.*

7. *Now repeat the last step for the words "d'una," centering them on the word "foll" to the left.*

8. *To add more color, interest, and difficulty, the poem is written again but this time in Versal Capitals. The words are first drawn in pencil, very lightly, just for use as a guide. Then they are outlined in black ink, and later filled in with coffee, using a fine brush.*

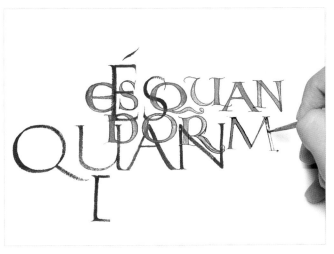

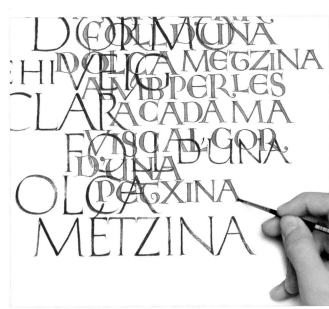

9. *The coffee makes an irregular brownish tone that has a very attractive aged look. Other ways to achieve a similar look would be to use aniline dyes or nogaline.*

10. *The new composition is as centered as possible, at times painting over the previously applied letters. The result looks musical and organic.*

11. *This is the finished poem written with two types of letters and two colors.*

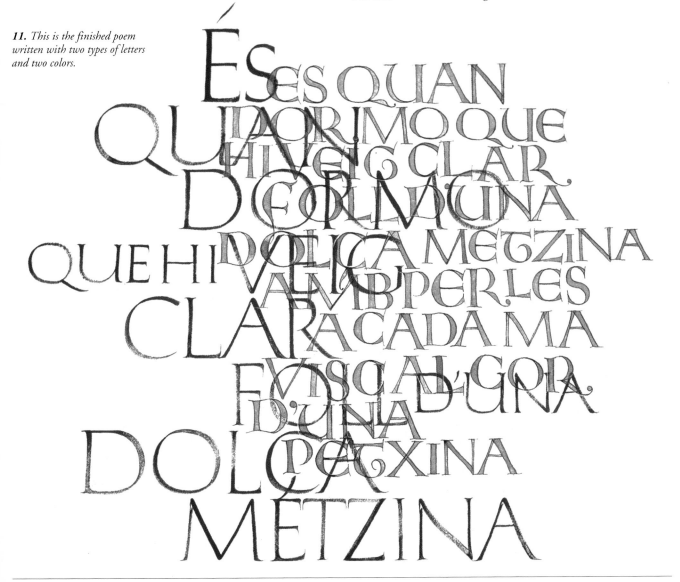

Free Calligraphic Composition With a Cola Pen

In this exercise the calligrapher Oriol Ribas will create a work with a tool that he made himself, a cola pen. The lettering from this pen is more flexible and dynamic, and very expressive work can be created with this tool, depending on its stiffness. The less stiff, the more expressive it can be, but it will also be more difficult to control. In this case the composition is a free theme that might inspire similar projects done for fun.

TOOLS AND MATERIALS

You will need the following tools and materials for this calligraphy exercise. In the first place a pencil or mechanical pencil for making the template or guidelines, handmade paper, a cola pen, and also some metal nib pens, black and red gouache, coffee, white paper, and gold leaf.

1. Begin by drawing some capitals using a cola pen and coffee instead of ink.

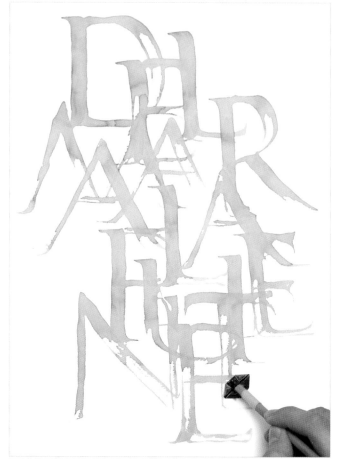

2. The composition can be free; the calligrapher Oriol Ribas opted for an irregular and harmonious layout.

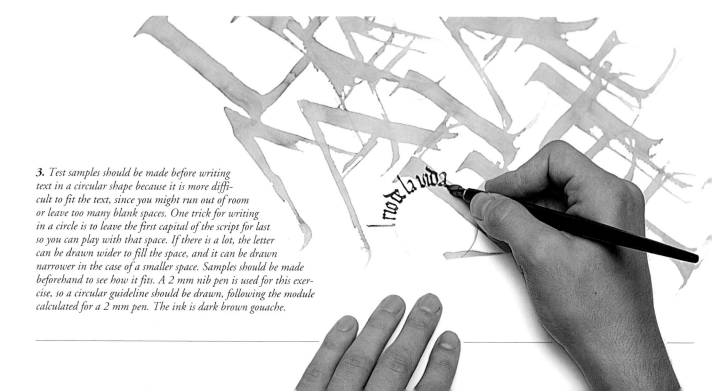

3. Test samples should be made before writing text in a circular shape because it is more difficult to fit the text, since you might run out of room or leave too many blank spaces. One trick for writing in a circle is to leave the first capital of the script for last so you can play with that space. If there is a lot, the letter can be drawn wider to fill the space, and it can be drawn narrower in the case of a smaller space. Samples should be made beforehand to see how it fits. A 2 mm nib pen is used for this exercise, so a circular guideline should be drawn, following the module calculated for a 2 mm pen. The ink is dark brown gouache.

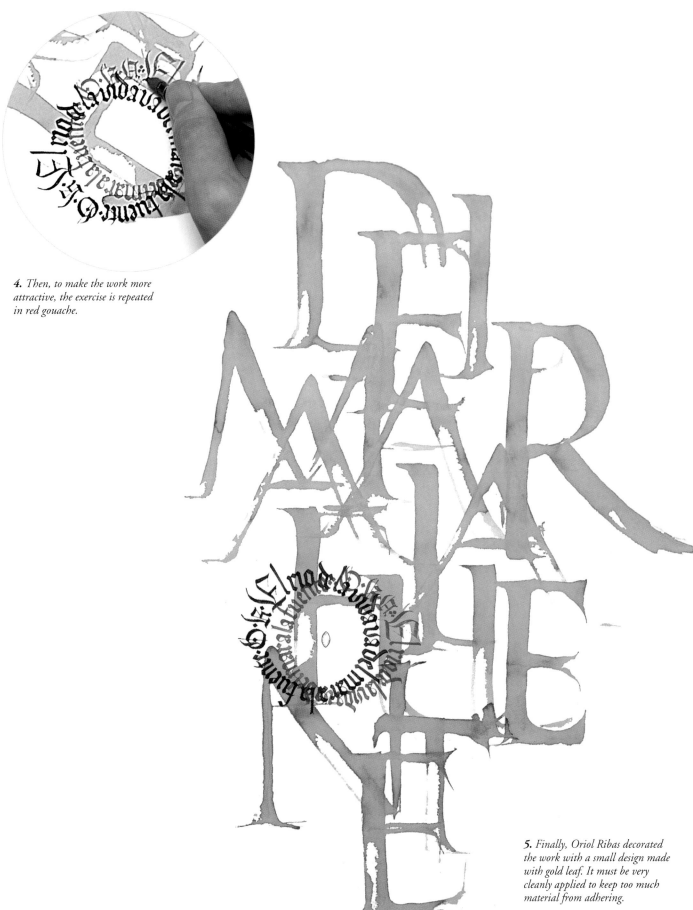

4. Then, to make the work more attractive, the exercise is repeated in red gouache.

5. Finally, Oriol Ribas decorated the work with a small design made with gold leaf. It must be very cleanly applied to keep too much material from adhering.

Calligraphy With a Gradated Effect

In this exercise Oriol Ribas writes a text in Gothic script on black Canson paper. He uses gouache paint for this, which is opaque and ideal for working on dark paper.

We remind you again that before starting any exercise, it is necessary to make several test samples with the paint. First, this is to check the paint color, and second, to check how fluid it is on the paper before starting to work. If possible, the sample should be made on the same kind of paper as you will use for the final piece, and you should work at getting acceptable results, especially if you have never attempted these effects before. When you feel sure, you can begin to create the final work on the good paper.

It is best to use gouache for writing calligraphy on dark paper because it has opaque pigments and it is easy to use because it is water-soluble. In the Middle Ages the scribes in the monasteries used a mixture of water and pigments and egg white as an agglutinate. The latter also gave the paint volume and made the script brighter. If you wish you can do this exercise with a similar mixture.

TOOLS AND MATERIALS

This project requires black Canson paper, yellow, white, and orange gouache paint, a 2.5 mm metal nib pen, a 0.5 mm mechanical pencil, and white paper.

1. After the sketch has been approved you can begin to draw the guidelines. First calculate the module, then draw the lines lightly with a 0.5 mm mechanical pencil. Next prepare the gouache for use, in this case yellow and orange colors.

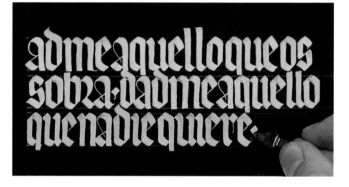

2. To create a graduated effect in the first line of the poem, a small amount of white gouache is mixed well with the yellow in a small container. When writing the second line, the mixture must have less white and more yellow, and so on consecutively in each line.

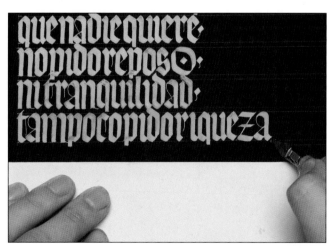

3. The fifth and sixth lines are written directly with pure yellow gouache, and you will be able to see the graduated color effect.

4. In the following lines, starting with the seventh, mix in orange gouache, from less to more as you continue the lines.

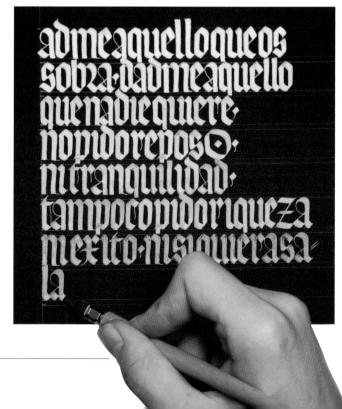

6. *The last line is written with pure, unmixed orange paint.*

5. *A little more orange is added in the eighth and ninth lines.*

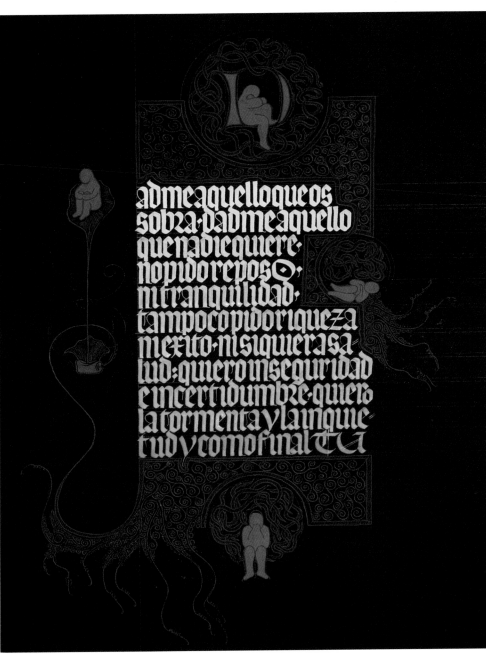

7. *To finalize the work, Oriol Ribas has decorated it with some illuminations in green gouache that include the capital letter and frame the calligraphy.*

An Exercise in Chinese Calligraphy

Chinese calligraphy is one of the oldest scripts, more gestural and artistic, and in China it is considered a sublime art at the same level as painting. This is why we have included it in the step-by-step exercises. In addition, it demonstrates the creation of a work of calligraphy with a Chinese brush. Here you can see how to write the word "luck" according to the instructions of the artist Walter Chen.

REQUIRED TOOLS AND MATERIALS

The tools required for Chinese calligraphy are very typical of that culture, and calligraphers in China know them as the "Four Treasures of the Study." They are mulberry paper, brushes, *sumi* ink, and the stone inkwell known as the *suzuri*. These tools should all be of good quality, because it will be reflected in the quality of the final work.

BEFORE STARTING

Posture is very important when practicing Chinese calligraphy. The back must be absolutely straight, but not tense. Black felt is placed on the table, under the mulberry paper to absorb any excess humidity from the ink. You should also have a piece of paper for tests, a rag, and of course the inkstone with enough ink in it for the exercise. After the appropriate brush is chosen it is held vertically between the index and middle fingers.

1. Begin the writing at the top of the letter, which is a dot.

THE WORD "LUCK"

Nine basic strokes in specific order and direction are made to write the word "luck" correctly. This is the *"ductus."* Generally, the order of writing in Chinese calligraphy is from top to bottom, and since there are two vertical parts, the one on the left is written first, then the right one. In the regular writing style, or *Kai shu*, which will be used in this exercise, all the Chinese letters are written following a model consecrated by tradition. In other styles, like the abstract, or *Tsao shu*, the calligrapher can put more of his or her personality into the work.

2. Next draw a horizontal line from left to right, applying more pressure at the beginning. This will make a line that is thicker at one end than the other. It is always helpful to practice on another piece of paper.

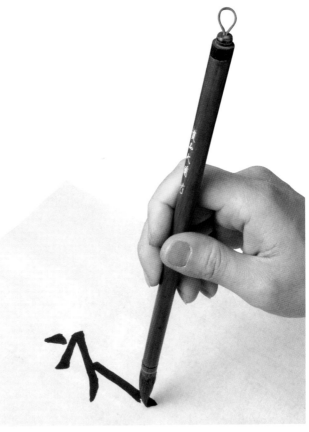

3. *Now continue by making a short stroke from right to left.*

4. *Make a vertical stroke from top to bottom, with a dot to the right of the vertical line, seen in the next step.*

5. *In this step you begin to write the second vertical part, to the right of the one you just made. Begin by making a horizontal stroke from left to right of decreasing thickness.*

6. *Now draw a rectangular shape from left to right.*

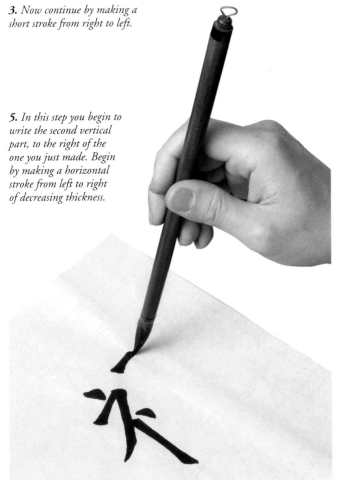

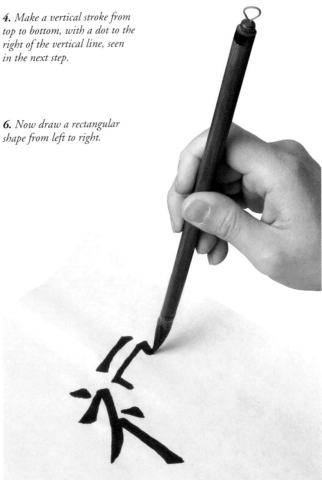

7. *Draw a horizontal stroke and then two vertical strokes at the sides of it. It is important to concentrate on the work to make the strokes meet perfectly. Small hooks are created at the ends of the lines by making a slight movement with the wrist when lifting the brush from the paper.*

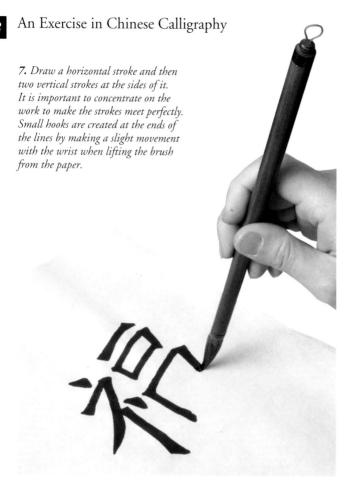

8. *Now a horizontal stroke is made to join the two previous vertical lines.*

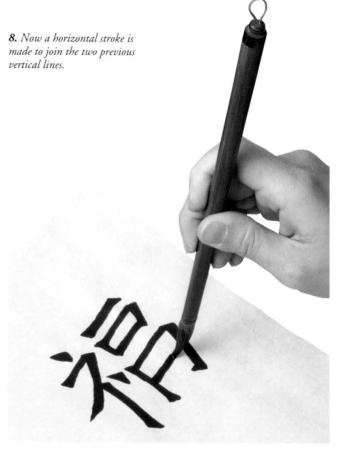

9. *Next a vertical stroke is added, the top of which touches the horizontal line. Finally, a horizontal stroke is added across the bottom.*

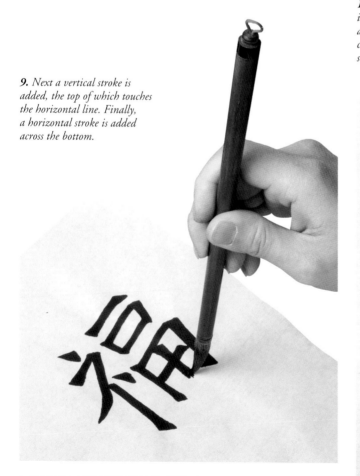

10. *In China a work of calligraphy that is done with excellence is considered a work of art. It is finished when the calligrapher signs it with his personal stamp and a special red ink.*

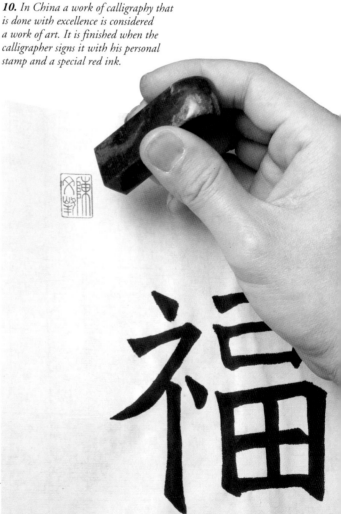

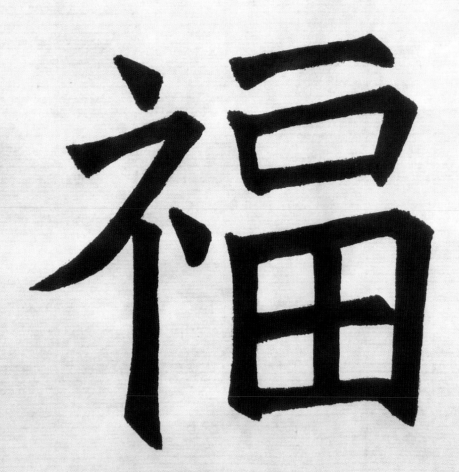

11. *The finished word "luck," with the artist's personal stamp at the top.*

Calligraphy on an Automobile

Calligraphy is an art that most people think is only practiced on a sheet of good paper or other quality support. In reality, you can do calligraphy on any support no matter how strange it might seem, like a lamp, the façade of a building, or a car. The last has the advantage of displaying the calligraphy for as many miles as it may travel. It is also a means of displaying a more professional facet of calligraphy, like the personalization of a car for publicity or commercial ends. In this exercise Oriol Ribas gives this car a tune-up with calligraphy.

TOOLS AND MATERIALS

For calligraphy on cars, you must take into account the nature of the various media that can be found. There is sheet metal with enamel paint on it, glass windows, and rubber gaskets. Although not as common, there is also plastic made from resin, used for some bodies. The type of paint you use can be the same for all surfaces, but it must have sufficient adhesion to the different materials and be resistant to external agents, especially sunlight. Before you begin, it is important to make sure that your surface is dry and cleared of any dust.

For your work to be permanent it is ideal to use auto body paint. Use a brush with a medium-sized edge, and another with a fine edge for details.

THE PROCESS

Calligraphy can be applied to any part of an automobile, from a corner of the bumper to the entire vehicle. The second case, shown on these pages, is more complex because of the great amount of text to be written. For this reason it is a good idea to plan the forms, the letters, the colors, the texts, and the surfaces to which they will be applied. This type of project is for people with a certain amount of experience, since fitting the letters into the sinuous forms requires some skill. Since the surface to be painted is quite large, we only show the main details on this page.

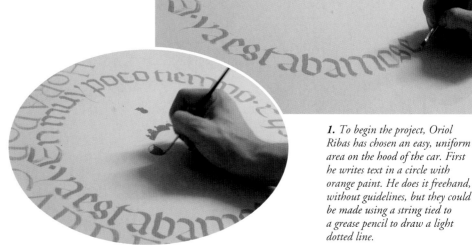

1. To begin the project, Oriol Ribas has chosen an easy, uniform area on the hood of the car. First he writes text in a circle with orange paint. He does it freehand, without guidelines, but they could be made using a string tied to a grease pencil to draw a light dotted line.

2. After writing the circular text, he begins writing yellow script that starts off perpendicular to the circle, approaches it and nearly surrounds it on the outside. At the far right of the hood the calligraphy separates from the circular text. An ornament is painted in the center.

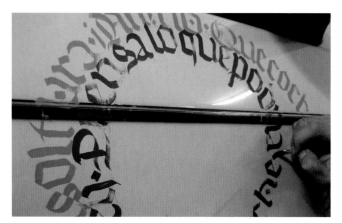

3. Next, circular text is added on the right side of the car. Here Oriol finds another material that he must paint over, the decorative plastic strips.

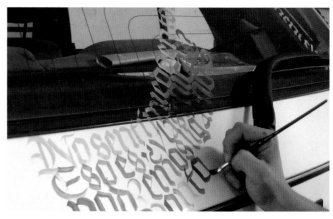

4. Work continues on the hatchback, where calligraphy is applied to the glass and the rubber around it. Work on this part is done with different colors, like orange and ultramarine blue.

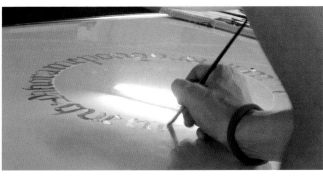

5. *Calligraphy begins on the roof of the car with the help of a ladder. The calligrapher carefully centers the circle of dark red text.*

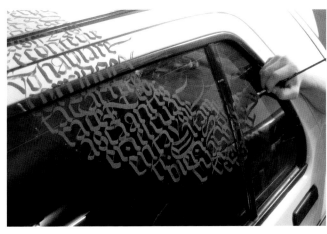

6. *Beginning at the circle he paints justified, tightly spaced text with blue paint. It is extended across the window on the left side while maintaining the width.*

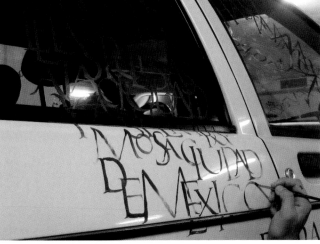

7. *The calligraphy is continued on other parts of the vehicle, like the right side. The calligrapher changes his colors according to a previously conceived plan. The basic scheme is complete, although there is still much work to be done.*

8. *This and the following photographs illustrate the completed work on different sides of the vehicle. In this front view you can see that the original inscription was embellished with different shapes, letters, and colors.*

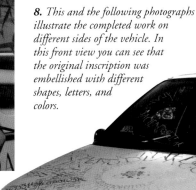

9. *A view of the calligraphy on the back of the car.*

10. *A view of the left side rear.*

Contents